LOCAL COLOR
A SENSE OF PLACE IN FOLK ART

LOCAL COLOR
A SENSE OF PLACE IN FOLK ART

by William Ferris

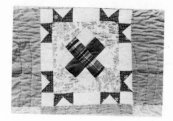

edited by Brenda McCallum
with a Foreword by Robert Penn Warren

developed by the
Center for Southern Folklore

McGRAW-HILL BOOK COMPANY

New York St. Louis San Francisco Bogotá
Guatemala Hamburg Lisbon Madrid Mexico Montreal
Panama Paris San Juan São Paulo Tokyo Toronto

Note: Unless otherwise noted, all photos are from the Center for Southern Folklore Archives, Memphis, Tennessee

A portion of this manuscript is reprinted from:
William Ferris, ed., *Afro-American Folk Art and Crafts.*
Boston: G. K. Hall, Inc., 1982

Extensive field research on each of the artists was conducted
and assembled during the past decade through the Center for
Southern Folklore, Memphis, Tennessee. Co-founder and executive
director Judy Peiser and the Center staff have interviewed
artists and featured them in documentary films, traveling
exhibits and community presentations.

1 2 3 4 5 6 7 8 9 DOC DOC 8 7 6 5 4 3 2

ISBN 0-07-020651-1 {PBK}
 0-07-020652-X {H.C.}

LIBRARY OF CONGRESS CATALOGING IN PUBLICATION DATA

Ferris, William, 1942–
 Local color.
 Bibliography: p.
 Includes index.
 1. Folk art—Mississippi. 2. Folklore in art—
Mississippi. I. Title.
NK835.M7F47 1983 745'.09762 82-10052

Book design by Suzanne Haldane

In memory of
Theora Hamblett, 1895–1977
and
Victor Bobb, 1892–1978

PREFACE

SPECIAL THANKS are due to each of the artists in *Local Color* who opened their homes and believed in our effort. Their conversations unveil a deeply personal view of their lives and art. Our work has been pursued with a sense of urgency and sadly two of the artists—Victor Bobb and Theora Hamblett—did not live to see the publication.

Extensive field research on each of the artists was assembled during the past decade through the Center for Southern Folklore, Memphis, Tennessee. Working with Judy Peiser, David Evans, and Center staff we have featured artists in documentary films and traveling exhibits. Through the Center, with support from the Folk Arts Panel of the National Endowment for the Arts, Brenda McCallum edited the interviews which follow.

This study of Southern artists and their relation to the region is clearly shaped by Eudora Welty's "Place in Fiction." Miss Welty's writings provide a touchstone for understanding artists and their culture.

Walker Evans shared valuable counsel on how one sees and understands folk art. Walker viewed films on the artists and noted their connection to Southern worlds he had explored earlier in this century. Henry Glassie and George Kubler's pioneering studies of material culture offered an important frame for the work. Others who offered encouragement and counsel on the volume are Patti Black, John Blassingame, Simon Bronner, David Evans, Charles Montgomery, Robert Thompson, John Vlach, and Maude Wahlman.

The manuscript was carefully shepherded through the publishing world by Wendy Weil and has been ably edited by Tim McGinnis. Sue Hart provided thorough readings and editorial work. which the author here explores—the world of the back-country and untutored artists in Mississippi. What we have here is a series of

Support for research on the volume was at various points provided by the National Endowment for the Arts, the National Endowment for the Humanities, the Rockefeller Foundation, the Ford Foundation, the Wenner-Gren Foundation, the Mississippi Arts Commission, the Mississippi Committee for the Humanities, the Tennessee Arts Commission, the Mississippi Agricultural and Industrial Board, Yale University, and the University of Mississippi.

A final, deeply felt thanks is due Robert Penn Warren, who viewed films on the artists, read the manuscript, and prefaced the work with his moving essay.

<div style="text-align: right">

William Ferris
University of Mississippi

</div>

FOREWORD

W E ALL HAVE little obsessive concerns, even if we are
scarcely aware of them, which may run from hobbies to passionate
professional preoccupations. For me, one such concern has been to
see all of America, all parts, and different layers of life in it. For in-
stance over a period of several years, in the Depression, in a fifty-
dollar Studebaker and with a red bandana on head, I saw most of
the Middle and Far West, and the desert country, and now, almost a
half-century later, I have been in every state, in various stages of
life, just out of curiosity or because of a long or short job.

I was raised in the South, in the little corner of tobacco country
just north of Nashville, on the very line of Kentucky. I was of solid
Confederate heritage, but I really discovered my Southernness only
when, at the age of twenty, I went to California and began my wan-
derings. It was only then that I began to read Southern (and Amer-
ican) history—though I had heard those things "talked" all my life.
So I discovered the South: a fish doesn't think much about water.
And later I was to see a lot of America, and find out quite a lot of
the ways people talk, eat, and spend their Saturday nights. There
are thousands of such things and you never get through, and there
are always new places.

But there are places and ways you think you know pretty
well—and deceive yourself. I thought I knew a good deal about
Mississippi, but on every page of this book, I have found something
new and fascinating, big or little. After all, this book has much to do
with the cotton country, and it was not the tobacco country that I
had known best. But it is about individuals too—and there is on
this point no end of variety and curiosity. There seems to be no end,
too, to what at first glance seems the restricted area of interest
which the author here explores—the world of the back-country and
untutored artists in Mississippi. What we have here is a series of

portraits and hints of the life stories of folk artists, in their own words, with a rich pictorial accompaniment.

One of the first that pops into my mind is the needlework artist of Belzoni, but there is also, for example, a fund of information about the 140-proof red-hot whiskey from "the island." There is the man with no middle name till he gave himself one—a superfluous act, for his fame as a walking-stick maker had become so wide that he could receive, safe and sound, a letter addressed familiarly to "Hickory Stick Vic, Mississippi." There is the inventor of the one-string guitar, who also invented a way of drawing a complex music from it—because every night he had to have some music. There is the little boy who taught himself to make figures in clay to sell to buy a school book and crayons, a little boy whose life passion became working at clay figures, and whose dreams were often full of images—faces—he knew he had to make.

In fact, an abiding interest in this book is the penetration to the inner lives of people you'd never see in real life, or would pass, un-noticing, on the street of a small town or a country lane. The reader's human picture is widened and deepened, and a whole new range of worth and sensibility opened. Man is a more curious and perceptive and courageous and valuable creature than we had guessed.

To turn to a matter of more specialized sort, the reader who has a special interest in the arts discovers among these untutored and deprived artists a depth of self-examination and speculation rarely guessed. For instance, the needlework artist of Belzoni, when asked why she kept so devoted at her task and never sold one piece, said: "My needlework, it's just something like a family picture to me. And sometimes, when people want to buy my pictures, well, I feel selfish. One lady said, 'Well, if you make the pictures, why don't you want to sell them? Why don't you want to share them with people?' But I do share them. When I go to festivals and things like that, it delights me for people to look at my pictures . . . I don't mean to be selfish . . . it's just, well, you don't want to give your old family pictures away, you know . . ."

She had begun, she tells, "wanting to save all my beautiful memories—all the things that happened when my children were lit-tle." But her scope broadened. "Like I thought about the wedding

of my greatgrandparents. I didn't have any pictures of their wedding, so I just imagined how their wedding might have looked, and I embroidered myself a picture of it. And I like it just as much as I would if I had a real picture, I think."

As for the sculptor, as I have said, he sometimes dreams what he must make. "The picture . . . that means if I was going to make a man that looked just like you, that would recollect you. The picture comes in dreams. The dreams just come to me. I lay down and dream about the sculpture, about how to fix one of the heads . . . I'm liable to dream anything. That gives you in your head what to do."

Over and over again, there are hints of the sources and meanings of the thing created. Over and over, we come across the idea of the relation between the artist and the people around him, but as frequently is hinted a personal relation of the artist to his work. In evidence: "The blues is a kind of thing that if you're driving along, plowing in the field, and something comes to you, you just start to sing. You make that up yourself. You can put anything in a blues . . . I make up my own songs myself. That's the way I play. I can't play someone else's songs and their tune."

In a way this book is about some of the deep issues of aesthetics, if we wish to take it into that lingo. But that fact does nothing to diminish the sense of the "making" as a natural and essential part of life. Ultimately, the book is about the richness of life—and the necessity of art in that richness. There seems to be a deep revelation of this in the fact that these untutored folk artists (primitive though sometimes greatly gifted) are not set off as special in their world. They are accepted as a natural, though unusual, part of it, and they seem to feel no pride (not even awareness) in their role. In other words, it is the modern world of "high culture" and "high technology" that makes sharper and sharper the difference between art and non-art, between artist and the ordinary citizen, rich or poor. In our world, unless his work fetches a fine figure, or his face gets on the cover of a magazine, the artist is apt to meet with contempt, however well concealed. It is far too often forgotten that art and life have an inextricably entwined rootage. That is what we find here.

Robert Penn Warren

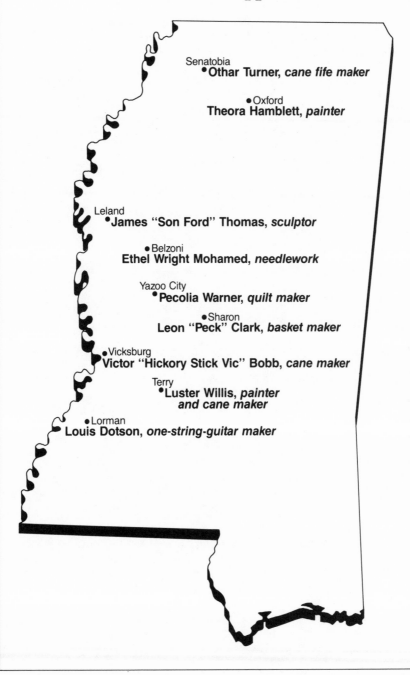

Mississippi Folk Artists

Senatobia
Othar Turner, *cane fife maker*

Oxford
Theora Hamblett, *painter*

Leland
James "Son Ford" Thomas, *sculptor*

Belzoni
Ethel Wright Mohamed, *needlework*

Yazoo City
Pecolia Warner, *quilt maker*

Sharon
Leon "Peck" Clark, *basket maker*

Vicksburg
Victor "Hickory Stick Vic" Bobb, *cane maker*

Terry
Luster Willis, *painter
and cane maker*

Lorman
Louis Dotson, *one-string-guitar maker*

Paul J. Pugliese

CONTENTS

INTRODUCTION

AMERICAN ARTISTS are often identified with the place in which they set their art. From Twain's Mississippi River to Faulkner's Yoknapatawpha County, from Grofe's Grand Canyon to Bernstein's West Side, from Wyeth's Chadds Ford to Ansel Adams's Yosemite, American artists celebrate place and are in turn defined by it. The Southern folk artist has particularly deep ties to place. In their more isolated region with its long, vivid history, folk art is an intensely personal expression. It is not conceived with the museum in mind. Its images appear as dreams and visions to artists who release them on canvas, cloth, and in sculpture. Artists often treat their pieces as children and share them only with family and friends.

Local Color grows out of fieldwork in the sixties which focused on Southern blues and folktales. The work was done with conviction that significant folk performers would never be recognized unless recorded with photographs, film and taped recordings. It became increasingly clear that white and black artists shared a folk art with a powerful, complex vision. This art was largely unexplored in spite of its fundamental connection to verbal forms such as music and folktales. This connection was first explained to me by James Thomas, who translates his dreams and visions into blues, folktales, and sculpture. Artists like Thomas repeatedly point to memory, dreams, and visions as the emotional core of their work.

The artists in this collection represent a particularly valuable Southern perspective. They witnessed the change from preindustrial to space age experience, and each remembers dirt roads where horses, mules and wagons were the only transportation. Each remembers when the automobile, television, and airplane first

touched his or her life. Each saw family and community evolve as social and technological change reshaped the South. Theirs is the final generation to remember what Pecolia Warner describes as "way back times." Peck Clark speculates that people are often sick today "on account of we left them old rules." An older order is clearly present in their lives and art.

These artists have the longest memory, and as they reflect on "that long time behind and that short time ahead," age and death are familiar faces. Ethel Mohamed sees age as a liberating experience. "Seventy is nothing to dread . . . At seventy you can be the age of whoever you are talking to." After painting the murdered body of Emmett Till lying in his coffin, Luster Willis reflects that "death is interesting because it's something that, sooner or later, we all will have to meet." Observing Till in his casket, he says, "Some folks will come by and look at it, and wag their heads and walk away and say, 'I wouldn't draw such as that.'"

Black and white artists share deep bonds in many areas. Both regard the past with reverence, and acknowledge older masters from whom they learned. Victor Bobb learned to carve walking canes from Mr. Hill. Leon Clark first made baskets with Rob Woods. Ethel Mohamed and Pecolia Warner began to sew under the watchful eyes of their mothers. Theora Hamblett, James Thomas, and Luster Willis heard internal voices in visions and "futures" which inspired their work. Respect for elders is a constant theme. Sometimes this respect was forcefully imposed, as when Leon Clark's mother cut off his pants to remind him he was still not grown. Theora Hamblett cared for her father until his death, and later his image returned to counsel her at critical points in her life. Each refers to deceased elders in describing how their life and art have evolved.

Artists are also conscious of the place and season in which they work. Asserting that he is more comfortable in the countryside, Louis Dotson says he "always liked to be in the sticks." He views the city as a strange world and recalls how his wife once went to Jackson and "couldn't find her family until she saw them in the streets." In the countryside seasons also influence artists' work. Peck Clark makes his sage brooms in the fall when sage grass has dried.

Luster Willis finds winter and spring are best suited for his paintings. Theora Hamblett's foliage and flowers identify the season in which her paintings are set.

Throughout these narratives we are repeatedly struck by the eloquence of artists who reflect on art and on the creative process. They repeatedly explain how they discover images in their imagination and then shape them in their art. Luster Willis states the process quite simply. "I can see things and feel them with my imagination, then sketch them on a piece of paper." The original image cannot be verbalized. It must be made art because it "can't actually be brought into words. A picture tells more than a thousand words could express." When Willis needs an image, he reflects, "I just fish it out of my mind and try to draw it, kind of through imagination." None of these artists articulate their thoughts in writing. Yet in conversations each presents a clearly defined, thoughtful view of the creative process, and even more importantly each shapes pieces— quilts, paintings, and sculpture—whose power goes beyond words.

The life and work of a folk artist must be considered together because each deepens our understanding of the other. Artists' voices are an important counterpart to their work, and as we weave our thoughts with their own, we unfold a closer sense of their vision and allay Theora Hamblett's fear that her work may be interpreted apart from the vision which inspired it. "It hurts me for someone to come in and give their interpretation of one of my paintings, just entirely different from the way I meant it. Sometimes I'm afraid that the story behind my visions is going to be lost."

The artist renders scenes with painting, sculpture, and needlework that range from literal to highly abstract visions. As Theora Hamblett paints her dogtrot home and country church, as Pecolia Warner quilts a log cabin and Pigpen pattern, and as Ethel Mohamed stitches her husband's wagon and dry goods store, we see their community. Pecolia Warner recalls: "I was born in a log house—it was made out of logs with mud between them and rough boards nailed on to hold the mud in there. And I've pieced up a log cabin quilt. It's a string quilt, and it's easy to piece." She isolates the familiar and allows the viewer to see through her work. To understand her image we must learn to read shapes like the "P" quilt,

whose inspiration stresses the importance of visual literacy. "I was sitting around and didn't have anything to do, so I said, 'I just believe I'll make me a piece that will be the start of my name.' It's a P quilt, I call it. I want to make more letters, just like I made that P. I bet I could even do the whole alphabet."

Conversations with artists teach us to read the shapes and colors of sculpture, painting, and needlework. The artists depict familiar scenes with language appropriate to their medium, and as we look at their collected works, distinctive styles emerge.

A strong sense of place influences each of the artists. Ethel Mohamed, who lives in Belzoni, was born in the Mississippi hills in Webster County, and moved down to the Delta with her family while she was a child. She feels that the difference between hill and Delta places is reflected in their music. "The spirit of the people is in their music. When you hit the Delta, the cotton country, it's just wonderful, the music people in the Delta make. People in the Delta are not conservative like people in the Mississippi hills." Through her stitchery Mrs. Mohamed embraces worlds she and her family have known. Needlework portraits of her childhood in Webster County, Mr. Mohamed's birthplace in Lebanon, and their common world of Belzoni enrich our sense of how place, past and present, shapes art.

Theora Hamblett also reflects on place through her art. As she draws places from memory, her paintings recapture the landscape, buildings, and family that shaped her childhood in Paris, Mississippi.

> Near our house was an ever-flowing spring and it made no difference how dry the weather got, all the families could go to the spring to wash. There was plenty of water. See, the mother is working at the tub. The daughter is lazily poking the clothes down, and the little boy is lying out in the grass playing with a dog. And this here is the big old tree that stood in our yard lot. It always had those three knots on it. The tree is dead now, but the last time I was out there, those three knots were still on it.

Sense of place is also shaped by the world of memory, imagination, and visions within the artist. This internal place is an important balance to the more literal rendering of landscape into art. Ethel

Mohamed describes her store as her "public world." "It's a world with people. It's the store world, the business world." At home she discovers a private world in the attic where her children's toys touch her imagination and memories. "Really the attic is a world of enchantment to me. I see their toys, and I can almost see the children at play again. So I stay there a little while, you know, and I enjoy that, kind of like it was a special fairyland."

Mrs. Mohamed's needlework mediates between her private and public world. It articulates her rich memory of family inspired by her attic and presents these memories to those who may never know the artist in her home. Her stitchery gives us access to the internal private place of the artist. Created in the shelter of her home, the art is a statement that she can share with the public world.

Artists often stood apart as children and observed others their age. Theora Hamblett remembers that "a lot of time I didn't join in with the other children playing. I stood off, and watched the other children." James Thomas had a similar childhood experience. "Most of the time when I was young I never did fool with no boys or nothing. I hardly ever would play with anybody. Just anything would cross my mind, I'd do that." Loneliness and isolation encourage artists to depict their internal world. Luster Willis explains how his work emerges during periods of loneliness: "I get my feeling for drawing when I get a little lonesome. You have to have that feeling to do something. I can draw my best pictures when I'm alone, private."

Childhood memories of landscape, homes, and family provide a foundation for their later work. There is an urgency in each artist's work as they freeze this memory of life before it changed. Theora Hamblett remembers the stable, old hickory trees her father planted, and paints them as they stood before they were "slain." "I don't go back out there. I don't want to see that. My favorite trees are all gone." But the trees stand remembered and preserved in their full beauty on Miss Hamblett's canvases. By depicting memories through their art the artist frames his or her culture into recognizable units. Pecolia Warner's quilts stretched across her bed and Theora Hamblett's paintings on her walls each preserve the

memory of their maker, for when we see the artist's work we see through his or her eyes. Ethel Mohamed's memory allows her to relive experiences as each piece of stitchery evokes an important event in her motherhood. These events touched all her family, and her art cements their history as a family.

> I started out wanting to save all my beautiful memories. . . .
> It's not that you dread the future, but you kind of want to
> hang on to the past, especially when you have children. All
> my little memories are very dear to me now. So it's a great
> pleasure to me to make pictures out of my memories.

The internal sense of place recalled in the artists' memories is expanded and enriched by their imaginations. Images are rendered greater than life and give the art suggestive rather than literal power. Ethel Mohamed is comfortable with wildly colorful birds which spring from imagination. "I think so much in my pictures is from imagination. I think that might be the reason my birds are different colors—not that they actually are—because my pictures are a sort of fairyland. It's a world of enchantment."

Literal and imaginary worlds merge as imagined images become part of art. Like colored birds in Ethel Mohamed's stitchery, unknown people emerge in Luster Willis's paintings. Willis discovers "make-up" characters as they run across his mind. The make-up figure is shaped when Willis allows his mind to wander and fix on images that surface. He reflects on how he moves beyond the literal level of memory, of remembered images, and into the world of his imagination. "Some of the people in my pictures are just make-up characters. They come to me through imagination. Sometimes I just sketch something that runs across my mind, and I see if I can paint it."

The third and most interesting level of the artist's internal place involves dreams and visions. This level appears during sleep or in semi-conscious states, and its revelation haunts the artist until released through art. Theora Hamblett felt her gift for visions was inherited from her grandmother Cobb who frequently dreamed of supernatural events. When she closed her eyes, Miss Hamblett was haunted by visions until she painted them. While in a hospital she

xxii

saw vines. "I'd strain my eyes by keeping them open, just to keep that vision away. This vision of the vines lingered and lingered. I had to fight it off. I succeeded in keeping it away by keeping my eyes open as much as possible. After I paint them, then I'm never bothered with that memory constantly coming back again."

In developing their art, repetition, balance, superimposition of materials and perspective are particularly important. When artists repeat the same visual idea, repetition is never exact. Rather, variations are shaped on the same theme. While James Thomas has molded numerous skulls, each piece is distinctively different from others. Pecolia Warner has quilted a series of star quilts, but color variations make each a distinct piece. Artists thus develop incremental repetition in their work as they unveil variations with each piece.

Balance and symmetry is particularly important in quilts, needlework, and painting which focus our eye on a central image. Theora Hamblett's painting of her dogtrot home, the structure she knew as a child, focuses our eye through a central hall with two rooms on either side to the seed house beyond. "You could see all the way through the hall to the seed house way in the distance. It was really a good distance back, but in my memory that was the effect." The dogtrot's hallway is a central axis around which she balances her painting. She repeats this balancing technique using paths and roads that lead through the center of canvases in both her visions and her childhood scenes.

Superimposition of materials is basic to mediums such as painting, needlework, and quilting where oil paint, stitches, and cloth pieces are attached to a primary surface. Surface texture is used to affect responses from the viewer as Ethel Mohamed and Theora Hamblett accentuate trees in their art by using more thread and double layers of paint. Mrs. Mohamed says, "If I want a tree to look heavy and stand out, I'll use six strands of thread." Theora Hamblett places red paint over yellow to add life to her trees. "I always put two coats of paint: red over yellow. That yellow underneath makes the red show up better, I just automatically grew into doing that, putting two coats of paint on the leaves." Luster Willis amplifies this technique in what he terms a "set-in." Willis paints and cuts out images which he then attaches to a darker background

surface so that it will "show up better." For each artist superimposition of materials increases texture and three dimensionality. Superimposed tactile surfaces moving beside and over each other are as important for Theora Hamblett as for Luster Willis. Each animates his or her work with bursts of color and shapes which draw the viewer's eye to unexpected, sometimes frightening images.

Perspective is used in very different ways by artists. In Theora Hamblett's paintings human forms are dwarfed by large trees and fields. Her tiny stick-like human figures are overshadowed by the natural world. In stark contrast to Miss Hamblett's perspective, James Thomas confronts us with life-sized clay faces and skulls. He molds detailed human expressions which stand apart from any reference to nature.

Mrs. Mohamed's stitchery of Sacred Harp Singing at Double Springs Baptist Church focuses our eye on four-part harmony inside the church surrounded by a myriad of outdoor activities from dinner on the grounds to horse trading. "And see the man behind the tree taking a drink. He thinks nobody sees him, but we do." Like an Alabama mountain song, her needlework reveals the total world of a Sacred Harp sing.

> Sacred Harp Singin'
> Dinner on the grounds
> Whiskey in the woods
> An' the devil all around.
> (Carl Carmer, *Stars Fell on Alabama*)

Each artist has a strong sense of family, and many inherit skills from their parents. Among women, the relation of mother and daughter in what Pecolia Warner calls "fireplace training" is especially important. The mothers of Ethel Mohamed, Theora Hamblett, and Pecolia Warner introduced each to their art. Mrs. Warner remembers: "I been wanting to piece quilts ever since I saw my mother doing it. I wanted that to grow up in me—how to make quilts." Most artists are interested in their skills from childhood. Though Mrs. Mohamed and Miss Hamblett began their work later in life, their interest in needlework and painting was learned as children. Theora Hamblett's mother gave her a box of crayons at

the age of eight, and that was when she "first became interested in painting." Mrs. Mohamed reflects on this connection: "You know, I think there's a lot of truly wonderful things in Mississippi that are just handed down from mother to daughter, and never studied in books. Often a woman will say, 'I want to do just like Mama did.' And that's the real artist, isn't it, to bring that down from one generation to another."

With a firm hold on family, artists create a progeny of sculpted faces, quilts, and painted scenes. Ethel Mohamed says, "I'd feel kind of lost without my pictures. They're like having my children around me." As artists memorialize their family in their work, they will in turn be remembered through their art. Pecolia Warner hopes to be remembered through her quilts. "They'll say, 'Well, I knew one old lady, that's all she did was to piece quilts.' I'd like them to remember me quilting."

At times the artists insert themselves more literally into their work through self-portraits or signatures. Like a folksinger or storyteller, they take the license of introducing the audience to the art's creator. Luster Willis's self-portrait, Ethel Mohamed's stitched name, Pecolia Warner's "P" quilt, and James Thomas's signed skull personalize each piece.

Artists' homes are filled with their work, and a visitor moving through each room feels watched by their art. Within this world the artist locates a space where at certain times he or she works. Luster Willis paints late at night near his fireplace. Theora Hamblett painted during the day in a bedroom. James Thomas sculpts on his front porch in the afternoons. Artists find their spot and from it produce objects that soon decorate their homes and those of their friends. Their art draws the community together as people gather and comment on new pieces by the artist. Local women gather in Pecolia's home to help with stitching on her quilts. As art brings community groups together, it realizes Ethel Mohamed's belief that "art helps people understand each other." Connected as they are to memories and the passage of life, the artist's perspective is that neighbors need to stand together. James Thomas reflects: "White folks and black folks got to learn to live together. You may not need me today but you'll need me one day. I may not need you to-

day, but I'll need you one day. We all going to the same place, and that's down in the clay."

Artists draw heavily on religion as a source of images. Pecolia Warner often dreams of the Holy Spirit and feels it is the guiding force in her life. Theora Hamblett's visions are filled with biblical references, especially those found in Revelations. Luster Willis illustrates parables such as the story of Lazarus. And Ethel Mohamed dramatizes community celebrations in the church such as Sacred Harp singing and weddings. Each draws images from both biblical texts and local religious history in their art.

An important affinity is felt for animals and the natural world. The artist's eye wanders from barnyard animals to creatures such as crawfish, alligators, and bullfrogs. Artists are curious about animal life and sometimes imagine themselves as the animals they portray. Looking at her needlework depicting animals, birds, and insects, Ethel Mohamed recalls how as a child: "I used to wish I could go home with the rabbits, and maybe spend the night with them (and) I wanted to crawl up in that tree with the chickens and be a chicken for one night. Their world fascinated me, you know. And I guess I like bugs as well as I do animals. I think God loves little bugs and little frogs and things just as well as He loves us."

James Thomas's animals stare at the viewer with quizzical looks which suggest human expressions. His human faces, like those created by Luster Willis and Theora Hamblett, are accentuated by eyes which have a haunting stare. Their look is strongly reminiscent of old photographs, which are an important resource for the artists. Photographs offer a glimpse of ancestral faces and establish the expression of a person posing. The frozen, wide-eyed stare familiar in old photographs is at times recaptured by artists in a literal rendition of a photograph. Theora Hamblett's portrait of her brother Hubert accentuates his eyes and strongly suggests an old photograph of him as a soldier in World War I. Hubert's photograph lay in a trunk and seems an outline for Miss Hamblett's strongest painting. She had a vision of Hubert shortly before his death and was struck by his eyes. "Those eyes, the rays of light, oh, how his eyes did shine with joy and glory."

Media is an important source of images for artists who are inspired by the color of shapes and sounds discovered through radio, television, and newspapers. Luster Willis carves familiar faces from television on his cedar walking canes. Images of George Burns, Redd Foxx, Jimmy Carter, Ed Sullivan, and Gerald Ford adorn his pieces. Ethel Mohamed decided to embroider her name within a color border encircling it after seeing a similar design in *TV Guide*. "One night I just saw such beautiful colors around a name in the *TV Guide* so I just made my name like that." And Theora Hamblett heard Pat Boone advertising milk on the radio. When he sang, "Will the circle be unbroken," a choir of angels sang his chorus and the memory of the radio program haunted her for several years. "So I painted the people listening to a man singing at a microphone, with angels in a circle way back in the distance singing the chorus with him. Well, when I painted that, I never was bothered with that memory just constantly coming back again and again." Pecolia Warner often adapts newspaper patterns in her quilts and at one point was even inspired by the tape recorder on which I interviewed her. She looked at my machine and commented: "Like that wheel (the recorder reel) going around there—I can look at that wheel and imagine me a quilt from it. Just by looking at it I could do that. I guess I'd call it a tape recorder quilt."

Voices and images in *Local Color* unveil a moving portrait of the South and suggest how landscape and season inspire artists to share real and imagined worlds with their neighbors. Their art is a special gift offered to friends, to those who know, who will understand. It leads us into a sacred place where we learn to see and marvel at familiar, everyday beauty transformed by the artist's hand. Like Pecolia's "P" quilt on a cold night, their art offers beauty and shelter to each of us.

<div align="right">

William Ferris
University of Mississippi

</div>

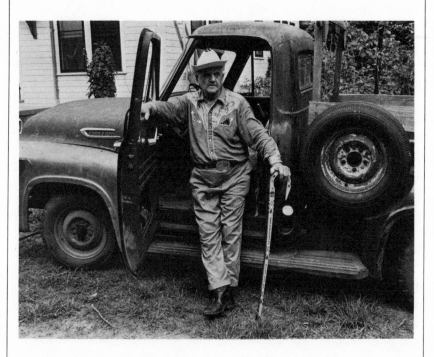

Victor "Hickory Stick Vic" Bobb

Cane maker | Vicksburg, Mississippi | 1892–1978

ICAN REMEMBER the date that something happened by tying it into something else. That's what I go by, I relate it to the time that a certain thing happened. I was born on January 16, 1892. That was two-and-a-half years after my parents was married. They lived in the first little house going down the hill there, by Gibson and Dabney Streets [in Vicksburg, Mississippi]. They pushed that house down with a bulldozer here not long ago to make a parking lot out of it. But that's where I was born.

I never did get a birth certificate. Back during the First World War I asked old Doctor Wilson—he was the doctor when I was born—to fix me up with something so that I could get a birth certificate. I went up to his office one day and he just commenced to writing. I said, "Ain't you even going to ask me anything?" He says, "I don't have to. I remember the night you was born. It was the coldest night *I* ever saw."

And I got the weather bureau to look up the date I was born and it *was* the coldest night that there ever was in Vicksburg! And he also told me that the night after I was born, somebody had broke into the house and stole my father's pants with his paycheck. They sold them way up on Bowmar Avenue. That old doctor remembered all that and he fixed me up with some papers. I sent them over to the Capitol in Jackson, but they sent them back. They said they were too busy with the soldiers, and I should send them in later. See, I was only in class four because I was working for the government during World War I. I never have sent those papers back to Jackson. So actually, I haven't been born yet. I'm in bad shape as far as that's concerned!

I was named after my mother. Her name was Victoria Oslin.

Her family was from up at Swifton [Arkansas]. Three years after me, my little brother was born. They named him Walter after my father. I can remember. I was a year-and-a-half or two years old, and my parents still hadn't named me. And finally one day my mother says, "What are we going to name him? We got to name him something." So my father says, "We'll name him Victor after you." She says, "What are we going to give him for a middle name?" My father says, "He don't need no middle name. If he ever gets any money, let him get one of his own." Now they're trying to give me a nickname: "Hickory Stick Vic" they all call me. I once got a letter that was addressed to "Hickory Stick Vic, somewhere in Mississippi." They put it in my mailbox. So that must be my middle name. I think it's worked out all right.

All of my father's people were steamboat people. That's the Charlie Bobb family, now. He was my grandfather. He was a steamboat engineer, and he was called the Steamboat Bobb. He had six children, three girls and three boys: Charlie, John, and Seymour. Two of them was steamboat engineers, and two of his girls married steamboat pilots. My father, that was John Bobb, he was the Yacht Bobb. One of the first lots ever sold in Vicksburg was sold to him. Then there was the Farmer Bobb. That was Seymour, my uncle, Henry and them's daddy. He always wore a big black hat. The Bobb family settled here in Warren County, but they came from New Orleans. They tell me that our name is German. I can't really vouch for that.

My grandfather, that's Charlie Bobb, was engineer on the steamboat *Ruth*. It was one of the two boats that went up in what they call the "upper bends"—that's up around Greenville [Mississippi]. The *Ruth* used to haul freight around those long bends in the river up there. They built a new boat then, the *Belle of the Bends*, to take the place of the two boats. My grandfather was its engineer, too. And my father was a striker for him. A striker is a helper on a steamboat. You have to stay there so much time to learn and get your license. My father got off the boat in about 1899.

I remember the snag boat *Meigs*. It was used to get the torpedoes out of the Mississippi River after the Spanish-American War was over. My uncle had been mate on that boat for, oh, fifteen or

3

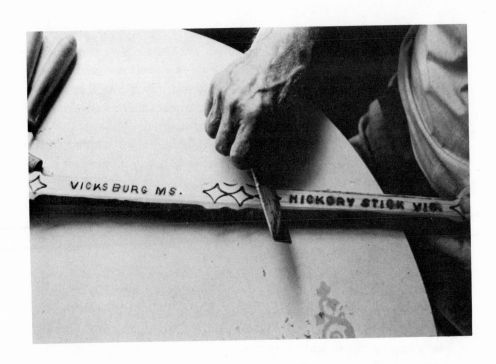

twenty years. The *Meigs* used to go out there and pull all those bombs and mines out of the river, and put them out on the deck. See, these snag boats are built tapered out in front so there's room to put the snags when you pull them out of the water. Captain Finnis used to run the *Meigs* then, but everybody called him "Fin Star." Well, they say that one time the mate was up on the upper deck, and he called out to Captain Finnis, "We got one that's hung under the bow and we can't get it out." The captain says, "Pull it, and we'll all go to hell together." And he did. The mate pulled it out of the water, and it blowed the whole front of the boat off—everything except the kitchen and the back end of that boat went up into the air. I think fifteen of the crew was killed, and only five or six was left.

And I remember about that old man "Fin Star." He had a hobby of collecting diamonds. He had one of those old river cups—big and thick, without a handle—full of unmounted diamonds that he had collected from all over the world. Well, he would pour them out on the table and he'd take his pencil and point out every one of them—where he'd gotten them, and the history of

each one. I remember seeing him do it just as well as if it was yesterday. And that was in 1900. I was only eight years old but I can remember him just as well as if it was yesterday.

They used to bring ice in here by barge from up the lakes, down from the Ohio River. They cut it up there and brought it down here packed in sawdust. Then they came out with machinery to make the ice and decided to build an ice house here to manufacture ice. They bought the machines in St. Louis and had them shipped in by boat. That's when my father got off the *Belle of the Bends.* They hired him to install all that machinery. But about a year later, he was tightening a flange where some ammonia pipes were leaking, and one of the bolts broke and it burnt his eyes some. So he gave that up and worked at the oil mill for a while. They pressed the oil out of the cottonseed there. Then he went on the tug *Joe Seay.* It was the first tugboat that the Pittsburgh Coal Company ever had in Vicksburg. My father was engineer on the *Joe Seay* up the river here long about 1901 or 1902. See, I can tie that in with the time that they opened the Yazoo Canal by dredging the Mississippi River. They kept that canal dredged out so that boats could come right on up to City Front [Vicksburg, Mississippi] and land.

My father was a good mechanic. I've always said if I got to be half as good a mechanic as he was, I'd be satisfied. But I haven't yet. I can remember my father . . . he'd take a ten-dollar gold piece and drill a hole through the edge of it all the way through and take the gold out. He didn't do that for no trick or nothing. He said that was the way the Chinese done it, and if they could drill it out, why, he could too. I can't drill one that straight to save my life.

My old Uncle Seymour was quite a character. That was "Farmer Bobb," my father's brother. I could tell you some things about him. He was one of the best rifle shots that most people have ever seen. One time he was sitting on the porch reading the paper. He had been teaching these two boys how to use a rifle. They came around and set up a three-pound coffee can on the fence post. Then they started taking turns shooting at that can. Each one of them missed it two or three times. Then old Uncle Seymour told them, "By God, I'll beat you shooting with your own rifle." He was just sitting there on a chair on the porch. He took up the rifle and hit

that can. It blowed down most of the fence and the chicken house. They had filled it full of dynamite and they'd been missing on purpose all that time!

I started to Speed Street School when I was six. Speed Street went to the sixth grade. I have a picture of all of us who were at the school then. And I've got everybody's name on the picture. I'm the only one that's living now . . . Then I went to Walnut Street School. It was a one-story school where the Central Fire Station is now. I finished to the eighth grade there.

The first job I had was down at the batting factory here in Vicksburg, where the Standard Oil Company is now. They had a plant where they took cottonseed and got the lint off of it. It was almost like a cotton gin, but it was made a little bit different. The machinery ran faster, too. They made the lint into rolls of batting like they use in quilts and mattresses and stuff. I started working there when I was eleven or twelve, during the three months' vacation when I wasn't in school.

The next year I worked on the ferry boat that carried passengers from City Front [Vicksburg, Mississippi] to Delta Point

[Louisiana]. It was the *Charles J. Miller* and it had just been re-
paired. My father drowned in 1904, and he wasn't but thirty-seven
years old. The year before he died he had dropped his seven-
thousand-dollar insurance policy in the New York Life, and all he
had was two-thousand dollars in Woodmen of the World. So my
mother put that two thousand dollars down on a house and started
taking in boarders. She married my stepfather in 1913. At that time
she made some money by sewing for people. She had one of them
old pedal sewing machines, and I remember I used to just sit there
on the floor and pedal as she sewed. Anyway, I had to quit school
after my father died, and went to work learning the machinist's
trade. I wasn't but fifteen. On Friday, the thirteenth day of May in
1907, that's the day I started learning my trade. The unluckiest day
in the week, month, and . . . I don't know about the year. But I
never have had an accident of any kind, never lost a fingernail,
never had a broken bone. I worked for four years there as a
machinist at the railroad shop. At that time the pay was five cents an
hour, ten hours a day.

Then in 1906, the government fleet [U.S. Army Corps of En-
gineers] moved into Vicksburg, working off a barge on the river.
The government machine shop, tin shop, blacksmith shop, the
boiler, the engine, and everything was on a barge at that time.
There was just five people working for the fleet here then. They had
a lot of work on the steamboats on the Mississippi River. Well, this
fellow named Blondie Aiken, he took me up there to the fleet. I
wasn't but nineteen then. That was in 1911. The chief clerk saw
me and said, "Why, you ain't nothing but a boy. How old are
you, son?"

I told him I was nineteen.

He says, "You can't get no papers until you're twenty . . .
Let's say you've just turned twenty-one."

So I said I was twenty-one and got my papers and went on to
work there. Well, it was during World War II before I finally got
back to my right age. I worked as foreman of the machine shop
there from November 1, 1917, until July 31, 1953. I retired at
sixty-two.

Well, I remember one of them army officers from the govern-

ment fleet—Major James O'Connor, a little Irishman—kept hearing about me going down to Belk's Island—that's a little island inside the big island, Palmyra. There was always talk about the bootleg liquor they made down there, and about how good the hunting was. Man, you could kill stuff down there—deer, ducks, birds—there wasn't no limit then. I killed eighty-nine mallard ducks one time, and I said I wasn't going to shoot a thing. Well, anyway, Major O'Connor, he kept wanting to go down there with me to the island. The government fleet had a little old steel hull boat, a tugboat about thirty-five or forty-feet long, named the *Chicot*, and we were going to go down there in that. So he kept talking about it and said, "When we get time, we'll go down there." At that time we'd get off at noon on Saturday. We'd only work half a day. So the major called me one Saturday morning. He said, "We're going to the island this evening."

I said, "Ain't nobody knows we're coming and they won't meet us with the wagon. We'll have to walk about five miles."

He said, "Oh, that will be all right."

I says, "It will be nearly dark when we get down there." That was on up, you know, to where what we used to call Belk's Island.

He says, "Well, that's all right, too."

So we went on down there and tied the boat up at old Gus Luckett's store. He was the deputy sheriff's brother. Well, we walked on down the levee because it was a little closer that way, about four-and-a-half or five miles. Well, we walked on up to the old Brierfield house[1] there at Davis Island. That old house had faced the river when it was built, but the river had worked away from it. It had filled in there for about two-and-a-half or three miles, and they had built a road behind the house. Well, that fellow Gatewood was the caretaker of that old house. He used to be one of the guards down at the county prison, down at Ursino. So the major and I walked on up there and knocked on the door. I could hear old Gatewood coming. Now, he wore red underwear the year round—and half the time he didn't have on any boots or shoes or nothing, but he always had a spur on. Why he wore it I don't know, but you always could hear that spur a clanging. If you never knew

8

Gatewood, you missed a whole lot. Finally he came out and said, "Who's that?"

I said, "Me, Gatewood, it's me, Victor. I got the Major with me."

"What g.d. major?" he asks.

So meanwhile, Major O'Connor is backing on down them steps, and saying, "Vic, we're in the wrong place, ain't we?"

I told him, "No, we're in the right place."

So Gatewood finally opened the door about that time and said, "Tell him to come on in."

I introduced them. There was a big old round table in that house. Them rooms was twenty-foot square and the ceilings were eighteen-foot, see. Right in the middle of that table—and it was set right in the middle of the room—there's two jugs sitting there. I felt one of them. It was still warm. And two tumblers was sitting there, too.

Gatewood says, "Maybe the major would like to have a drink."

"A drink of what?" he said.

I told him, "That's whiskey made over here on the island." That was good old corn whiskey, hot as a firecracker. He poured him out a tumbler full, about 140-proof and still hot, see, right out of the still. Gatewood had just brought it over. But the major, he drank that whole tumbler full right off. Then he just sat there, and directly he poured himself out another glass. I said, "Major, that stuff is pretty powerful."

He says, "Oh, it tastes pretty good to me!"

They had good liquor down there on that island . . . One time Old Man Morrissey, he put him a boat (the *Charles J. Miller*) down there by Centennial Island. He was right on the line between the two states. The Louisiana people would get after him, and he'd just move the width of the boat over to the Mississippi side of the line. And the Mississippi people would get after him then, and he'd move over just the width of the boat again! They claim they spent half a million dollars trying to find out whether he was in Louisiana or Mississippi.

Well, along about that time these levee contractors, they was

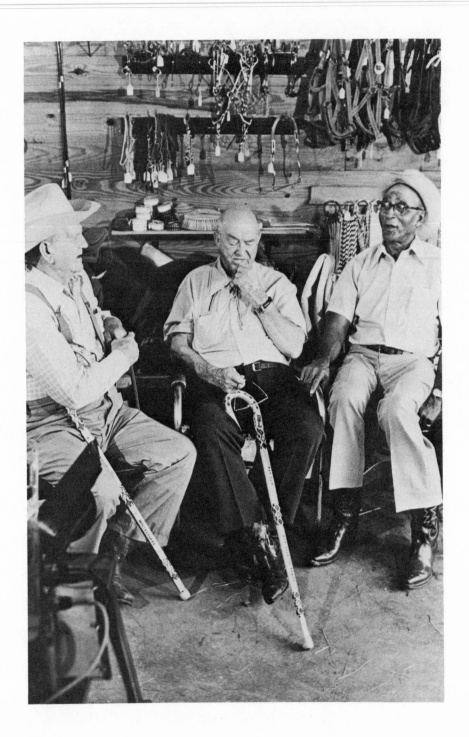

building the levees with mules and hauling that dirt with slips. For a while they used wheelbarrows, and then they got to using slips with the mules. And then they went on from building the levees, to hauling willows with the mules. They used to make willow mats to put on the river banks. Those willow mats could even float, just like a raft. We could slide them right off the boat or the barge, and then fasten them to the shore. They were used to pave the banks. This ties in now with Ray Lum—Ray would rent them mules to the government to haul willow branches with. They used the branches to weave the mats. But then willows commenced to getting scarce. They had to haul them sometimes four or five miles by them mules in those big old wagons, see. So the district engineer was trying to think up something else to use as a substitute for the willows. So they came out then with concrete mats. It was really just like the old willow mat, but with concrete cast on wire taking over. That was Mr. D. M. Sharer that had that idea to make a concrete mat.

So, anyway, there was a period of about twenty years, I'd say, that Ray Lum was renting mules to the government every year. Oh, he'd have as many as fifteen-hundred mules at fifty dollars apiece rented at one time. I went along with him on a lot of them trips of his. He bought them mules for fifty dollars apiece. Then he'd go and rent them to the government for nine months at fifty dollars apiece for each month. And then the government had to feed them. They got them good and fat and used to working, and then Ray would sell them for two-hundred-and-fifty dollars apiece!

Now I'm going to tell you something to prove I'm crazy. I saw in *Popular Mechanics* that this place was offering parts for sale for twenty-four dollars and eighty cents, I think it was, to build a five-tube superheterodyne radio. Now that was six months before the first radio station was ever completed. So I ordered the parts. Two months before KDKA radio in Pittsburgh came on the air I had a radio ready. And when it first came on, they were only on the air from ten o'clock until twelve o'clock. It interfered with the telegraphy on the railroad or something. But when it came, I was ready. That first program from Pittsburgh, though, I never will forget. They gave some news and then they gave the weather.

The announcer said, "And now I'll give the weather report

We just had a report from Havre, Montana. It's forty degrees below zero. I don't know how cold it is here in Pittsburgh, but it lacks a hell of a lot being spring!"

That was the first weather report I got over the radio. On that station in Pittsburgh, they also had this prisoner on the radio. His name was Harry Snodgrass. Every Wednesday night they'd let him out of prison for two hours or so to go and play the piano over the radio. He was in there for life. That was back in the early twenties. Anyway, then a month and a half later that station in Cincinnati [WLW] came on. Well, then I started to making radios to sell. You just got the parts together and put them on a panel and baseboard, see. They wasn't much trouble, except that you had three different tuning dials. I sold several of them.

In about 1923 or 1924—somewhere along there—three or four years before he went across [the Atlantic], Charles Lindbergh and a friend of his were barnstorming around the country carrying up people. They'd take up passengers for three dollars and fly them around for ten minutes all over town in an old World War I plane that he had. Paid four-hundred-and-seventy dollars for it. It was practically a wreck. His partner—his name was Jonesson, kind of peculiar name—took sick and Lindbergh left him in the hospital in Memphis, and flew ahead to Vicksburg to scout around and try and find other places to take up passengers. And coming into Vicksburg the motor cut out on him—he stripped a gear on his camshaft and had to make a forced landing up there at Houston Brothers' lumber yard. That's out where the first fairgrounds used to be, up until about 1900. Being in the National Guard, the first place Lindbergh thought of going was to the U.S. Army Corps of Engineers for help in getting his plane fixed. That's who I was working for then at the government fleet. Well, he had one of those foreign-made motors. It was made in France, I believe.

I don't know what happened—whether one of the valves stuck or what—but two teeth had broken out of the spiral gear on the camshaft in his motor. So he went up to the army officer at the government office and they came out to see me in a chauffeured car. I was foreman then in the machine shop.

The major said, 'This kid . . . " He called me a kid. I was real

young then. He said, "This kid can fix that thing." The major told me, "Go ahead, Vic. If you can help him out any way you can, go ahead and help him."

I says, "I don't know whether I can fix it or not, but I sure can try." So I brought the thing home, and I sat here that night. And finally I says to myself, "I can fix that thing." Took me a day and a half to do it, but I done a dentist job on that gear, and put it back together. Lindbergh was a pretty good mechanic himself, and I never will forget what he said to me when I got his motor fixed. He says, "You know, that's stronger than the original gear." It really was stronger than it had been before, because I had the steel going in different directions. So after I got it fixed, why, Lindbergh got permission then for me to go up there and help him put it together. So, we got that gear put in there.

And Lindbergh asks me, "You reckon you could find a place around here where I could take some passengers up?"

I says, "Yeah, I know a place what we call Kleinston." That's the lower landing in the bottom on the river near Vicksburg. It's down there where the transfer boats used to land. There's a big flat by the levee, where they used to have circuses and shows, and all like that.

So he says, "Let's fly on down there. It'll be a good way to try that gear out."

I says, "Well, you reckon that gear is all right?"

Lindbergh says, "I *know* that it is. Don't worry about that."

So we took off, from up at Sandy Bottom. We got up in the air, and I motioned for him to circle around and land at Kleinston. He set his plane down right on that circle made by the railroad tracks.

I had been up in a plane before—but as we were up there I saw that *this* one had what looked like a piece of split spruce wrapped with some old hay wire holding the fuselage together. The fuselage had been broken. It was wrapped round and round with hay wire, just like an old spring or something. That thing was working hard, and I kept my hand on it and held it tight until we landed. For a week I had the impression of that hay wire on my hand!

After we landed, Lindbergh said, "Vic, what were you holding onto that wire for?"

13

I told him, "Man, that thing is dangerous!"

He told me, "I plan to fix the other side just like it, because it's flexible, it'll give. If you had a crash it will give, and it won't break."

Well, it stands to reason, I suppose. That hay wire was like a spring and it would give a little, I guess. But I still remember the impression of that wire on my hand from holding onto it during the whole flight!

I got them to put a piece in the paper that he'd be taking people flying. And people came and was standing in line just waiting for him to land. For two days, we took people up. He left Vicksburg with a hundred-and-ninety-seven dollars. He wanted to give me some of that money, but I wouldn't take it. But he did take me out and give me a good dinner. And so Lindbergh went back to Memphis and picked up his partner from the hospital there and went on, to Pensacola, Florida, I think. And the first time I heard from him after that was a year later. He was in Kansas City, and he wrote: "No trouble, everything O.K. Lindbergh." That's all he said in that letter. Then before he went across I heard from him several times thanking me for what I had done. And he wrote a nice letter to my district engineer on top of that and I got a twenty-five-dollar a month raise! Which helped me a whole lot, because I wasn't getting but a hundred-and-fifty a month then, as foreman of the machine shop.

You know, Vicksburg had never observed the Fourth of July much, because that was the day they surrendered to the Yankees. Now, it won't hurt to tell the difference between a "Yankee" and a "Damn Yankee" will it? Well, a "Yankee" stays at home. Anyway, Eisenhower came here to make a speech on the Fourth of July at the new courthouse. And the government had an inspection boat, the steamer *General John Newton*, that they rode up and down in, patrolling the river. So Eisenhower spent the night at the government fleet on the *John Newton*. And the next day he made a talk at the new courthouse. That was the first time he mentioned anything about wanting to be President. Somebody asked him if he was nominated would he accept, and he said sure he would. They asked, "Democrat or Republican?" He said, "Either way." That's what he said.

Well, when he got through making his talk he went back to the *John Newton*. They were having a party for him on there with all the army officers and everybody. Well, they all ended up going in to town, but Eisenhower said he had some letters he had to write or something. So he said, "I'll be on later and I'll call you when I'm ready for a car." Then he came up to my office and wanted to know if he could use my phone. So I told him O.K. I didn't know who he was. I mean, I just had an idea who he was. I was putting a walking stick I had made into a box to ship it off to somebody. See, I make a box out of pasteboard and line it all inside with Christmas paper, and then I ship them.

And he says, "Would you mind my seeing that?"

I says, "No sir." And I handed it to him.

He asked, "Who made that?"

And I told him I did.

He said, "Who do you make them for?"

I says, "I make them for people that does something outstanding or deserves it."

"Well," he said, "maybe someday I'll get one."

And I said, "Maybe so."

But then after Eisenhower was nominated, I had one stick already made for one of those Koestler boys that run the bakery here in Vicksburg. It was the third one that I had made for him, and I had his name already wrote on it with a pencil, but I hadn't burnt it in yet. So I didn't have to wait to make a stick for Eisenhower. I just rubbed his name off of it, and burnt Ike's name on it. Well, I put on the outside: "I like Ike." And on the inside, I put: "Ike likes Mamie." And I put "White House, Washington, D.C." on it too. Now he had just been nominated. I saw him make a talk up at Memphis. He carried his hand over that part of the walking stick. And I got to shake hands with him. I said, "What are you hiding that from?"

He said, "I don't want to be *too* sure."

Well, when he was elected, he did get to Washington all right.

When he got to the White House, he hung his walking stick up over his desk, like most of them do. Well, it wasn't too long after that—it was less than a year—when Winston Churchill came over

here. And he saw the stick, admired it, and asked Ike about where he got it and all. Ike told him. And he got that walking stick down off the wall and let Churchill try it out.

And he says, "I wonder if I could get one."

Ike says, "I don't know. But I'll find out pretty quick."

So he put in a call, through my district engineer, not direct to me. And the district engineer called me.

He said, "Vic, you get on the phone. Ike wants to talk to you."

"Ike, who?" I asked.

"Eisenhower," he said.

I says to myself, "Oh, hell." So I got on the phone and he said, "Vic," he says, "Sir Winston Churchill is here. He's walking with your stick. The walking stick you made me. He wants to know how he could get one."

I asked, "You think he deserves it?"

He says, "I'm pretty sure he does . . . what do you think about it?"

I says, "I think he does too. So we'll just make him one." So I made Churchill a walking stick and shipped it to Ike. And Ike kept it until Churchill came over to America the next year, and he presented it to him. I had put on it: "Sir Winston Churchill. 10 Downing Street. London, England." And Churchill waited until he got back at Downing Street to write me a letter.

You'd be surprised at how many people that I give a stick to never have a thought of ever using it. Usually they find a place and just hang it on their wall. There's a man right here in town now— Mr. Raworth, the one that the YMCA is named after. Well, twenty-two years ago I gave him a walking stick. He was trust officer at the Merchants' Bank then, and them ladies up there asked me to make him one. He told me, "Vic, I hope that I never have to use it." Well, now he's in a wheelchair, but last summer he made a trip over to London, England, and he walked around the streets there with his stick. Everywhere he'd go, at every corner nearly he said, somebody would say, "There's a man that's got a stick just like Mr. Churchill's." He says there was at least a hundred people that recognized that stick because it was like the one I had made for Winston Churchill!

Brown Palace Hotel,
Denver 2, Colorado.
August 1, 1952.

Dear Mr. Bobb:

Carl Norgren just sent over to me the very
unique cane that you designed. I shall take
it home this evening to show it to Mrs. Eisen-
hower -- I know that she will be as intrigued
as I, and will be equally appreciative.

Thank you very much.

Sincerely,

Dwight D Eisenhower

Mr. Victor Bobb,
Route 2, Box 94-B,
Vicksburg,
Mississippi.

For my first canes, I used to take a rattan vine and wrap it around a box-elder sapling. I'd wrap that vine around the tree, and then in two years or so they'd grow together—the vine grew half way into the wood, you know. Then I'd cut it off when it grew to the size of a walking stick, and put a handle on it. I'd turn up a round ball almost as large as a baseball for a handle. I'd make it just like them old shift levers on cars. That's the way I started to making them. Well, after doing that for a year or two, then I started on the other kind of canes. That was the kind where I bent them over and tied them with a rope and growed them crooked. I just pulled a hickory tree over, and tied a rope around it. It took it two or three years before I could cut it off to be the right length for a walking stick. But I'd have that handle already growed crooked.

Then along about that time, Mr. Hill [William Jesse Hill] was making sticks and selling them around at these livestock auction sales. It's like . . . Well, the way that come about, there still is an outfit over in Arkansas—where there is more hickory than anything else—that has advertising sticks for its auction sales. They're just plain walking sticks, and they're stenciled—just some name like "Lum Commission Company," or whatever it is. They used to give them away. Well, this Mr. Hill that lived down there at Rocky Springs [Mississippi], he was making walking sticks. He was just cutting them out and bending them—doing very little finishing on them. Now, Mr. Hill used to bring his sticks up here to Vicksburg and sell them at these auction sales for a dollar or a dollar-fifty apiece. Mr. Will McBroom was working round out there at the sale barn then—that was when Ray Lum had his livestock sales way over yonder by the cemetery.[2]

Mr. McBroom said, "Vic, if I buy one of them sticks, can you put my name on it like that place in Arkansas has stenciled on there?"

I told him, "Yeah, I can put your name on it."

He said, "If you don't somebody will steal it."

So I put his name on that stick. I took an ice pick and heated it up with my blowtorch, and wrote his name on there just like you would with a pen—I burnt it on there. Well, it's almost impossible to do because you've got hard grain and you've got soft grain

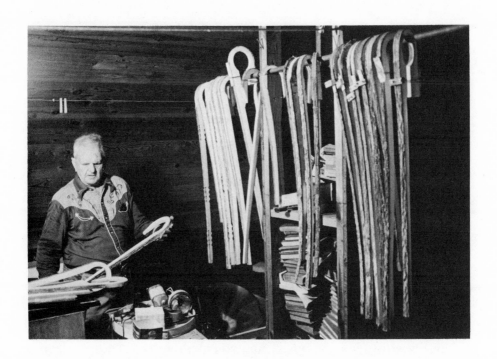

together—the whole year's growth. But I put his name on it all right. And then I made a walking stick for Earl Purdy. He was herdsman for Ed Moore—that's E. E. Moore—at that time. Ed hadn't gone as much into the cattle business then as Hot [M. P. Moore] had. Old Hot Moore, he's the big dealer, see. They're brothers. Them and Bob Halbert was the first ones that perfected the Polled Hereford cattle. Well, I got a stick already made from Mr. Hill for that one too. I put Earl Purdy's name on it with an ice pick. And I took it up there to him—that was up at Senatobia [Mississippi] on Ed Moore's place, the Double E Ranch.

I really started making *these* kind of walking sticks right after World War I. It was in 1918. Because, I remember, there was a fellow that came up here from Gainesville, Florida—Mr. A. E. Melton—who wanted a bull that Ed Moore owned. Mr. Melton, he was in the Hereford business. Ed Moore wanted twenty-five thousand dollars for that bull.

And this fellow, Melton, he saw that stick I had made for Earl

Purdy, and he told Ed, "I'll take that bull if you'll get me a stick like Earl Purdy's with my name on it."

Ed asked me about it, and I said, "You just as good as sold that bull." So I made the stick for Mr. Melton. I started numbering the walking sticks I made then, so that was number one.

So then after Mr. Melton left, Ed Moore talked to me. He says, "Look Vic, could you make one walking stick for me for each one of my sales? I'll give it to whoever buys the top animal in the sale." I said that I could do that. At that time I was still using an ice pick, see, to make the figures on the sticks. So I come home, and I says to myself, "Hell, that way ain't right! I know how you brand a cow, so I'll do them that a way." Copper tubing jumped into my mind. "That'd be easy," I thought to myself. So I ended up taking five-sixteenths' copper tubing, heating it up with my torch, and cutting and shaping it to look like letters. Well, I started out with an O and a C. Well, an O ain't anything but a straight piece of copper tubing pulled out with some pliers just a little wee bit to make it longer one way than it is the other. And you mash it the same way, then take a saw and cut a piece out of it, and it makes a C. To make a B, I made a tool just half the width of the O. I'd touch it twice to make a B, once for a P, and once for a R. I put all the curved parts on first, and then I come in there with a straight piece and put a tail on it. And all that lettering I make with five tools, five different pieces of copper tubing. I lay it off before I start to letter it, and I copy the lettering I want on a piece of paper first—I use that copying paper my boy uses in school. And so that's the way I started putting the letters and numbers on them walking sticks.

To start with, I was filing grooves and notches in there for decoration. But I'm continually changing them things. Every year— with no exception since I started—there's some change I make on them sticks. I said to myself one time, "Why don't I just put a diamond shape on them?" So I took a piece of copper tubing and stuck it into a piece of square iron, and hammered it down while it was red hot. Then I'd take my pliers and mash it to make it whatever width I wanted for a design—like a star, or a dot, or something.

And if the bakery hadn't shut down, I wouldn't have learned

something else . . . I used to take my sticks up there to Koestler's Bakery—and between the boiler and the oven, I had a pipe down through there where I'd hang them up to dry. Well, the sap runs up, not down, it runs up in the handle when it goes to start to drying. So then when the bakery closed down I figured that if I put them in a lard barrel full of water, the sap would come right out of there. The water dries the sap out, then the water itself will dry out, and then you're left with a pretty white stick. Now I learned that just this year. I don't know what the hell else I'll learn. There ain't much else to learn. Maybe I'll learn to make them faster. That's the only thing—to increase production, make more canes.

Well, like I said, every year I find a new way to do something. Now I didn't make no curved handles on them to start with, but they wasn't near as good as now either. For the first two years that I was doing the stockmen's walking sticks, I bought them already bent from Mr. Hill down at Rocky Springs. So his canes was the first ones that I started to working on. Then Mr. Hill saw me one day over there at the livestock sale. He says, "Vic, I've got arthritis so bad in my hands that I just can't bend them anymore. I just can't work on them canes." Well, he wouldn't have had to show me how to bend them because I could have figured out a way for myself. But I appreciated him taking me down there and showing me. Well, what he had set up was a locust post with about a three-quarter bolt drove into the end of it. He had a table and he had stuck that locust post up from that table through the rafters. And he'd bend his walking stick around that, and just pull on it. Then he took a piece of hay wire, wrapped it around about three times, twisted it, and took it off when it was dry. He bent his canes laying flat, see. Well, the way I'm doing it is the same thing, only I've got it upright where it's more convenient.

Well, after he showed me how he bent his walking sticks, Mr. Hill took me over and showed me the difference in the kinds of hickory trees. He told me, "We got five kinds of hickory that grows around here, and the poorest land we got is the best place to get it. If grass will grow on a ridge, a tree from there won't make a good walking stick. It's got to be very poor ground so that the tree will grow slow." So he took me over to the cemetery right across the

21

road from where he lived there in Rocky Springs, and showed me the kind of hickory to get. It's the one that has five leaves on the stem.

He said, "Vic, always cut it on the north side of the ridge[3] because it's exposed to the weather and it grows slower."

I says, "I don't see how that would make any difference."

"Well," he says, "when we split it, I'll show you why." So he split that tree and you could see that there's the same number of rings in a tree from the north side as in one from the south side of the ridge. Only they're closer together, and they are much tougher. That wood will bend better and make a better walking stick. Well, that has always proved to be true. I've tried it from the north side and I've tried it from the south side. And wood cut on the south side never would make near as good a stick.

You take a hickory tree—about four or five inches in diameter—and first you split it half in two. Then you split each half into three pieces, just like you would a pie. That's the first stage in making a walking stick. Then you shape the stick up. You want a lit-

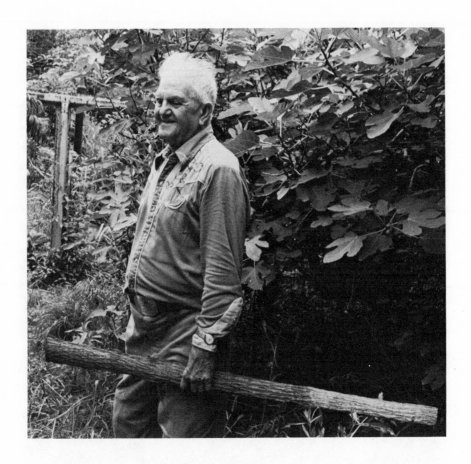

tle curve in it because otherwise as you're walking it's trying to get
back under you all the time. And you leave some of the bark on.
That way the bark will dry faster than the wood does, and it will
pull the stick crooked as it dries. I've got some sticks that I've just
bent. I've got some in the rough. And I have some that I've burnt
the letters on. I just do a little on them in steps, see. That's the way
I do them. Anyway, then I put it in this vice that I made, and press
against it, and I can shape it up any way that I want. I call that
breaking its back. Then I bend the handle. I use a jack, clamps, and
wedges with my bender. The secret in bending it is to do it in the
wintertime, not let it dry out too long, and make sure you've got it
cut straight across the grain. Your grain has got to go as near to
straight as possible through the handle. I don't even attempt to

23

bend any unless the grain's right. Some of them still don't bend quite right, and I call them my culls. I'll salvage some of them and get them finished up for the crippled people over there in the hospital at Jackson.

After the stick's roughed out and bent, then I do the finishing on it. I cut in the notches and designs, and then put the lettering and numbers on there. See, besides the name, I put on there the number that the stick is, and, on the other side, the year. Then I decorate the sticks. I didn't put no color on them for about thirty or more years. I used to just make them black and white, with varnish over that to seal it. Well, like I said, I'm always experimenting with making my sticks. One time somebody asked me to make a stick for John Rice—he was one of those big cattlemen from up at Montana. His brand was a wagon wrench, and he sent me a diagram of it. I burned in the design of that wagon wrench on the walking stick that I was making for him. And then I decided to paint that brand red to make it stand out. That was the first color that I ever used on my canes. Then after that I decided to start painting the designs on them all. I'd put on red and green and orange dots—the colors of traffic lights, and then I got to adding on even more. I started putting whatever design people wanted on them sticks—brands, Masonic emblems, and all different things. And the people out at the discount store—they started giving me pieces of broken costume jewelry. So to suit the person I'd put some of that jewelry on there. Now I load them sticks down with decorations. On *most* all of them I put the Confederate Flag—but when I make a stick for north of the Mason-Dixon line, I *always* put it on there!

So anyway, I got to making them canes for stockmen, and then Ed Moore said, "Vic, how about making me *two* for my sale? One for the top bull, and one for the top heifer?"

"All right," I said, "But how about you breeding a heifer for me?" So I'd take a heifer up there and have Ed breed it, and in return I'd make him two sticks for his sale. Then the next year when I'd go back to Ed's sale, I'd bring my heifer and its calf back home. Well, that went on for years, but now I haven't got but about six head of cattle left.

Then long about 1950 Ed Moore had one of his sales. There

wasn't many people there, but there was this German there I remember, from Freehold, New Jersey. He bid on the top heifer—she was a champion in the national show—but there was some mistake, and he lost the bid. Well, anyway, this fellow was up there somewhere in the stand. I had never seen him before, and I wasn't paying no attention to him. I didn't really know *who* was buying them cattle. I was just helping them out at the gate there, helping to bring the cattle in and out. . . . Well, I went up to Ed Moore's house after the sale was over. People would always go by there after the sales and Ed's mother-in-law would have a big turkey and a ham cooked up and plenty to drink. Ed Moore knew I wouldn't drink, but he gave me a Coca-Cola—and sometimes I'd pour just enough whiskey in it to taste it. Sometimes I wouldn't even put any whiskey in it, and had a better time than the rest of them. But anyway, this night when we got up there, Ed met us at the door and *he* handed me the Coke, see. Like I said, he knew I didn't drink. Well, I didn't think much about it.

Now, I'll have to go back a little piece, to during the sale. Well, this fellow that wanted that prize heifer, see, he went over there to Ed and said, "Mr. Moore, how can I get one of those walking sticks? I wanted a heifer all right but I really was bidding on that heifer just to get that walking stick!" He had more money than sense.

"Well," Ed says, "There's the old guy over there that makes them. If you bought enough heifers, maybe he'd make you one."

So he came over to me, and asked me about it. None of them heifers had sold under three-thousand dollars apiece. And he looked like a roughneck just like I was. I was there working. And he was dressed about like I was. So I said, "You'd have to buy at least six of them." He didn't look like he could buy even one of them. And I thought that was the end of *that* deal.

Well, later—at Ed's place—that old fellow says, "Yeah, Vic, I got my walking stick." I asked him if he'd bought a heifer.

He said, "No, I bought six heifers."

Then Ed Moore told me, "He bought six heifers, Vic—that averaged two-thousand-eight-hundred-and-fifty dollars apiece! Are you going to make him a stick?"

"Hell, I'll have to," I said. "That was the deal." And I kept on

sipping that Coke. Well, I *could* taste the whiskey in it. But I was tired and so I just kept on sipping it. And we talked on awhile, and then Ed put his arm around me, and said, "Vic . . . how many sticks can you make for my sale next year?"

"Well," I said, "I'm just going to make you two—just like I've been making."

"Oh," he says, "That ain't enough. These damn people buy my cattle just to get them sticks! We could have just a stick sale and give them a cow for free."

"Oh, you're kidding me now," I said.

Ed told me, "I know you don't want to sell one." I had said, see, when I made the first one that I'd never sell any of my walking sticks. And I don't think I'll ever sell one. If I sell one, I'll quit.

You know, it's pretty damn hard not to sell them now . . . Maybe so many people like my canes because they can't buy them! I'll tell you of one instance where that showed up. I gave a walking stick one time to an old man that farmed and sold pecans. He lived up on Eagle Lake. Well this old man, I forget his name—anyway, he went over to see Cliff Parker about borrowing a harrow from him. He commenced to introducing himself to Cliff—to telling him who he was. Cliff told him, he said, "You don't have to tell me a thing. You're all right or you wouldn't have that cane!" See, my canes are like identification cards, just like a traveler's card. When you see one of my walking sticks you know that person's done something and they're all right, or they wouldn't have one of my sticks.

You can see the letters I have, more than a hundred-and-fifty of them, the tone of the people I've made them for. And that's worth more to me than money. I could *use* the money, but I don't *need* it. What's the use of me taking money then having to go and spend it? People give me anything I want. I just think making canes is something I like to do and want to do. As long as I'm able I'm going to keep on making walking sticks. I don't really think of my walking sticks as an art. I just look at it as something that's useful. *I* think they're useful. There's not a week that goes by when somebody that I gave a stick to years and years ago comes to needing it just to get along. It's just something that's useful. I don't think it's a work of art. It's just a work of talent. It takes a lot of patience. It's

just a case of patience and talent to make something that's useful. The fact that you can't buy them makes them valuable. Someday, there's no telling what they'll be worth. But I just get a kick out of making them for people and getting to see them when I present their stick to them. It's just something that I like to do.

Well, anyway, Ed Moore, he just kept on talking to me. And I just kept on sipping on that Coke. And I felt myself getting up a little bit off my seat, and I says, "Ah, hell, I'd better not drink no more Coke."

But Ed said, "Now, look, you won't sell one, but I'm going to sign a check and leave it over there in my store for you. I'll just leave the check there signed, and you can fill it out for whatever amount it is . . . How many sticks can you make?"

I told him I didn't know, and just kept on that a way.

He says, "Well, now, just how many *can* you make?"

I finally says, "Well, I haven't got but thirty-two bent now and I got to make one or two others . . . but, hell, I *could* make one for every cow you're going to sell." But I didn't tell him that I *would*. Then I reached down there for my Coke, and I looked at it and it was full again. His wife had done brought another one and set it down there. And I think she put about two or three jiggers in that one. Well, anyway, I sipped on that Coke and I got up off the seat then. I felt like I was about three or four inches off my chair. So I says, "Why don't we shoot the works."

He asks, "What do you mean?"

So I said, "I'll make one for each cow you sell." But I was kidding. Of course *I* knew what I was doing, I wasn't drunk or nothing. I was just feeling good . . . we all was. We were having a big time and we was well-pleased with the way the sale went and all. I was just kidding. And I thought *he* was, too.

But anyway, a while later the first thing I see is the *Polled Hereford World*—and there on the center two pages was a list of the bulls and heifers Ed Moore was going to sell, with the pedigrees and all listed. And he'd written there, by a picture of me working on the walking sticks: "Through the courtesy and generosity of my good friend Colonel Victor Bobb, one of his famous canes will be given away with each animal sold." Well, I was still at the government

fleet then, see, and I didn't even have no phone. Well, anyway, I stopped somewhere on the way home and called Ed. I told him, "Ed, I can't make no fifty sticks by February!" That's when the sale was going to be.

"It ain't fifty," he told me, "it's fifty-seven."

I said, "Hell, I can't make no fifty-seven canes. I ain't got but thirty-two bent." So I says to myself, I'm going to show him that I *can* get them finished. And so I'd come home from the fleet and start on them as soon as I'd fed the cows. I'd go upstairs and work all night, then come down here and get me a cup of coffee and something they're going to just start to grabbing it. They ain't weeks. I was determined to get those sticks done in time. Then I come home one day, and all my tools and all the sticks was out in the yard. My wife done throwed them all out there. She said she couldn't sleep at night! Well, I was managing the fair then too, so I took them all out to the fairgrounds and finished them.

Instead of going to all the trouble like I do now, I just roughed them out with a drawknife and a plane. I'd run them through the planer and get them all pretty close to the same thickness. They was all pretty much alike then. Well, I couldn't put the individual names on them because I didn't know who was going to buy them, but I took Ed Moore's catalogue and put the name of each animal on there, like, "Victor Domino 12," or whatever it was. I says, "I'm going to show that peapicker that I can make fifty-seven walking sticks by the eighteenth of February"—that was the day of the sale. So, on that day I had fifty-seven walking sticks finished. And I took them up there and, man, was Ed ever surprised! I had them in two or three different boxes, see.

And he said, "Go over to the store and get your check."

I says, "Ed, you know better than that. You're trying to bribe me now. I got a damn good notion to put every one of them sticks back in the boxes. There ain't going to be no money changed hands cause I ain't going to take it!" But he had sent over there to his store anyway and got the check and brought it over and gave it to me. Well, I tore that check up right in front of several people there.

So he told me, "Vic you're just a plain damn fool."

I told him, "I was born that away and I can't help it!" So that's

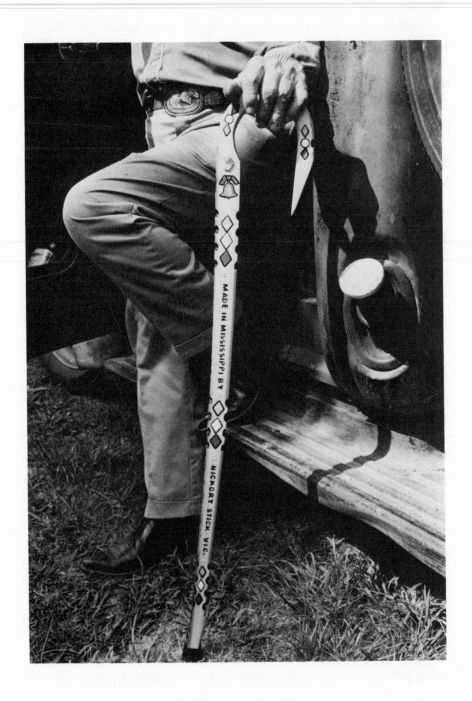

the way them first sticks was made. And I didn't make walking sticks only for just Ed Moore, I done the same thing for Charlie Brown, and several more stockmen that had them livestock sales.

Well, I got this letter one time, it came after there had been an article about me in the Memphis newspaper. But this letter came from Long Island, New York. It said in there that I had been offered all kinds of money, but never had sold any of my walking sticks. So this fellow wrote me a letter. He said that he saw by the article that I never would sell my canes, but that he would contribute ten dollars to any charity I wanted to give it to, if I would send him some seeds so he could grow some canes hisself! See, they called them canes in the article. So he thought they just grew that way right out of the ground. And he said to please send him instructions on how to plant them! So I stopped up there at Stan's Seed Store, and got a tablespoon full of sunflower seeds and put them in there in a little cellophane package. I wrote him to plant them two feet apart, keep them well-fertilized and watered—and if they didn't grow to suit him, well, the only thing I knew was for him to move to Mississippi. I told him that we had the only soil that they would grow in! Well, I haven't heard from him yet, but the next time I get six or eight walking sticks finished, I'm going to stand them out in a row about two feet apart, and get somebody to come out here and take a picture of them. I'm going to send it to him and tell him that's how canes grow in Mississippi! I don't know what he thought about it when he planted them seeds, and saw them big sunflowers turn up all over the place. But there's people in New York, I hear, that never have seen a tree. So he really does think that I grow my canes, I reckon.

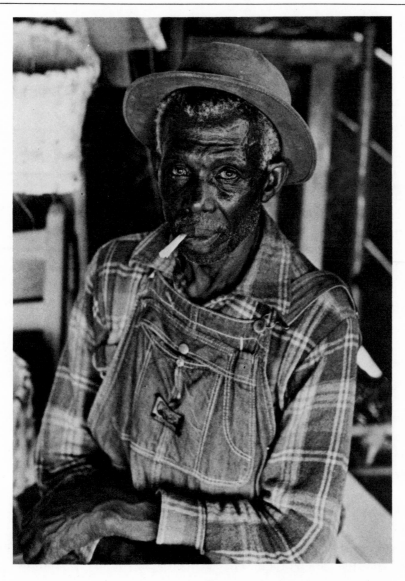

Leon "Peck" Clark

Basket Maker | Sharon, Mississippi | Born 1906

My MAMA and daddy used to talk about way back yonder—about their parents and grandparents that was in slavery. See, my mother and father, they weren't slaves. My daddy was a carpenter, a bricklayer, and a farmer. He was sort of a mechanic, too. My mother was just a housekeeper and she would try to teach us kids. Slaves was winding up a good while before they was born. But their parents was in slavery, they came from Africa. They was telling us about how they first caught them. Course that was sort of a tale, you know.

When they first caught them, the fellows from over here went over to Africa and built a great big pen—built it high. Then they carried over there a lot of old light bread, and meat skins, and bones, and different things to where they were. They threw that stuff right on up to the gate of that big pen. Well, you know, they acted just like chickens or dogs or something—whenever they get something they're going to just start to grabbing it. They ain't going to never look up, you know. They'll never look up to see what it is, or who is coming. They ain't going to do it. So the first thing you know seventy-five or a hundred people just got to running and grabbing at that food stuff, and before you know it, they were running right into that big pen. Then the fellow turned around and shut the gate on them. He catched them, you know. And they tell me they run hundreds of them into that big pen. When all of them got in there, the white folks dropped the door. They had them all right. There was a river, it didn't have no name. And they named that river Niger, because they were bringing the Negroes from Africa over here. Then they loaded them onto the ship. They loaded them on, and brought them on over here.

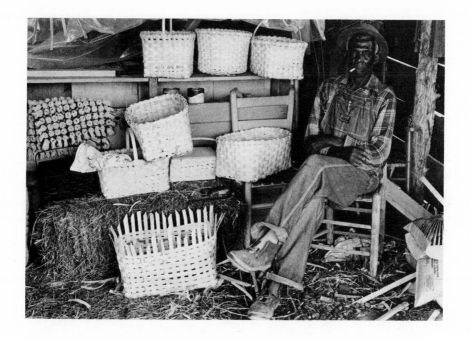

Well, when they brought them to this country, then the men sold them. Way back in them days they'd put them up on a great big old stump or post or rock somewhere, and they'd bid them off just like they bid off cows and things now. Different big farmers got them. Well now, you take this country . . . a whole lot of slaves worked around here. You take right up there, about a quarter of a mile, that was a slave-time house. Then on back here probably every eight or ten miles apart there were slave-time houses.

I read up at school [the Headstart Center where he is a part-time janitor] the whole history of that slavery, and after I read it, I said lots of times, "My mama and papa sure was talking true about it, about slavery and the Civil War." They told us about it, but we didn't know for sure until after they printed these books and different things, you know. Why, after I went to reading them I said, "Well, they sure was telling the truth about it. That sure was true."

I remember lots of things about a long time ago and the old folks. Lots of times when I had a bad cold or was sick pretty bad, there was a weed Mama always gave us . . . called St. John's weed.[1] Now when I get a bad cold or something like that, I'll go out and

35

get some St. John's weed. I boil it, put me a little sugar in it, and take it. It's just as good as the doctors' medicine, I reckon.

There were no regular doctors in those days. There was this old man, a root doctor. He was a Baptist preacher, too. When children had the flu or measles or a cold or something like that, why the mothers would always send for him. You never heard tell of a child going to a regular doctor. They'd just send for the root doctor, you know. He'd come there and tell the old people, he'd say, "Put on some water in a kettle." Then he'd get the grubbing hoe and go on out into the woods. When he'd come back he'd have a handful of roots. He'd wash them, and put them in the pot and boil them. They'd give us children a little sugar with them. You know, back in them days children weren't used to sugar. You'd give them some sugar, and they'd swallow anything along with it. I remember the medicine they called Indian herbs.[2] It was just about like a plug of Brown Mule Tobacco. And it was just as bitter[3] and nasty as anything you ever tasted. Folks used to give that to children for worms, you know. And we all didn't like it, but we'd take a drink of that stuff just to get to taste the sugar, you know. Yes sir, that's what we'd do. But that old man was good, though. He was a good old doctor. Whenever anybody would get sick they'd send for him.

But that's gone out of style. You don't get that at all now. That's the reason why so many children and so many people are sick and dying today . . . just on account of we left them old rules.

I learned about making brooms from the old folks, too. My mama used to take us out into the fields in the fall after the frost fell. All of us would go out to the fields and bring a great big arms' full of sage grass.[4] We'd bring it in and take a knife and trim it down. Then we'd take a string and wrap it around to tie it up, just so you could take it in your hand and sweep up the floor with it. And whenever one broom would wear out, why we'd take the string out of that and get new sage to make another one out of. And that caused the broom never to give out, you see. You'd have them from one end of the year to the other one.

I was born in Madison County, State of Mississippi, nine miles south of Canton in a place called Miltonville, way down there. I went to school there in a place called Fairview School.

36

I can remember pretty good about things when I was coming up. I was raised and brought up way better than the young is raised now. In them days, when we was coming up, they used to have shows in town—the Ringling Brothers' Shows. There were six of us, three girls and three boys. When we went to town, Mama put three on one side and three on the other side. We stayed right there until the parade went around. Then when the show was gone, why, Mama would take us back round behind the store, and put us back in the wagon. And we'd sit there until they got ready to go back home again. We always had these old cans with us—salmon cans. Mama and them would cut the tops out of them, you know, and we'd carry them with us. Well, every time they'd go and buy a drink in the store, they had all of us children line up there. They'd pour so much in each one's can. Then there was cheese, sardines and soda crackers, and things like that that they brought to feed us off. And we were just as happy as we ever had been.

Now back in them days—and it wasn't so long ago—people hired children, you know, to chop and pick cotton. Now these days, if a person hires a child to pick cotton, they have to pay him money. But in those days back there when I was coming up, we would go out there and work all day long. When payday come, why Mama would give us a dime or fifteen cents. Well, we thought we had a heap of money. Whatever we wanted, why they got it for us. We were just as happy to go out there and work all day and get a dime or fifteen cents on Saturday as we was to get a thousand dollars now. But it ain't that way now, though.

I left home when I was around about thirteen years old. Been away ever since. But my mama tried her best to raise me and to school me. Some say I got grown too quick—*I* thought I was grown. I run off from home and went up in Kentucky in '21, I think, to work on the railroad. I went away and stayed about a year, and when I come back home I had bought me a new suit, with long pants. At that time, boys my age weren't wearing long pants. They wore those pants with the buttons up on the leg, and black rib stockings. So I come in one night after eating, and sat down and started to smoking. I had a package of Camel cigarettes and some matches—and I left them in my pocket when I went to bed that

night. When I got up the next morning, why Mama had cut them pants off and hemmed them up short and put three buttons on them! So I got up the next night and put on a pair of overalls. My sister hoisted up a window and I got out. And I went away then and stayed about three or four more years and then come back again. When I come back Mama told me, "*Now* you're grown, now you can smoke and wear long pants."

The day I got religion was the happiest day I ever saw in my life. It sure was a change on me. I remember that day well—it was on a Wednesday night around about twelve-thirty. I remember I was on my way to church. I was walking alone. I seed [saw] my whole self leave me and just go on east from me, just as natural as I ever saw anything in my life . . . I was going this way . . . and it went on that away from me. I didn't leave. I went on to church. It's just something that comes on you. I was surprised myself. I thought when you got religion that the good feeling stayed with you all the time . . . but there's no way in the world a person can live *that* life. If you felt that way all the time there wouldn't be no way in the world for you to live. The spirit just comes and is gone. It can't stay with you. But it's a true fact: when you call Him and want Him, he comes. Lots of people say a prayer every day. I don't do that. I pray when I feel my trouble. If I'm walking along in the woods, if I'm out there plowing or fishing or whatever it is, when it strikes me to pray, I pray. It looks to me like I get more results out of praying by myself than I would in a crowd. Yes sir.

I moved up to the Sharon neighborhood in 1926. I came here to the sawmill and I met Shine after her first husband died. We got married in 1930 and we've been together ever since. I've always been a farmer right around here. We've got cows, hogs, chickens, turkeys, guineas, and a mule. I plant Louisiana cane, peas, corn, potatoes, peanuts, things like that. Anything excusing cotton . . . I don't plant no cotton.

All of my life I've been interested in doing something. The minute I'm not doing something, I'm asleep. I don't know nothing that I can't do some of it. I can hunt and fish, drive a tractor, drive a car—I clean up, I can sweep, I cook, I can wash and iron, I sew. You know, I can do most any old common thing like that. And my

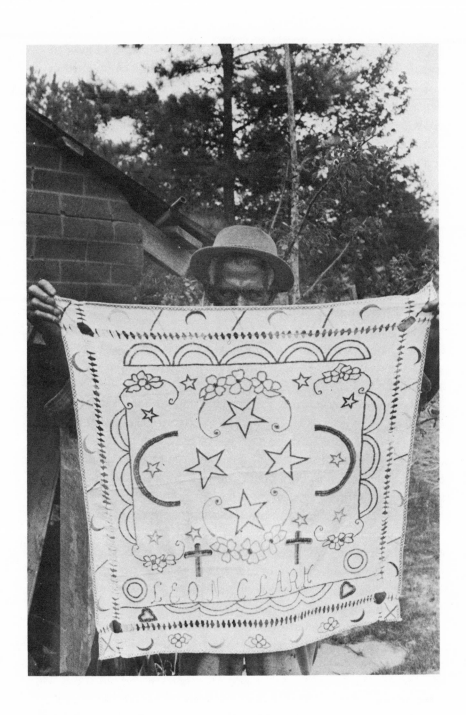

daddy learned me how to carpenter, how to lay brick, and how to blacksmith. When I first came up here I worked in a camp cutting lumber, what you call a little old groundhog sawmill. And I used to have a blacksmith shop. Well, the reason I quit that, my eyes got bad. All that smoke, you know, I couldn't see the stuff. Of course back then when I had that shop a person could sharpen a plow point for a dime. It's around a dollar now. I sharpened many plow points for just a dime. We thought we were making money then. I do a little carpenter work now at times, but I got old and I can't climb like I used to. Just me and my old lady built this house here by ourselves. I don't need anybody. I do better by myself. Other people, they just worry me. Of course I ain't got my house like I'm supposed to have it, but it will keep the rain off me, and I can say I got a place to stay. I guess there ain't nobody going to tell me to move because I have a place of my own . . . Later on I struck up making baskets and bottoming chairs. I bottomed a good many chairs—rocking chairs, and those big double chairs you set out in the yard that two or three people can sit in. I've bottomed a good many of them.

My mother learned me needlework, and all like that too, you know. I've been doing that all my life, probably since I was nine or ten years old. Way back there we used to have a thing at school, what you call an exhibit, with a lot of children making different things for it. Well, for seven years one girl and I always won the prize for crocheting and stuff like that. At home we always had a thing called hoops. You can draw out what you want to, then take your hoop and put it over there on what you drew, and tighten it up. Then you take your needle and punch it through, and work it on out. I usually draw a tree or a flower or stars—just things like you see them outside there. I've worked cows, horses, mules, dogs, chickens, and all things like that, but no humans.

I got my own crocheting stuff, needle, hoops, and everything. I first cut out or draw a pattern and then I get to work on it. I design it with different things to make it look pretty. You know, I can just take a thing and look at it and made me a pattern and cut it out. But sometimes it puzzles me trying to figure things out. First thing I do if I go anywhere and see anything I like, why I come back and study

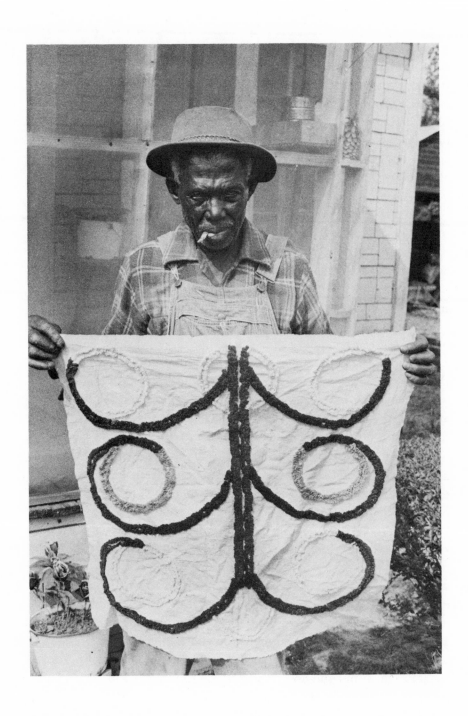

it out. Then I draw it out until I get it just like I want. Anything I
start, I'll take a pencil and draw it out first and make me a plan. I
may start different things one or two ways, but if that way ain't right
I'll keep on until I do get it right. Then at the end it'll work out just
like I had mapped it out. Then I take my needle and I punch it
out—punch and pull, punch and pull. See, you punch down, and it
comes up, and it'll stay just like that. That's the way that's made. It's
all made by hand. Well, after I get it through, you see, I clip it. I
clip it sometimes to make it come out furry.

I made a lot of things while Shine was gone to the North—up
to Gary [Indiana] to see her daughter. But after I started on my
basketwork, why I didn't get to finish some of this needlework. I
never did get to finish it. I just laid all this aside for a while, you see.
I was more interested in the basket proposition than I was in this
here. Well, probably sometime I'll start back again.

That time my old lady left going up north to visit, there was
nobody but me at home. I didn't have nothing to do. She was going
to town before she left, and I told her, I said, "You buy me some
thread." She asked me, "What are you going to do with that?" I
said, "I'm going to do some work." So she bought me the thread
and I started to do some hoop work. Well, I done that sort of work
for a while and I told her before she left, I said, "Look," I says, "I
want you to cut me out some shorts." You know, these that you go
and buy, they don't last you, it's no time before they get tore all to
pieces. So she cut me out one pair, and when she got back, I think I
had made me five pairs of shorts. So I didn't have to buy me any
shorts. I like that kind of work. I ain't never didn't like no work that
I ever started. If I didn't like it I wouldn't fool with it. Lots of
people say to me, "You sure has got good patience. I say, "Yeah,
sure has." A lot of times on Sunday when I get to working in a rush
my old lady tells me, "The devil will get you." I say, "Well, I feel a
whole lot more better here doing this than going into those joints
and places like that, sitting down lying and telling a lot of tales—
because I can do a whole lot better here at home." A lot of times
she'll get mad, but she doesn't fuss at me too much. I never do get
shamed enough to quit, though. I say, "Oh, I'm going, I'm going,"

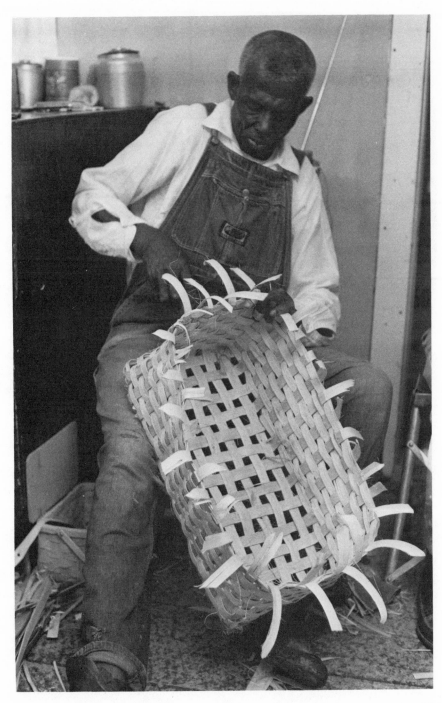

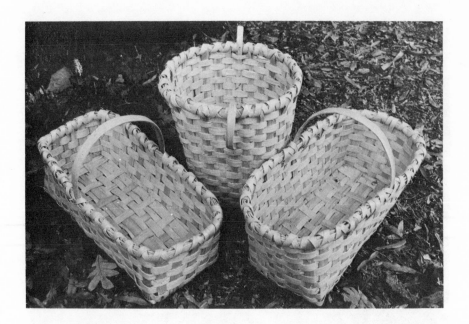

and then I just finish whatever it is I'm doing. I like it. I like to be doing something all the time.

Making baskets was the only thing coming through my life that I didn't learn until after I got grown. I met this old fellow called Rob Woods that was making them, and I'd go and sit down and just watch him. Me and him started working together in '49. Fact of the business, I didn't know nothing about baskets, and so I'd go down and look at him, maybe six months before I started. And so finally one time he said, "It's easy to learn." So I said that I was going to try it. I've been making baskets ever since.

In about a year I could beat him making them. When I runned with him we might get four or five baskets done a week. Then after I went by myself, I'd get six a week, and he'd get just two and three. Before he wound up his time I could make them just as good as he did.

We used to work together with farming. We didn't stay far apart. At night I'd get on my mule and ride over to his house. I'd stay there making baskets until twelve or one o'clock, working by the coal-oil lamp light. Then I'd come on home and go to bed and

44

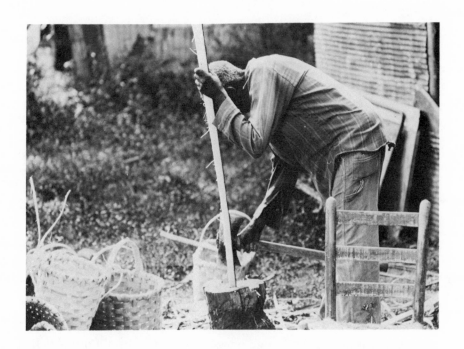

get up the next morning and go on to the field. Then the next night, the same thing until we'd get his order filled for so many baskets. Then we'd lay down and rest. A lot of times on Sunday we'd work all day.

Then after he died about ten or twelve years ago, why I took the job up myself. I'm about the onliest only one now who's making them. Now I got a nice boy, Marion Edward Collins, that's interested in making baskets. I'm going to learn him. I'm going to show him how to split that white oak, lay it, and run it up. I'm glad to pick him up because I'm getting old. There ain't nobody in Madison County making baskets but me—that's the reason I want to start some young one making them.

I make all sizes of baskets for probably anything a person would want them for—cotton, yellow corn, beans, potatoes, feed, eggs, picnics, clothes, garbage—and I make some with lining for pocketbooks and sewing kits, things like that for the ladies.

First thing I do is go to the woods and get my timber. I can pull hickory, I can pull post oak, and I can pull long-leaf pine if I can

find it. But I use white oak because just about any kind of white oak will pull. I like to get wood from the hills, it's got rough bark. It's better than the wood from the swamp. It's prettier, it's tougher, and it holds up better. Lots of times I get more than just one piece. Whenever I go out, I go on and get me two or three pieces and tote[5] it on out. Sometimes I leave a piece back over there for hard times. Like if I need a piece right quick, why I could run right there and get it. When I bring my timber back, I split it. I bust it open just like you'd bust it for posts. Then I turn and quarter it. I split it again just the size and width where I want to pull it. Well, then I'll get the heart out of it. I take my ax and trim it down, skin the back off of it, then turn around and go to running it.

Colors come in there by well water. No rain water or pond water will color it. Only thing I get to color my baskets is the water in the well. I roll it up and put it in a bucket and put me some well water in there and let it stay overnight. Well, the next day it will be that darker color. The longer it stays in there, the deeper that color will be. A lot of people thought it was some sort of stain or paint I put on there. It's not any sort of stain; this is done by water. I don't care how wet it is or what, it's not coming off of there at all. It's going to stay that color. It's not going to ruin your clothes at all.

It don't take me long. Except of course sometimes I have a pretty good piece to walk to get my timber. Oh, it'll take me just about two-and-a-half hours to get it out of the woods and back here and worked up like I want it. After I work it out like I want, I just lay it out until night. You know, it looks to me like I can do a whole lot more work by myself at night than I can with somebody talking to me. When anybody's talking to me, why I'll have to stop and keep saying "yeah" and "no" and answering their questions. But when I go about it myself, I can do a whole lot more work. When night comes I take my knives and things and start to pulling it.

Pulling it means getting it to a certain size. I can pull it just as thin as I want or just as thick as I want. Whenever it's green it pulls a whole lot better. When my strips get too dry on me, I just tie up a bundle and put them in the pond. They run good when I take them out of that water. Then I take them out there and lay them in the sun for about ten or fifteen minutes and then go and pull them. But

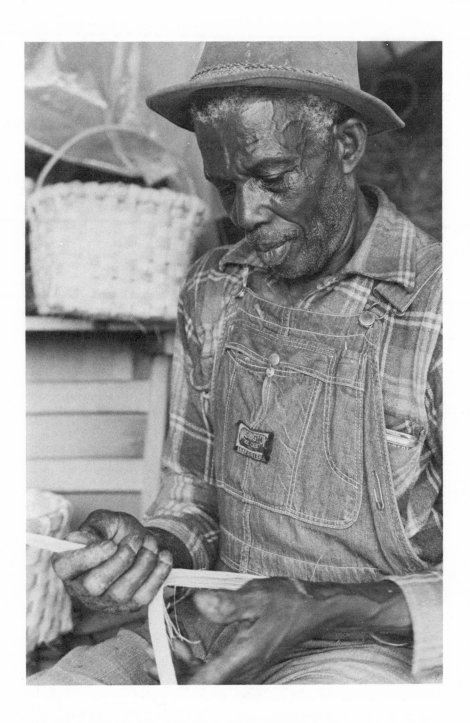

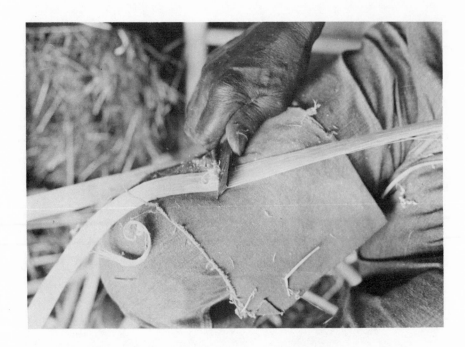

at the time you first get them, boy, they're not going to pull because they'll break.

The only thing that ever went wrong, maybe I'd be pulling a piece of timber and it may not hit the right grain. If you don't hit the right grain it'll go another way. Well, a lot of times I'll take my knife and try and pull it back in that grain. When it starts to running to one side, I put my knee against it and make it come back straight. When it's the right width I can feel it, but if it doesn't go back, there's no way to carry it on out. Just as long as it's coming straight down that grain, there's no way in the world to make a mistake on it. I pull the splinters off of there, and it's ready to be dressed and ready to lay for baskets.

I take thirteen and seven splits for the first lay. Now some of the larger baskets take nine, but with smaller ones it only takes seven. I first start my point by laying the devil's leg. If you don't get that one like you want to, you'll never run a basket. It's got to be arched. I tie it with strings, because when it gets full dry, it will slip. I tie it to hold it into place.

48

Next thing I do, I get those those strips and lay them all even. At the starting point I go right under . . . two, four, six, seven. . . . When they get out of line, I straighten every one of them up, right where I want them. You have to lay that there and let it dry. I just put it in the sun for about an hour, maybe two hours, and then it's dry and I can start running it up. I just set it and start going around and around with it.

Start it right, like you was building a house. Get the corners and always keep them level. That's the foundation. That's the main thing, getting it from the bottom. A lot of times you start to pull it, it will break out. If you get those corners right, it won't do it.

Then you run it through, in and out, and that's what you call lacing it. If I make a mistake in lacing it, I call that dropping a stitch, like the old folks used to holler when they was knitting. Then I have to go back and pull it off. If I don't, then every one of them ain't going to run the right way. Then you stop the holes up and put the handle on it. You put the handle down in there far enough to keep it from coming out, then you go back to lacing it again. Now, when that dries, I can stop the cracks up. Ain't going to be no cracks when it's dry. Now when the basket dries good—it's all green and limber at first—it's going to be a whole lot more stouter. It'll be hard, and stiff, and real strong. It'll really last. Well, I get them run up just like I want them, then I put my rims on them and then I wrap them. Put my handles on there, wrap them down, nail them down, and I'm through with them. Yes sir.

I don't just start one and finish it all at one time. Probably I'd get my timber and work it up to where I can handle it in the daytime. At night I get back there in the kitchen and lay all my baskets and run them all. It may take me two or three nights to do six or seven baskets.

Well, I'll tell you . . . I like it all. I like to go and get the timber, and I like bolting it and splitting it up, and I like weaving it. I like laying the baskets and I like running them up. I like knocking them down, then I like running them up. I like it all. It's hard, but it's easy. Ain't nothing at all that hard if you ever learn a thing. It's just like when you lay the foundation of a house: if you ever get from off the ground right, why, you can go to work.

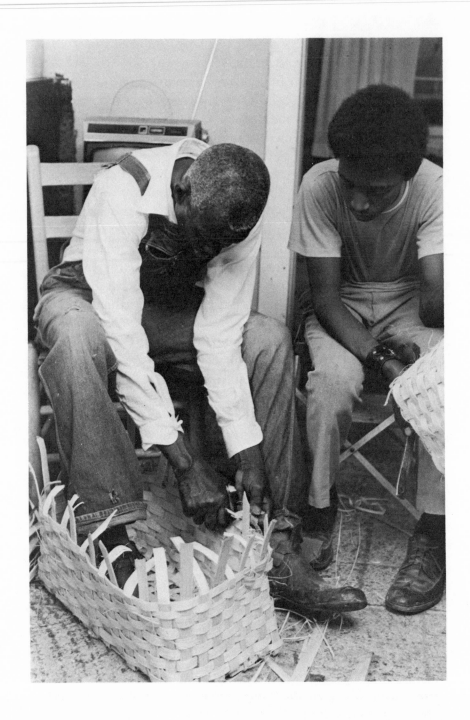

They call my wife Shine, and they call me Peck.[6] Shine's
mother told her that when she was about two years old that her
daddy used to whistle all the time. She would try to dance. She'd
just be stomping, you know, trying to dance, and he'd say, "Look at
my baby how she's shining." They all went to calling her Shine after
that. But her real name is Ada, after her grandmother. Now the way
my name come by was because we lived in a field of some pines,
you know, and one time I said, "look at that peckerwood." My
daddy started calling me "peckerwood," and then way down the line
he just took the "wood" off, and started calling me just Peck. And
so that's what they been calling me all my life. Of course now not
everybody knows my name is really Leon Clark. You can go to Can-
ton, or wherever you go, and holler about Leon, and they'll say they
don't know him. But if you holler about Peck Clark, they'll say they
know me.

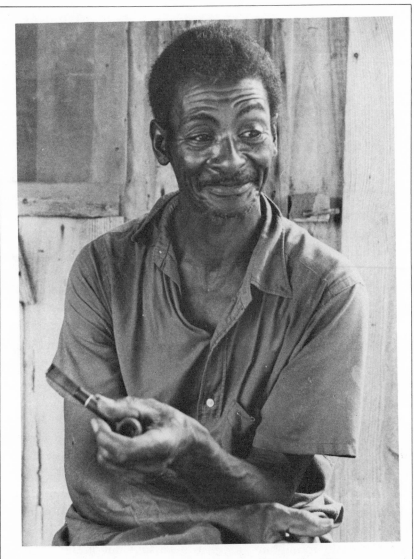

Louis Dotson

One-string-Guitar Maker │ Lorman,
Mississippi │ Born 1917

Y OU KNOW, I never did like the city. I always liked to be in the sticks. I just don't like to be in no town. I've been to Jackson, Natchez, Vicksburg, and Tallulah [Louisiana]. When I go in there, I'll just get what I'm going after then come right on back out. I won't stay there; I head right for home. I liked Tallulah best, but I wouldn't stay over there either. It's too low there for me. When that water gets up out of that river, it takes all of that town back in there with it. I'd just rather be in the country than be in the town.

A person could go into a town and ask for somebody, and if they ain't got the house number, the street number, or something or the other, they'd never know where they were. Nobody'd know. You'd just be blundering around all over that town. But in the country, people know other people.

In town, you can't even find your own kinfolks. Addie Mae [Mrs. Dotson] went to Jackson once, to see her cousin that was staying there. He lived on Pascagoula Street, that's all she knew. So she went there and asked them if they knew her cousin, Arthur Menefee. And everybody told her they didn't know nothing about that name. And she didn't know his house number. So she just fooled around there on his street and finally he come out. That's the way she finally found him . . . just by passing him on the street. In town, they ain't going to tell you nothing about nobody. Not even about your own people. That was in Jackson. And I imagine it's the same in any other big city. I like it in the country. I don't get lonesome here. There always be some company around. See, right here in this community it's all family people—my sister, my brother-in-law, my auntie,[1] and my sister's oldest daughter. And the kids would rather be in the country where they can run over the hills

and holler and play. That's what they say. I haven't ever been nowhere I'd like to live but right around here in Lorman.

I was born on April 25, 1917, in Franklin County, Mississippi. My mama and my daddy was born in Franklin, too. And that's where I was raised. My people moved out of Franklin, up here to Lorman, and they brought me out with them, too. I was just a kid and I had to follow. I had seven sisters and eight brothers . . . there were sixteen of us children. My father, he farmed and he logged. He raised cotton and corn, sweet potatoes, peas, and peanuts. He had good gardens. My father wasn't no lazy man. He always liked to be doing something. My mama was the same way. She just *went* plumb till she couldn't go no more. Just like he did. I got to the first and second grades in school. I had to walk about four miles. It was on gravel, too, and my feet would be so sore that I could hardly stand up on them. It was just too far. When I was twelve or thirteen years old, I started picking cotton. I made me some knee pads and put them on, and went to picking that cotton on my knees. I picked two hundred-and-fifty pounds some days.

I remember I used to get up and make coffee for my daddy when he had to go to work. He'd get me up around four o'clock in the morning and say, "Get up, Son, and make me some coffee and fix my lunch for me. Mama's sick. She ain't able to get up. So you get up and fix my lunch. I got to go to work and try to make it for you all." So I'd get up and wash my face, and go into the kitchen and put the pot on the stove for coffee, and fix his lunch. We'd get that ground coffee, you know. You'd put a little cornmeal in it after you'd ground it, and you'd put it in the pot and put the cup under the bottom of it to catch it when it ran out down there. So I'd fix me a little cup of coffee, too, and put it on the side, out of the way. Then I'd bring him a cup, and he'd say, "Well, I'll save you a little swallow from my cup, Son." He didn't know that I'd had me a cup already. Well, *now* I can cook most anything I want to. And I can clean house. I can do all of that.

Ever since I was a little bit of a boy, I used to blow the bottle. Me and another boy, name of Ritchie Coleman, used to blow them Coca-Cola bottles. He was a little older than I was. But we was raised up together. We never did follow no bad bunch. We'd be

down there at Brassfield's [a local store] all the time. Ritchie used to live on one hill, and I lived on another one. We'd blow them bottles to call one another. See, when I'd blow in the bottle and whoop in it, he'd know what I meant. If he'd blow in his and whoop in it, I'd hear him, and I'd go to him. We'd meet up then, see. We'd always carry a bottle around with us so we'd be able to get to one another. We called that talking the bottle. See, you have to fill that Coke bottle a little over half full of water. You can blow and whoop in it then. If you don't have the water in it, it takes up too much air, and you can't do no whooping.

Sometimes we'd leave home and Mama'd tell us what to do, our work, you know. She'd say, "You'd better not go nowhere until you get your work done, you hear? If you do, I'm going to skin you!" But we'd slip off, anyhow. I'd go to blowing my bottle, he'd go to blowing his, and we'd meet up. But when I got back there to the house, Mama'd sure put it on me. She'd have that switch in the corner, waiting. And she'd go to working on me with that switch. My mother would always tell me, say, "You all better not let sundown catch you away from here." So when that sun started to fall over that west corner, yonder, we'd get back for the night. If we were a great distance away, we'd have to run it out. We had to be home when that sun got hid.

I remember I was awful bad when I was coming up. I'd kill all of my mother's chickens and break the eggs. I'd do all the dirty things I could do. When we got to be pretty good-sized boys, we didn't want them little ones to follow us, you know. So we'd catch them and tie their toes together and leave them in the road. Mama and them, they'd have to come and get them and cut them loose. See, we tied them up real tight. By the time they'd cut them loose, we'd be gone. But, oh, when we got back home, would they whop us! Mama would beat me. She'd run me half a day to catch me, though. I wouldn't stand still for her to whop me. When she'd drop back to hit me, I was gone again. Sometimes she'd have a stick and she'd throw it up on me like you would an old shotgun. When she'd catch me, she'd get angry, you know, and then she'd wear me out. I had to take it that way. Them old folks was hard on us in them days. They'd jump on us and beat us. They'd tie us up. But they done

changed up now. It ain't like it used to be. They'd whop children way back. They don't whop them now. They let them go by theirself. But I think it's best to whop them to learn them something, to keep them straight. Because if you don't, that kid's going to grow up and do something . . . either rob or kill, one. He ain't going to stand no talking to. I used to hear my daddy say that you're supposed to bend the sapling when it's little. If you let it get grown and go to bend it, it'll break.

When l was able, I used to work down at Harrison county cutting logs, burning logs, loading logs. That was for pulpwood. I worked at the box factory in Port Gibson, too. You know, when I was logging a right smart [a lot], I could take an ax and just stand off from a tree and throw that ax and it would stick in that tree, with the handle down. We sawed with them old crosscut saws then, and I would just hang my saw up on that ax and it'd stay there until the next morning. Those saws, J. C. [a friend, J. C. Morgan] says they used to be called old thousand legs. You see them now sometimes. People got them hanging up in their houses. We'd take them things and cut logs all day long. They had a handle on each end. But now they can get out there and cut more logs with them power saws.

You know, when I moved over here, there wasn't a fruit tree on this hill. Not no kind. Now I got thirteen peach trees, apricot trees, and one little apple tree. I planted all that. I bought peaches, see, from different people off these trucks and things. I just throwed them stones around and they started coming up. I just let them stay there rather than tearing them up. And I scattered the little sets about, all around the house. That's how I come by to having them peach trees. They bear pretty good. We don't never sell none. We just give people peaches when they come to the house. And I set them chinaberry trees[2] out, too. They're for shade trees. See, that sun would just go right down on the porch, you couldn't sit on it at all. Well, I put them trees out there and they just growed up and spreaded out. So now it's cool on the porch. Any time you go there, it's cool.

There are certain days to plant on, you know. There's the Double Odd Days, the Twin Days, and then when there's a full moon. Addie Mae, she's the one that works the garden, she always

plants three days before, or three days after, the full moon. If you
want okra to start blooming right from the ground on up, you got
to let a little chap plant it. He's got to squat down as low as he can
get to the ground when he plants it. You've got to let a young child
plant it so it'll start fruiting from the ground. That's a real good
sign. See, if you just take it and stand straight up and plant it, the
okra is going to get just as tall as you are before it starts to bloom.
My grandbaby planted that okra back there for me. It makes a dif-
ference in it, 'cause I done experienced it.

I enjoy making different little things. Like I make fish boxes,
them little old cages you tote in your hand when you go fishing.
See, you use them for to put your fish inside, down in the water.
You make them out of a piece of wire. You take you a little piece of
screen and you make it so you can open it and shut it up again. You
put a little bit of chain on it, fasten it onto the cage, and just drop it
down in the water. When you catch a fish, you put him in that box,
and set your top down on it. Can't no snake get in there to it. Your

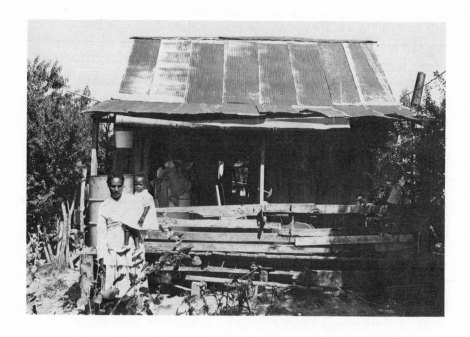

fish stay fresh, and when you carry him home he'll still be alive. I make me dip nets to catch minnows with, too. They're made out of some screen wire, too. See, you spread the net open and lay it down in the water and the minnows will come up there and you can just pick them right up. I catch minnows in that ditch down there from the big pond.

If you want to catch catfish, you fish on the dark [waning] moon.[3] An old fellow told me that, he said, "Catfish bite on the dark moon." It works that way sometimes. Sometimes you can throw your hook out there and by the time you get it out, a fish already took your hook. There just be some in there big as a buffalo [fish]. At night you can see them jump up out of the water, just turn bottom-up-ards right in the middle of that pond. We got bass and catfish in that pond over there. But the secret to good fishing is it takes patience. They'll bite minnows and earthworms and crickets, and they'll bite these artificial baits, too. When I had a reel I used to use them, but I ain't got no reel now. It got burned up in the house fire. Using a plain old cane fishing pole is all right. But I haven't been fishing in about a month. Been so dry, we couldn't find noth-

ing to fish with. They say it's good luck when you spit on your bait when you put it on your hook, but sometimes it just don't help none. It just takes patience.

And I like to make little feed cups and things for the chickens, and pitch me a good hen house and nests for them. I put plenty of dry grass in there so they can lay. I built all them little buildings out back. I've been living in this house twenty-one years. Charlie Patten, he put this house up. See, his wife is my sister. I was sick at the time and I wasn't able to do nothing. If I had built it myself it would of been built better than this. It ain't a shotgun house,[4] now. I'd call this some kind of little bungalow. If you'd like you could add two more rooms on this one. We lived right down the road for seven years before we moved here.

I been playing the harmonica a long time. I used to keep it in my pocket when I was going to the woods working. I used to play a jew's harp, too. And I could play piano pretty good. I used to play a guitar. But one instrument I never could play, and that was a fiddle. I never could do nothing with a fiddle. But I ain't got none of them around here now. You know, I used to be a pretty good tap dancer. That was in my younger days. I had some plates on the toes and heels of my shoes and I could get out there on that floor and I could get right *with* that music . . . *right* there with it. That'd be at a juke,[5] at them old country balls. I'd go a lot to them juke joints. There'd always be tap dancing going on there, and I'd step right in there with them. They paid me, too. I'd say, "I ain't going to tap dance for nothing. It takes something to tap dance. It's hard to do." So they would pay me. That would be Carl and Felix Williams, they was brothers, and they had a juke house back behind that brick church over there. I remember, they'd have records, and people would play. They'd have them old blues, them old hard blues. They'd have them break-down blues, too. And they'd play them old tap-dance pieces. There'd be a lot of us out there dancing . . . womens and mens. You could catch them by the hands and set them spinning around, and not miss a lick. You'd keep right up with it.

My daddy used to play music. He used to play all the time. That's how I learned how to play the guitar. After he died, why the

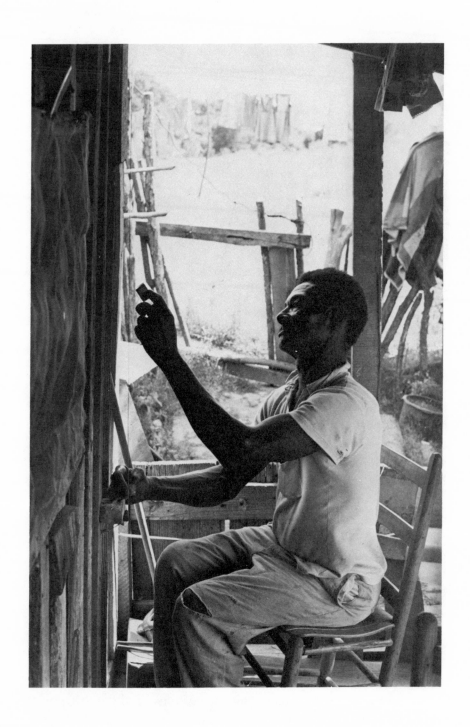

other boys they made away with the box then. I couldn't get another one. So I decided to put me up a wire. I just call it part of a guitar. It's a one-string guitar.[6] But it sounds like it's got six strings on it. Course I can mess with six of them sometimes. Be around somebody who's got a guitar, I take it and pick it up and hit a few licks on it.

It's been a long time ago when I made the first one. See, I didn't have no radio right at the present time then. I had to have some music some kind of way. So I put me one up and I'd make my own music. I started making them when I was young. I was about twenty-some years old then. I never did see nobody do that. I just took it up all my own self. I ain't never did see nobody playing none like this wire. I never seed nobody that's played that. I just took that up on my own. And nobody else around here can play it but me. People, they come and listen to me. They say they don't see how I can do it. But I can play on it. I started, and I kept it up. That's what I did.

I used to be just sitting up here at the house and they all would be out working. I'd be lonesome here by myself and I just wanted

64

to get me up something to keep up a racket on. So I got to sitting
down and thinking, and I said, "Well, I'm going to put one up there
and try it. Let's see what I can make out of it." And I put it up there
up side of the house, and it sounded pretty good. Well at first I tried
it on that tree out there. But it wouldn't give no kind of sound. So I
took it off there and put it on the wall of the house. You can't just
put it anywhere, on any kind of board. It's got to be up side of the
house, else it ain't going to play. I don't know what makes it, but
you put it up side of this wall and it'll play. I'd say the house must
give a sound to it. Just like a guitar, you hear the sound of that box.
I say the house must be got the sound in it.

Me and another boy used to put us up one apiece and play
blues and different things. He'd have his and I'd have mine and we'd
be playing together. A lot of the youngsters would come and dance.
They had some sort of dance they called the Snake Hip.[7] That was
just a little old light Two-Step. We'd have a good tune up there and
they'd be dancing right along. We used to have plenty of fun off it.

You get your wire off a broom handle. Just unwind it from
around there and cut it off where you want it at. See, that broom

wire, that's the only one that plays. Another kind of wire won't
work. I tried every kind of wire but it won't work. I've tried wire off
a fence. I tried hay wire. It just wouldn't play. But now broom wire,
it'll play. So when the broom's weared out, I just get that wire and
keep it. It's funny the way that you can take an ordinary broom wire
and it sounds like it's near six strings.

First you go and put you a staple up yonder, wrap your wire,
and put you a brick up there. And you put you a nail or a little bolt
or something under there on the wall beneath that brick so it don't
touch that brick. You pull that wire real tight. That's where you get
your tightening, from the bottom. You've got to knock it down
until you get it real tight. See, that keeps it from growling on you.
It'll sound louder the tighter it is. You got to pull it just as tight as
you can get it. The tighter it is the better it plays. But if it's real
slack it ain't going to do nothing. If you have it real tight, it's going
to play. Get it tight enough, it'll talk, almost. I use a castor-oil bottle
to note it. It has a little higher ridge on the corners of it and that
makes it sound louder and better. I've been using it a good while
here on this wire. It works better on the one string. So you go to

playing then. It'll play most anything you want to. I just learned different pieces. I hear them and learn them, or they just come to me, I make them up myself. Sometimes I just keep adding more and more to them. I play "Sitting On Top Of The World,"[8] "Bottle Up And Go,"[9] "Vicksburg On A High Hill and Louisiana Just Below,"[10] "Forty-Four Blues,"[11] "Going Down To New Orleans And Get Me A Mojo Hand,"[12] "Monday Morning Blues,"[13] and "When The Saints Go Marching In."[14]

Some of them I heard on the radio. As for TV, I watch just the news on it. When the news is over, I be through with it. I really likes the radio. I listen from four o'clock in the morning until daylight. I like radio because I can catch good spirituals on the radio. But I'll tell you, one thing I never got is religion. I say when you die, your soul dies too. That's right. That preacher can't preach to you up there in heaven, so he can't preach to you down here. There's no need of me walking up behind the preacher and telling him what I got and what I ain't got. I just don't have no religion. But I decided I'd get just as far as the next fellow got. All you have to do is treat everybody right.

Theora Hamblett

Painter | Oxford, Mississippi | 1895–1977

I LOVE the countryside in Mississippi. Most all of the places that I paint are right around my home—near Paris, Mississippi. I have a whole room full of paintings in yonder of memories of my childhood. Many of them are set right in the yard lot of my old home place. It's gone now, but it was at O'Tuckolofa Bottom, up from Water Valley, and about eleven miles east to Paris. We had cattle and cows, sheep, hogs, chickens, and all like that. I've done three or four little paintings of Mama feeding the chickens. And I've done milking time at the old home place, Mama milking in the cow's break. See, the cow's fastened up.[1] I used to milk out of the break. I didn't want all of that trouble. And we had a chicken coop, a seed house, a big old barn, a little dairy, and a smoke house.

My old home was a dogtrot house. You could see all the way through the hall to the seed house way in the distance. It was really a good little distance back, but in my memory, that was the effect. This painting shows Papa standing next to the fence gate. We had a picket fence around our yard. There is a visitor fixing to tie his horse up and go in. I did a painting of the old home place yard fence, but I painted it to make it look better. And I painted me out in the yard, looking at all the quilts Mama had put out to sunshine, me just amazed at all the pretty colors. I've also done washday scenes. Near our house was an ever-flowing spring, and it made no difference how dry the weather got, all the families could go to this spring to wash. There was plenty of water. See, the mother is washing at the tub. The daughter is lazily out in the grass playing with a dog. And this here is the big old tree that stood in our yard lot. It always had those three knots on it. That tree is dead now, but the last time I was out there, those three knots were still on it, just like

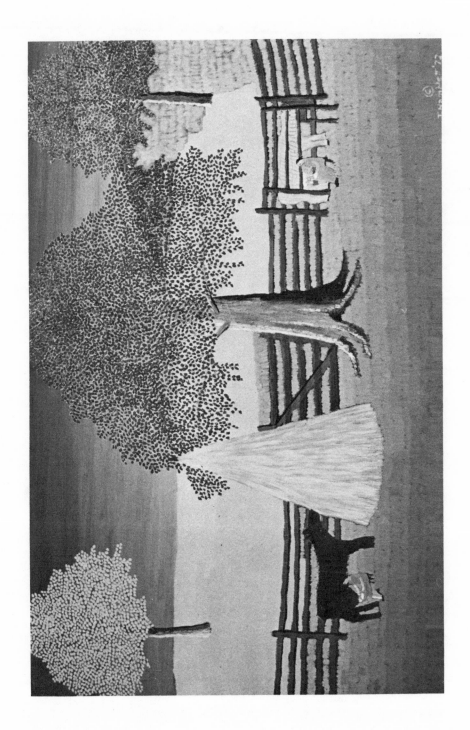

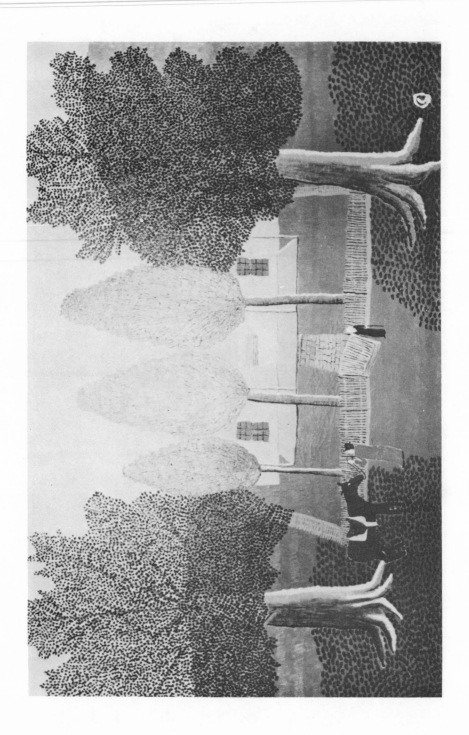

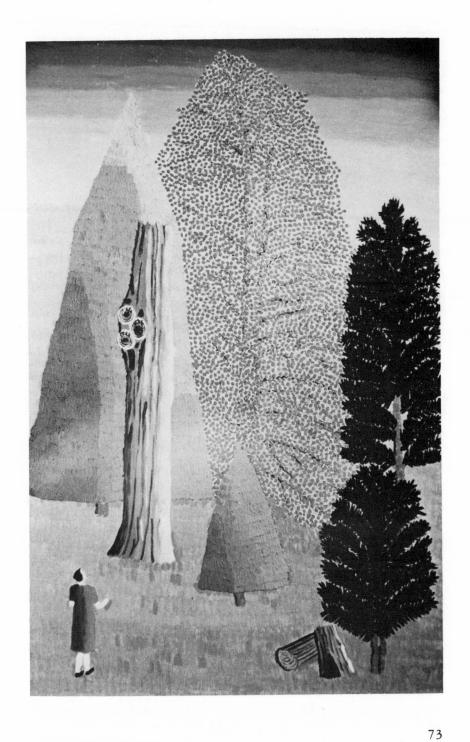

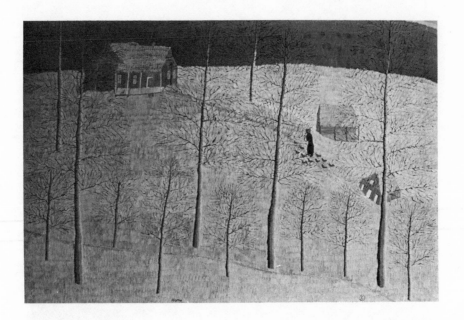

I remember from growing up. That old tree was a pretty good play yard for us children for a long, long time. I have a painting of it as a dead tree, too—with me just standing there amazed at how it looked.

There was something special about our old home place that we enjoyed. We had a lot of large oak trees in front of the house. Oh, they were four or five feet in diameter. I loved those old oak trees. On the north side of the house was the oak trees, all different shades of red in the fall. And on the west and southwest side of the house were the hickory trees. Those hickory trees were our delight and joy. When we left out there, there were over fifty scaly-bark hickory nut trees in the yard lot. In the early fall, oh, how we gathered nuts. One tree, the nuts on it always got ripe and dry before all the others.

Papa died when I was ten years old. And *he* loved his trees. They always said that the reason we had all those trees was that when Papa—he was an early settler in O'Tuckolofa Bottom—was clearing up the low land there, he would get the hickory sprouts and take them up to the yard lot and set them out. Long before I

began painting, I loved the trees around my old home place, too. There was something about the trees—they were stable, always the same. I'd go off and teach school and come back. Those trees were still the same as long as we lived there. Of course now we've been away thirty years, and they have slain—that's what I call it—most all of those trees I admired so much. It hurt me when I went back out home a few years ago and found most all those old hickory trees gone. Now I doubt that there is even a dozen left. So I don't go back out there. I don't want to see that. My favorite trees are all gone. Now they're gone, it doesn't look like the same place.

Well, I just love trees, I guess. It was the trees along the highways—the beautiful fall trees along the highways—that helped to inspire me to begin painting. I love to go places, and see those beautiful fall-colored trees. Now every tree along the highway doesn't always have a beautiful color, but you'll find them here and there. I wanted to paint those trees and put all the beautiful colored trees on my canvas. And that is one thing that gave me the urge to keep trying when I got a chance to learn oil painting. Now, painting the trees is the easiest part to me. See, I paint the trees first in all my paintings, and then I have to finish up the rest. Painting the fall trees is, I guess, my best drawing card, because more people want my trees than they do for me to paint houses and other things.

Before Papa passed away, I made my first trip to Water Valley and to the circus. You know, back in those days, circuses went through the country more so than they do now. They showed at all the small towns. I must have been eight years old when the circus came to Water Valley. I remember, one lady in the crowd picked me up and pointed out the circus train down the street. We were on Cemetery Hill—Water Valley was down in the valley, see, and there was a depot there. But, anyway, I remember that Mama got me a whole box of crayons. It was the first time I ever had a whole box of crayons for myself. I remember Papa's grandchildren would come and bring little scraps. So I was proud to have a whole box of my own. Or maybe because I was all excited about the circus that I remember everything that happened that day. I remember the high diver. It just liked to killed me to see him jump from that pole. It was twenty-five or thirty feet high, and he jumped off onto a tent-

like contraption, and that just frightened me to death. Anyway, when I went home, oh, how I drew and colored. That's how I first became interested in painting.

Now I use oil paints. Most of my colors, I mix with white to use. And, it's funny, but most of the paintings that I do for other people, they like my yellow better than any other color. People just like the different shades of yellow the best. On my trees, I always put two coats of paint: red over yellow. That yellow underneath makes the red show up better. I just automatically grew into doing that, putting two coats of paint on the leaves.

Now, I think I have seven or eight paintings in yonder going at one time. While one painting is drying, I work on another one, and alternate them that way. It usually takes about six weeks to paint all that number. Anywhere from six to eight weeks, depending on the number and the size. Now I usually paint only in this one room. Very seldom do I paint any outside of this room. And I usually paint in the morning—I paint Monday, Tuesday, and Wednesday

mornings, Thursday all day, and sometimes Friday all day. I just have to renege on painting Saturday and Sunday. On Sunday, even if I don't go anywhere, I find something to do. I like to read then if I don't have too much to do.

I grew up on the farm. I didn't know anything else *but* the farm until I was sixteen or seventeen. Papa died when I was ten and we were given enough to live on just one year. So I was eleven years old when I began hoeing. Of course my brother Hubert was thirteen and he did the plowing—he made the first little crop that year. And I used to help with the lye-soap making,[2] and I did a painting of that. We used to save the ashes from the fireplace through the winter, and put them in an empty flour barrel. We'd bring buckets of water and pour them on top, and the water would go through the ashes and come out as red lye. Then you'd put it in a wash pot with some hog grease, and boil it down over a fire to a strong thick lye soap.

The farm we had was over two-hundred acres. But much of it was not in cultivation, and we just made a little cotton crop that first year after Papa died. There came two weeks of rain the first of September, and almost ruined everybody's crop. We had about half a bale picked—the prettiest white cotton—when that rain set in. The rest of it got too dirty. I've done scenes of carrying cotton to the gin. We lived in the hills, see, and frequently they had to have three horses to get those wagons full of cotton up the hills. And often a little boy would ride on top of the wagon, right on top of the cotton.

Our sorghum patch all blew down that first year, too, and what a time we had gathering that sorghum to make our molasses. Back in those days everybody—most every family—made their own molasses. Now they've quit doing that. My sorghum-making painting shows the part [the sweep] that turned round and round when the horses were hitched. It worked those big iron pieces in the mill, the rollers that you put the cane between. It mashed out the juice and it ran into a barrel. Then it went through a pipe to the cooking pan. The juice was green then, but as it boiled over the fire, it turned red. You'd dip the skimmings off, but they were saved. When you'd go to visit you'd eat skimmings until you'd get sick.

79

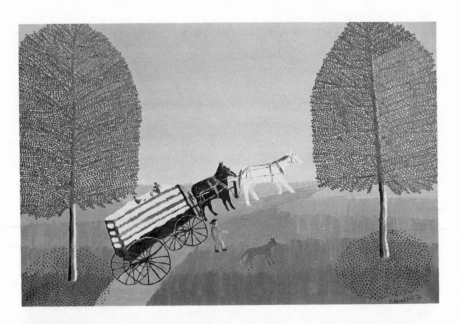

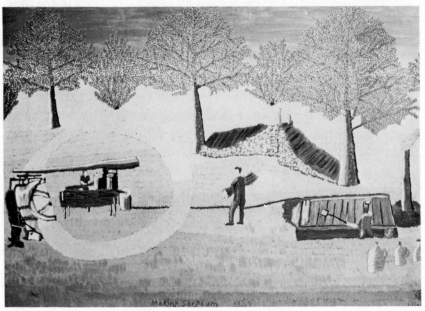

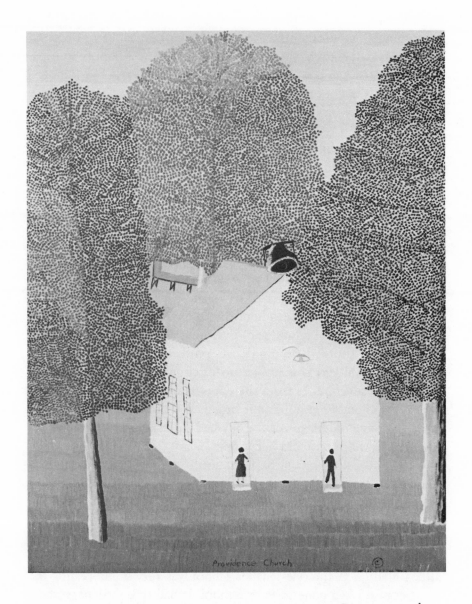

Providence Church

And of course the corn blew down, too, that year. But we saved
enough, so we had bread to eat, and corn to feed the stock that
year. We didn't have a man on the place for a couple of years. Then
Hubert was old enough. We were finally able to get tenants to live
and work on the place again.

When I was growing up there were three churches in the Paris

Community: the Methodist, the Baptist, and the Primitive Baptist. The Methodist church was at Paris, and there was a Baptist church at Spring Creek, and one about halfway between Paris and Banner. In the 1840s my grandfather helped organize Spring Creek Baptist Church, and my mother always went there. There was a stream, a baptismal pool, I remember, way back. And there were boys and girls constantly walking to that stream. We went to both the Methodist and the Baptist churches, one Sunday at one church, and the next Sunday at the other. I remember the old, old Baptist churches—where the men went in one door, and the ladies went in at another door. All the early Baptist churches were like that. And the men and women each sat on their own side of the church. Then there were some aisle seats that the young people sat in, but they didn't mix and mingle. One half would be the girls, and the other half would be the boys. There'd be an old church bell, too, and there'd be a wooden table, where they'd have all-day meetings. And they'd have all-day singings, too. Everyone would bring a lunch basket, and they'd spread the dinner out on that long wooden table. I went to those all-day singings at lots of churches as a girl. I lived at Paris, six or seven miles from the church, and ten miles from Spring Creek. I remember going in our buggy to those all-day meetings, where we sang old harp work. They had three or four old men that could really sing those old harp songs.

I kept up working on the farm until I finished high school. I finished at Lafayette County High School with the first graduating class, in 1915. And then I began teaching that winter at a one-teacher school. And about the time I began teaching, Hubert married. He went to Water Valley then and worked in the post office. And we just rented the old home place out then. That first winter after I graduated, the one-teacher school was very uninteresting to me, because I had gone to Paris School. It had three teachers: the primary, the middle grades, and then the big room. We used to walk to school. It was a mile each day to walk to Paris School and back. We had to get there by eight o'clock in the morning, and leave at four o'clock in the afternoon. And there were quite a bunch of children, a hundred-and-fifty children, with three teachers. It was

82

quite a large school when I was growing up. But that has changed. It became a small little school, and now it's not a school at all.

I did a painting of Paris School, with the children playing town ball. Town ball is where you throw the ball in front of the runner, and that counts them out. It's not like you have to put the ball *on* them, if you throw it in front of the runner so it crosses his path, he's out. But I never see children playing town ball these days. I guess they quit playing that long before I quit teaching.

But, anyway, I didn't like one-teacher schools. So I didn't teach for a couple of years, and then I decided I'd go back. And I went one summer to what was then Mississippi Normal College, and then taught again that winter. That was around the time the Armistice was signed for World War I. I enjoyed going to summer school, so I'd teach in the winter in order to get to go to summer school. I taught fifteen years, but not in succession. I wasn't strong, and I'd have to drop out for a year or so, and then go back to teaching. I taught five years in succession one time in order to get my state teacher's license. I painted old O'Tuckolofa School, where I taught for seven years in the twenties and early thirties. I taught longer there than anywhere else. Every child in the school had to ride there in a covered wagon. That was in 1924 or '25, now. Lots of people don't realize that. The next year they came to school on a homemade bus. This painting shows all the children at O'Tuckolofa playing a game called whip-cracker.

It was in teaching the little fellows in the primary grades that I learned to love children. I had never been around little fellows too much. See, I was the youngest of all Papa's children. Papa had two families of children. There was just my brother Hubert and I of Mama's family. But Papa had sixteen children all together. His first wife had fourteen children, and Mama had just us two. His first wife died, and his first-family children married and was gone. And so he jumped up and married Mama when she was right young. Well, she was in her early thirties. So of course I was around some of Papa's grandchildren—but those that were living around moved to Texas after he died. So I didn't have too many other little fellows to play with when I was growing up, except when I was in school. And a lot

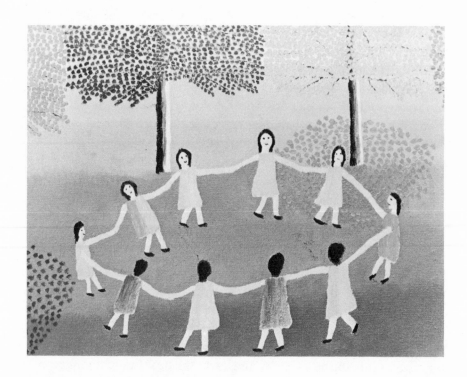

of times I didn't join in with the other children playing. I stood off, and watched the other children. So it was in teaching school that I learned to love children.

In summer school, they required us to take some kind of physical education, and I chose the children's singing-game classes. Drop the handkerchief, ring around the roses, and all those other singing games, I dearly loved them. And I wonder, if I hadn't had those classes, if playing those games would have impressed me as much. Of course, that was our physical education, but yet they were teaching us something that we could go back and teach our pupils ourselves. And no doubt, those classes were back in my mind and helped me to do the paintings I have done.

And then there's a dream connected with my paintings of children's games. I had done my painting, "Heaven's Descent to Earth," and I wasn't satisfied. But I had just wore out all my strength and energy. I began to want to paint something else, and I prayed for something to paint. So I dreamed another dream of children. It was

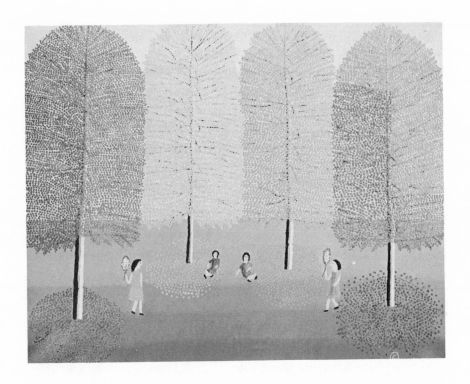

a long dream, but near the end of it, I was up in the mountains, out in the country. It was a weekday, and I heard some children laughing and talking, so I went out on the porch. They were near to the steps, and I said to them, "Why aren't you in school?" They told me they didn't have a teacher. So I said, "Well, I can teach you." And then at the end of the dream we were out in the schoolyard, playing games. So that was the birth of my children's games paintings. I guess that was just in my soul. I didn't take the hint right then that the dream was telling me to paint children's games. But about two years later I did my first painting of a children's game, "Drop the Handkerchief." Why, I don't know that in all my life I've been thrilled like I was thrilled over that painting. And before it came to me, I had painted all the scenes I could remember around my old home place. I had made up a few landscapes. I would put the trees in the background first, but I didn't have an old familiar scene or activity to put in the painting with them. So something within me

told me to paint the game of drop the handkerchief. I must have remembered that dream. And, oh, what a thrill of joy I had. So when you have one good thrill of joy you want to have another one. I don't have the same thrill now that I had with that first one, but I still enjoy painting landscape scenes with children in them. So it was paintings of children that I did the most of when I did get to painting. I have sold, through this Christmas [1976], two-hundred-and-twenty-five paintings of children, mostly children's games.

I went to Mississippi Normal College for several summers. My last summer there I really fell in love with art work. But that was the last time I got to go to summer school. My health gave down and Mama and I went back to the old home place. That was during the Depression, and I told Mama we could live out at the old home place and not suffer like a lot of people were. Mama lived one or two years with me there—I don't remember exactly—before she died. When she died I went back to teaching, and taught one year there at the school in O'Tuckolofa. But, I don't know, it just didn't satisfy my soul. So I went back to the old home place again and raised chickens for a couple of years. I could raise them all right, but I couldn't sell them for a living price. So I knew that I had to do something else. That was the first time in my life that I was alone. I was free to think and act for myself. During that time a small voice kept telling me, "You can't keep this up. You can't keep this up." Once I was picking berries, and one time I had gone over in the woods after a cow that had gotten out when I heard that voice say, "You can't keep this up."

So then I began to think seriously about what to do, and I decided to come to Oxford [Mississippi]. I thought maybe I would like Oxford better, and of course today I can see why the spirit led me to come here, instead of going to Water Valley. I bought this house in the last of October in 1939, fixed it up, and made it into an apartment house. I made an apartment for myself, and then big two-room apartments downstairs, and three-room apartments upstairs. And I worked and worked to get it fixed up and make it into an apartment house. And I made money off of it. I mean, I was able to pay some on the house. But there was one thing that kept coming up. Every time I would fix to rent it, I'd work hard to clean the

86

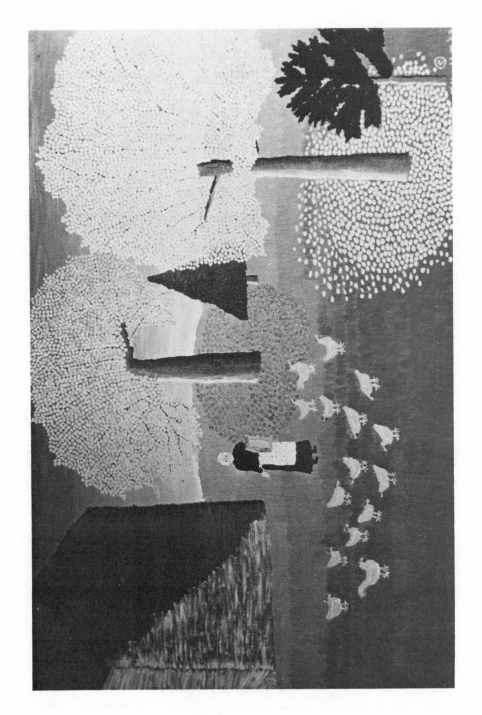

apartments, to get them spick-and-span clean. And then every night I'd go to bed and say to myself, "I'm going to sleep good tonight." Well, I'd sleep fairly good, but I'd wake up early, dreaming that I was in a big old house with several vacant apartments. And I was just miserable to rent those rooms. Of course, when I woke up I'd find that it was just a dream. Well, that dream happened to me many, many times. Just let me clean up an apartment and get someone to move in, and I'd wake up dreaming about having a house with empty apartments. Well, I didn't know what to make of that. I'd always be miserable when I'd wake up. Then later it flashed in my mind, it dawned on me, that when I was renting rooms, I wasn't doing what a higher power wanted me to do. A higher power wanted me to fill those rooms with paintings. And since I took over all the apartments, and filled most of the wall space with my paintings, I don't dream anymore about owning a big old house with a lot of empty rooms. So it's been ten years, I guess, since I dreamed like that.

My first vision was when I was away from home at school at Blue Mountain [Mississippi] and I dreamed one night of Papa. Papa

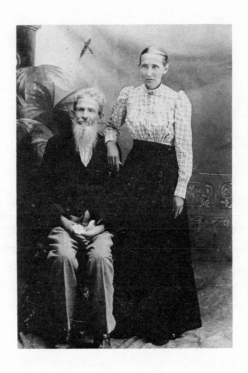

had been gone seven years, but I dreamed of seeing his face right
close above mine. As he hovered over me that night, he said,
"When you go home, I'll be with you." Well, that made me
homesick. That was my first time away from home. I was just seven-
teen, and I had been away from home six or seven months. That
made me so homesick that at the end of the quarter at school, I
went home. Well, I didn't realize . . . that dream was so real to me.
I was too young to think straightly. And I remember what hap-
pened when I went home. My brother Hubert had come to Water
Valley [train depot] after me in a buggy. When I got out to open
the gate and I looked toward the house, reality came over me that it
was just a dream. When I got inside that gate, I realized that Papa
wasn't really there. He'd been dead for seven long years. But, of
course, I should have realized that there *was* something that made
me want to go home. And that was the vision of Papa's face that has
always stayed with me.

This is Papa, taken when I must have been about eight years

old. Papa was white-headed, and, during the summers, it was my job to stay with him all the time after he got feeble. I was at his heels all the time. As a little child, Mama had Hubert all the time, and Papa had me. He felt sorry for me, I guess, because Mama didn't notice me. Hubert was just two years older than me and frequently we'd hunt lizards together. I can hear Mama yet, telling us, "Don't you catch those lizards. They'll bite you." Mama was a very demanding person, and it was always her wishes first. And I remember some places where Papa wouldn't let me go with him, and how mad I got.

This is Papa's face as I have seen it so many times. Sometimes it's plain; I don't always see it with those rays around the eyes and mouth like that. But I remember my father as a very old man. He had white hair, white whiskers, and a white beard. I try to tell myself that I'm seeing his image in my dream visions, that he is one of the angels that is guarding over me. I've heard them say that there are six angels guarding everyone. And I'm confident that Papa is one that's guarding over me. I still think of him, and see his face constantly. There's not many days that pass that I don't see his face. That's amazing to me.

Papa was with me again one Saturday afternoon in midsummer. I was ironing out in the hall, I remember. You had to iron with the old-timey heavy smoothing iron that had to be heated at the fireplace, so I went and got a fire going. It was very warm, I remember, and Mama came in fussing because my brother had gone to a ballgame. My brother Hubert was a big ballplayer and he went a lot to the games. But Mama would want him to stay at home on Saturday afternoons and work in the field. Ballgames was new then, and Mama just didn't understand anything about them whatsoever. She thought Hubert ought to be at home plowing. So this one Saturday afternoon, Hubert had gone to a ballgame about two miles away from home. And I became nervous at Mama fussing because he had gone. I didn't want her to be fussing at him. I always used to take up for him. So I said to Mama, "I'm going, too." Well, it was impossible for me to go to the ballgame because I didn't have any way to get there—all the ways to ride were done gone—and it was too far for me to walk. Anyway, I went back to the ironing board then and

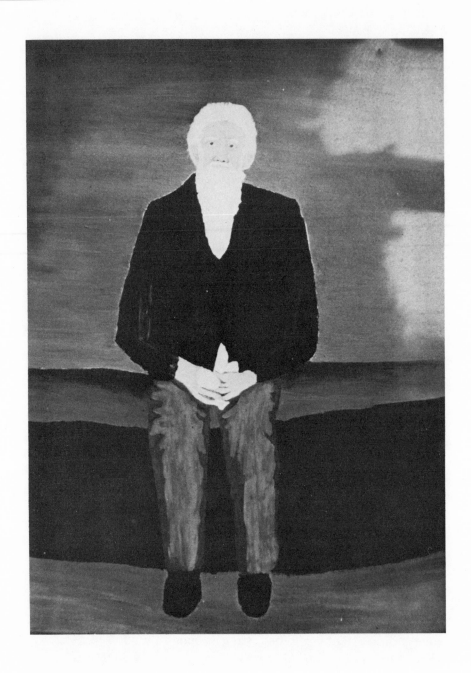

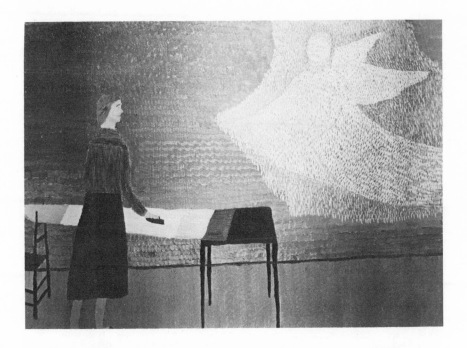

started ironing. I made about one lick, and then I heard something.
I looked up. I was facing a wall with an open door. But both that
wall and door vanished. And before my eyes there appeared Papa as
an angel, with his right hand stretched out nearest to me, and with
long, flowing sleeves. There was a heavy mist all around him like
rain, yet the sun was shining bright. So Papa—he was the angel—
spoke to me, and said, "No, baby, for my sake don't go." See, when
I told Mama I was going too, that's when the vision came to me.
And that vision of Papa stayed with me and was my guiding power
for several years. The spirit that went with that vision was what re-
ally counted, because I was seventeen years old and very sensitive.
You can get very blue and depressed and not know which way to
turn, but from time to time if I had to make a decision, I got off to
myself and meditated. I didn't know what meditation was then, I'd
never heard the word, but I'd get off to myself and wonder, "Will
Papa be pleased with what I'm thinking or doing?" And if my con-
science told me that he wouldn't be pleased, then I didn't do it.

That ironing board is the first vision that I painted. I call that

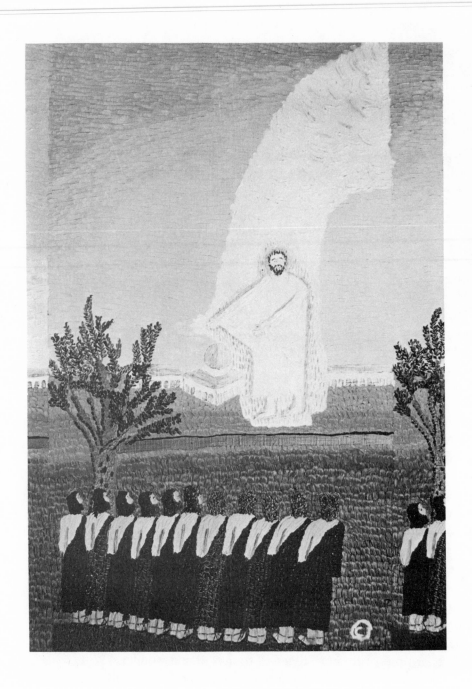

94

"Angel's Request." It created a good bit of attention, and I began then to paint some Bible stories that had angels in them. I wanted other visions to paint and I prayed for them. The first Bible story that came to me was "The Ascension." Christ raised his arms to bless the disciples and then began to ascend to heaven. And the disciples kept standing looking after him until two angels appeared and asked, "Why are ye gazing after him? He will come back as he went." I've always used the angel to represent the Holy Spirit. I've been told since then that angels haven't been used to represent the Holy Spirit since the Middle Ages. They said that one of the popes decreed then that a dove should always be used to represent the Holy Spirit. But I used it. I didn't know that much about symbolism.

Then during World War II, I had "Heaven's Descent to Earth" given to me. I saw a golden cloud, silver and golden chariots, and little celestial bodies beginning to descend to earth, and I clapped my hands and said, "Look, heaven's coming to earth." That's how I named the painting. I remember, it came to me one morning when I was mopping the floor. I was standing right near the air chute by the big old furnace we had when I recalled that dream. I kept wondering . . . it seemed like I must have dreamed it the night before and it was coming back to my memory. I don't know definitely whether it was a dream or not but I do remember it all came to me when I was mopping the floor by the furnace. I painted that four times, four successive summers. I painted those until I was tired, and I began to want to paint something else. So I prayed for God to send me more visions.

That painting I did of "Grandmother Cobb's Dream" is in my southwest room. It's a picture of the dream *she* had of my grandfather. But it's from my *own* vision of her dream. In some of my visions, there'll be places blank. And so I've substituted my own . . . I knew that they were intended for me to use my imagination. My grandmother Cobb had six children, but I think the oldest was only ten or twelve when Grandfather left for Civil War duty. He was in the Siege of Vicksburg and was in the Surrender [July 4, 1863]. History tells about how they were all dying with the measles at the camp in Vicksburg. So they surrendered, and the men from around

his community—Calhoun and Yalobusha and Lafayette counties—began walking on home from Vicksburg. There was no way for them to ride. They had to walk. The night of the first day they slept in a home out in the country from Grenada, and the next morning Grandfather took sick with the measles. So the others came on home and told my grandmother where they had left Grandfather Cobb. So she and my great-grandfather—her father—started riding to Grenada. And I'm sure they had to ride mules, because all the horses were hid out in the forest at that time to keep the Yankees from stealing them. But they did have their mules. So they rode all the way from Calhoun County where they lived, to a few miles beyond Grenada, but when they got there, Grandfather was already dead and buried. So they had to come back home again. And when cold weather came, they went back and brought Grandfather's body home, and buried him in the family cemetery at Spring Creek.

My grandmother Cobb was the type that grieved very much. I wonder if I inherited her spirit of seeing spiritual visions and all because she finally dreamed of seeing Grandfather Cobb fly down as an angel and pick up two of their children and fly off with them. She begged him to come back, but he looked at her and said no, that he had too good a home. So after that she felt at ease and was satisfied about his soul's salvation. He was not a member of the church, see, when he left home to enter service. I remember I was ten years old, Papa had just died and I was playing around nearby when I heard Mama telling another lady that story about Grandmother Cobb's dream. And I think I inherited my dream visions, because my grandmother Cobb had them.

I've painted the vines, too. Christ often spoke and compared himself to the [calamus] vine. I had a stroke on February 4, 1974, and I had to stay in the hospital. I was in a room where the wallpaper was golden yellow. And the first morning when I woke up I saw a vision on those walls. And then when I *closed* my eyes, I would *still* see those golden yellow walls, all covered with long vines. I'd strain my eyes by keeping them open, just to keep that vision away. Before, I'd often had my visions only momentarily, and they were gone in just a few seconds. But after I had that stroke, this vision of the vines lingered and lingered. I had to fight it off. I

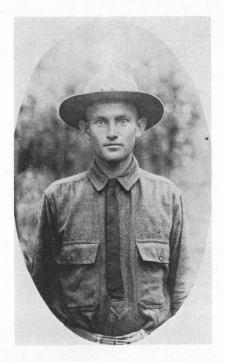

succeeded in keeping it away by keeping my eyes open as much as possible.

I remember one time that Pat Boone sang a song over the radio advertising milk. One night he sang "Will the Circle Not Be Unbroken,"[3] and a choir like angels way in the distance sang the chorus on that song. He would sing the verse by himself, and then they would join in with him in singing the chorus. The memory of that song, the vision it gave me, stayed with me for a couple of years. I couldn't forget it. So finally I said to myself, "I'm going to paint that vision so that I can get it off my mind." So I painted the people listening to a man singing at a microphone, with angels in a circle way back in the distance singing the chorus with him. Well, when I painted that, I never was bothered with that memory just constantly coming back again and again.

My brother Hubert had a heart attack in 1971, about the middle of June. They carried him to the hospital there in Water Valley, but they didn't let me know it until the next morning. He lived two

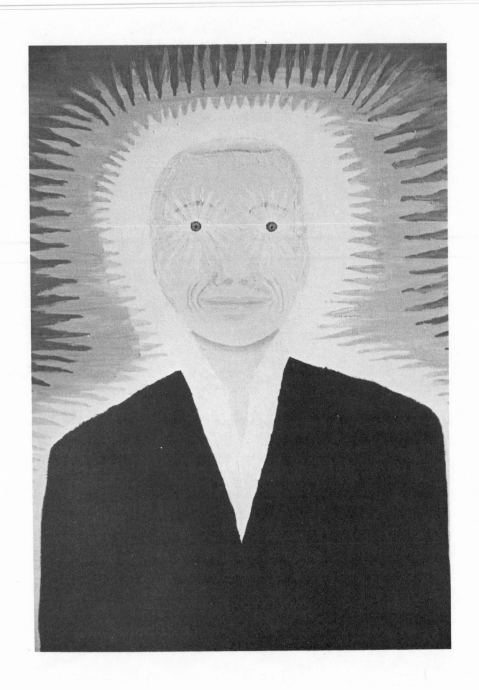

weeks in the hospital. And then he passed away on a Saturday night. I went to see him on Friday night, the night before he died. And I wasn't able to go back the next night, but his wife called at about eight-thirty and told me that he was better. Well, I couldn't believe it, I was confident that death was on him. I just knew that death was very close. I just walked the floor—these four big rooms—just walked around and around. And sometime later when I got into the northeast room, well, we had some work tables sitting in the middle of the room at that time. Those tables just disappeared. I didn't see them. And in their place what I saw was Hubert. I went in the west door of the room, and I saw Hubert come in at the other door. And I knew then what that meant. Well, when I saw it, I knew he was gone. And I began to cry, and I went and sat down on the bed. I don't know how long I sat there, but between ten and eleven o'clock the phone rang again, and his wife said he was gone. Well, several weeks later I painted this painting because that is what I saw when he entered the room. What I saw was a vision of him—his spiritual vision—and he was glorified—that wouldn't be saying too much. Those eyes, the rays of light, oh, how his eyes did shine with joy and glory.

I've had visitors to come in and interpret my paintings terrible . . . in a terrible way. *Interpret*, I reckon that's the word to say, I don't know. I want people to know what *I* meant by the paintings. That's what caused me to write that little book, *Dreams and Visions*,[4] to tell my versions of the dreams. Of course I've painted a lot of dreams and visions—all that were given me while I was strong enough to interpret them right, what *I* thought was right. But now I've quit painting my visions because I'm afraid I won't get them just right. The Museum of Modern Art was the first to call my paintings *visions*. That was "The Golden Gate"[5] they had. They called it "Vision." That was given to me when I was in my twenties. I never thought about it being a *vision*, to me it was just a *dream*. But when they named it a vision, *I* began to think of my dreams and all as being visions. But it hurts me for someone to come in and give their interpretation of one of my paintings, just entirely different from the way I mean it.

I don't really know why I have had these visions, but I have. I

wonder if a man would confess all the visions that I have had. There are people who call my visions weird. But to me they are very real, and very true to life. I wish I could get some of my loved ones to see them. After I paint them, then I'm never bothered with that memory constantly coming back again.

Sometimes I'm afraid that the story behind my visions is going to be lost. I worry more about that, but I done the best I could. I feel like, well, we've got to take it like it is. It's one of those things. We have to take what comes. We can't go back. And so I just keep on trying to paint. The after-life is quite a mystery, but I think we will be busy in some way or another. Well, I just hope we find a home up yonder where we *can* keep on working. I don't want to stop working.

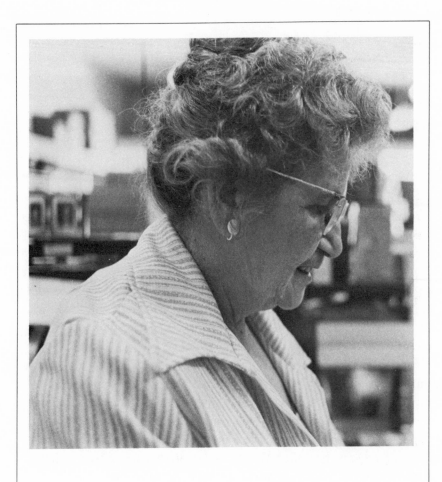

Ethel Wright Mohamed

Needleworker | Belzoni, Mississippi | Born 1907

M Y NEEDLEWORK, it's just something like a family pic-
ture album to me. And sometimes when people want to buy my pic-
tures, well, I feel selfish. One lady said, "Well, if you make the pic-
tures, why don't you want to sell them? Why don't you want to
share them with people?" But I do share them with people. When I
go to festivals and things like that, it delights me for people to look
at my pictures. And I feel like I am sharing them. I don't mean to
be selfish . . . it's just, well, you don't want to give your old family
pictures away, you know.

I started out wanting to save all my beautiful memories—all the
things that happened when my children were little. And not only
my children, but I wanted to remember things from *my* childhood,
too. Sometimes I get ideas for my needlework for something that
happened way in the past. Like I thought about the wedding of my
great-grandparents, Wiley Wright and Mariah Cartledge. I didn't
have any pictures of their wedding, so I just imagined how their
wedding might have looked, and I embroidered myself a pic-
ture of it. And I like it just as much as I would if I had a real pic-
ture, I think.

Wiley Wright was from North Carolina; Mariah Cartledge was
from South Carolina. Their families came to Mississippi in covered
wagons, in a big wagon train, and settled in Webster County. My
great-grandfather, that's Wiley Wright, came to Spring Creek in
about 1838 and homesteaded land there. He and Mariah were mar-
ried in 1851 at Double Springs Church, in Webster County. It was a
little log church. It's still standing today, but it's not a log church
anymore. They've remodeled it and covered over the logs. In my
picture I made the floor of the church brown because I didn't know

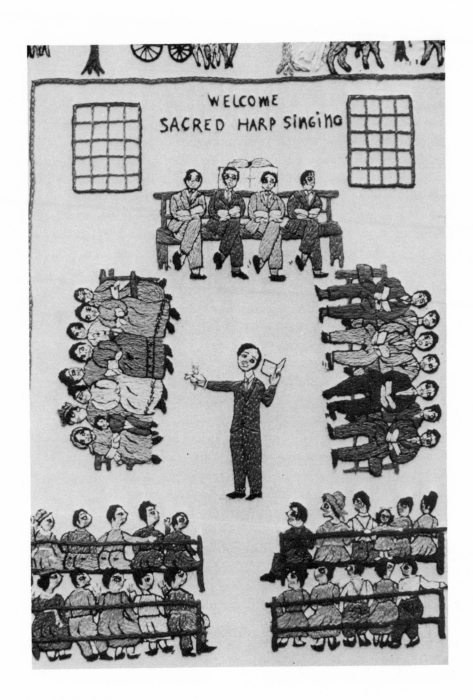

whether it had wooden or dirt floors. But I put a little rug under Mariah's dress. Maybe someone brought a little rug from home for her to stand on, see, so she wouldn't soil up her dress. And there's a fireplace, and they had some punch there in the front of the church. And then I've added some little scenes that I thought would be going on outside the church, during the wedding. There's the Cartledge family. They were a little more wealthy than the Wrights, so they had four horses and a driver. I have the flag so big up at the top of this picture because Mississippi was a real young state then.

And this is the same church, Double Springs Church, and that's where they had the Sacred Harp singing, you know. I remember as a child I didn't like the singing myself. I couldn't understand a word they said for one thing. I think harp singing is more for the adults anyway, than it is for children. In fact, there was more activity outside the church than there was inside; or at least I always thought so. And I was always so glad if I could stay outside the church. So that's the reason I have so much activity going on outside the church in this picture.

There's two sisters that haven't seen each other in a long time. And one woman, she lets her little baby lay by her on a little quilt under the tree. And there are all the wagons, parked under the trees. A granddaddy is tending to his little baby over there. And see the little boy that can't wait—he's looking at all the food on the tables, and he's got to have his plate filled right now. And there are two horse traders, the men always used to talk about that, you know, whenever there was a gathering of people. And this little man sitting right here, he's so ugly, that I said, "I should take you out and do you over. But, no, I won't, because you were just born that way. You'll just have to be ugly!" And see, the man behind the tree is taking a drink. He thinks nobody sees him, but we do.

I remember in Double Springs Church you had to sit so quiet. I didn't really like to go to church. You had to sit too still. But I would try to stay awake. You know, when you'd get home they'd ask you what the preacher had said, what was the subject. And I would try to listen carefully to find out what he was talking about, so I could tell them when I got home what the sermon was about. Well, usually they were too long, you know, for little children.

And then I did a picture of a housewarming in 1776. These two young people have been married about three days, so their friends and relatives all surprise them by coming over and having a party for them. They say that was the custom then. The celebration used to last two or three days, you know. See all the little log houses around there in the settlement, and all their neighbors that have come by? Everyone is bringing pigs, fowl, and all kinds of things that they're going to cook outside. The borders of the picture represent the *plenty*: all the fruit, vegetables, and meat, you know. That pig there, it's got a little baby, and they're coming to the party too, I guess. And see the baby in the log cradle. Of course, everybody's happy; it's 1776 and they're winning the war. You notice all the little flags. See, this might be the tin plates they'd beat, and the bells they might ring—I don't know what kind of music they had then. So they're singing and dancing; they're celebrating and having fun. It might have been like that.

Hassan Mohamed, my husband, was from a little village called Siren, near Beirut in Lebanon. His family raised cattle, sheep, wheat, and grapes, and they weren't of the real poor kind. They had some money, and I was always kind of proud of that, you know. He always said it was his big dream to come to America. It was such a land of promise and everything, you know. That was back when they needed people to farm and pick cotton, and all like that. He didn't come to pick cotton. But he did come, when he was eighteen, just a young man. That was in 1911. He came to New York first, with a group of young men from the old country. But he didn't want to work in the mills or factories or anything, so he came on down here to Mississippi. He came to Clarksdale first, because he wanted to come where the cotton was. He always said that he was sure he'd be all right if he could just get to the cotton country.

So he came to Clarksdale, and he peddled from 1911 to 1914. He met this man who told him, "Well, you can't talk English, but I'm going to put twenty-seven dollars' worth of merchandise in this suitcase, and you go on out down the road and try to sell it at the houses you come to. They'll know what it is you're selling, and they'll help you make the right change." I think he had yard goods, scissors, embroidery, watches, breast pins and other jewelry, things

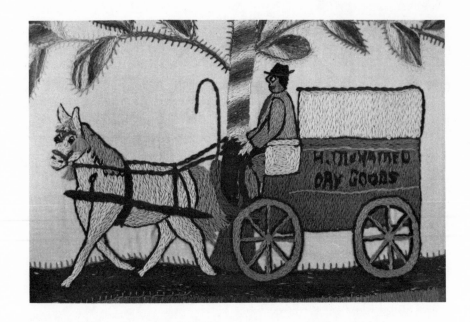

like that. And so he went out into the Delta country—he couldn't speak a word of English, now, except maybe to say "Good morning," or "Good evening," or to name what he was selling. He would go out onto the plantations in the Delta. And if he'd get there early—if his customer wasn't in from the fields yet—he would lay down under a tree and take a little nap until that customer came back to the house. And then he'd get up and go to the house and open up his suitcase on the porch. They'd all gather around—even call their neighbors over, you know—and he'd sell just about everything. And he'd learn a word or two of English from each customer; he soon learned money and he soon learned how to talk. And the people were so honest, they'd always give him the right change back. He said he didn't believe anybody in the Delta ever beat him out of anything. So most every day he went out and sold everything that he had in his suitcase. And he began to make regular customers on his route. He said that thrilled him to death. He was a good salesman, and he loved his work. He made more and more money. And he saved it. He'd always put his money in the bank.

And then in 1918 he bought a buggy and a horse so he could

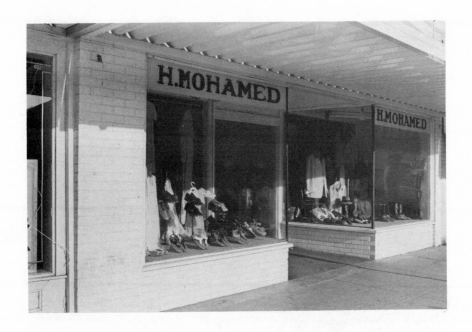

carry and sell more merchandise. And by 1922 he had saved enough money to buy a building—a store. He bought the store and the merchandise all at one time, and went right into business for himself. He had been a merchant for two years when we married. That was in 1924. We were married forty-one years. But my husband died about ten years ago. He was a wonderful father, and a great granddaddy. All of them loved him. And he was a real good merchant. He knew how to carry on and run a good business—he understood the buying and selling, and the dealing with people. And he was very sharp on buying merchandise; he knew good quality. He didn't want to buy anything cheap for the store. He was very careful about that. He'd say that our customers spent good money with us, so we wanted them to always have good merchandise. Like we always bought Star Brand Shoes—now they're called International Shoes—and they were the best you could get.

I did a picture of my husband during the Depression days, when they'd trade chickens for shoes or eggs or whatever they wanted to buy, back behind the store. See the sack full of chickens, and the man with the shoes. They each had their price, and so they

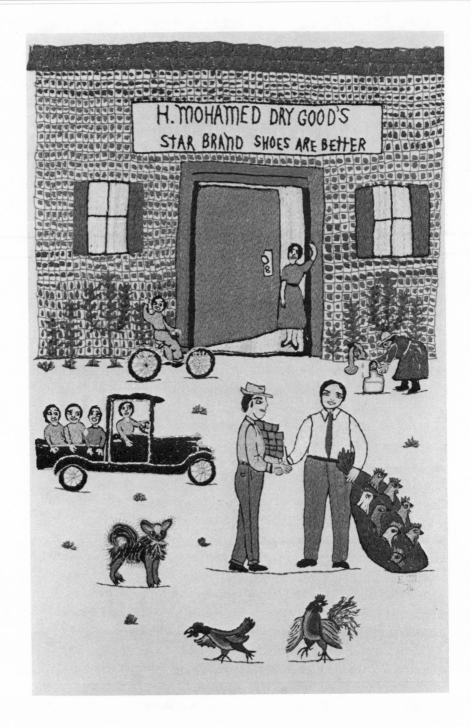

would go to trading. And there Daddy has come to the back door of the store to shake hands with them, and tell them to hurry back. There was a real friendly feeling then, you see. And that's me standing in the front door. See how little I was then! And see that little old dog there is so lazy he won't even chase those two chickens that have gotten away. And see the woman with the blue dress on, bending down at that hydrant behind the store. When my husband first built that store, he put that hydrant there because people who lived in the country had to drink pump water, and pump water didn't taste good. So he told all his customers to carry home fresh water from the hydrant behind the store. And that hydrant is still there, and people use it a lot today.

Well, my husband passed away in 1965. And the first year or two I really didn't do anything, I was just kind of getting myself together, you see. Then I realized that all my children were grown, married, and gone; my husband was gone, too. And now I lived alone; I had the store alone. So I thought to myself, it would be wonderful if I could carry on the business by myself, just like a man. So I said, "Now, I'm going to just pitch right in there, and I'm going to carry on that business just like he did, because my husband didn't ever tell me to close the store or anything. He just always wanted me to do what I wanted to do." And I didn't want to touch any of the money he left behind, so I went on ahead to see what I could do. And I managed the store real good and got along just fine. I really put everything I had into that store. I even bought the building next to the store, and built a playhouse in the back yard. I paid for all that myself. I was so proud of myself. And, you know, nobody ever said to me, "You did a good job." Nobody. Not even the children. I guess to them it was just routine, just matter-of-fact, you know. And then when I started to do my needlework, right away everybody said, "Oh, how wonderful." Isn't life funny? The thing I work so hard at, nobody ever said was any good. I think that's funny.

You know, I don't think there is another store like mine in the whole wide world. We sell shoes, dresses, overalls, things for the entire family—we even have long underwear that other stores don't have. Well, we have most everything. I try to keep it as much as

possible like it was when my husband first opened it up. I try to buy
the same things. You know, I really love my store just like it is. I
don't want to change it. I don't know, it's kind of comfortable like it
is. I know just where everything is. And so do my children and
grandchildren. It has been here so long until it fairly keeps itself.
It's a wonderful place. You know, there are a lot of old superstitions
about stores like this. They say if you miss your first customer, that
you'll have a bad day all day.[1] You are supposed to sell something to
the first customer that walks in, no matter if you have to literally
give something to him, so you'll have a good day. If a customer
comes in first thing and returns something—that's another sign that
it will be a bad day all day long. Merchants really have certain feel-
ings about these things, you know.

People have traded at my store so long, some of them fifty
years or so. And their children come in, and maybe I sold them
their first pair of shoes when they were little, children who've grown
up now, you know, and I see them today looking old. You feel
close to the people because you've known them forever. I love the

thrill of a new customer, and seeing the ones I've known such a long time. I love the work and I love the people who come in to trade with me. I don't know, the store is a wonderful thing. I love the store I guess because I love the people.

It's kind of unbelievable. You'd have to experience it yourself, I think to really understand it. A store like this is something . . . it's a way of life different from anything else. It's a different world. It's like I leave one world at home and come to another one downtown, here at the store. All day I'm dealing with people in the store. It seems like I keep in touch with the world more. I'd hate to ever have to give up the store. The store is so full of memories. And there is something great about coming to town and seeing the people, being with the people. I would miss that a lot; I wouldn't be part of the town anymore. I feel like I'm right in the middle of things in the store. I think if I was at home all the time I just couldn't keep up. I would get behind with everything, and I'd feel like I was losing out. The store's my public world, in a way. It's a world with people. It's the store world, the business world.

I was born Ethel Wright, in 1906, in Webster County, Mississippi. Back when I was growing up everybody had mules and other animals on their farms, so my daddy moved down to the Delta. He was a blacksmith in Shaw, Mississippi, not far from Belzoni. And he was a trader, too—he'd trade cows, mules, horses, saddles, just about everything. He was forever trading. And he'd sell things, too. If they were going to have an auction, Papa was usually the one to get up there and auction it off, you know. He had a good loud voice that carried. He was full of fun. I remember if we had parties, you know, he'd say, "Let's go." He always went. I know now that he went on account of me. But he got right into the fun of it, too. And he liked to play the fiddle for the dances. He'd never get tired. He was a good father. Yes, he was a real Mississippi man, my father. When I grew up we had plenty of food, and plenty of everything. I didn't know what being poor folks meant because my dad was a good provider. He owned his own place, you know. There was not a whole lot of money. But then people didn't need a lot of money. You know how it used to be in Mississippi.

I think that you can ride through the countryside and tell the

heart of the town by the music that's playing on the radio. Some towns have a certain type of music, and I can almost tell the kind of people that live there. And then other towns have a different type of music. The spirit of the people is in their music. When you hit the Delta, the cotton country, it's just wonderful, the music people in the Delta make. It's carefree. And in the Delta they spend money just like it's water. If they have a good crop in the fall time, there's just no end to the money here. If the cotton people make money, then *everybody* has money in the Delta. They just hand it out in bonuses to the people that live on the plantations. They give them labor bonuses, and Christmas money, and money on their birthdays. And if they go into the store to buy something, they'll buy for everyone in the store, you know. They have big hearts. And the merchants are happy when there's a good crop, because business is good then, you know. People in the Delta are not conservative like the people in the Mississippi hills. In the Delta everybody borrows to make their crop, but everybody gives, too, everybody's hand is open.

You know, in my store, customers walk in—we don't talk a whole lot—but they'll come in and say, "Good morning."

I say, "Good morning, and how are you today?"

And then they'll say, "Well, I'm not much, but I'm just glad to be here."

That's the main thing in the Delta, that's the philosophy. In spite of all our troubles, we're still glad to be here.

Of course, Belzoni is the only town I *really* know about in the Delta. I think cotton is wonderful, and it looks so pretty when it's growing, but it's coming into soybeans and rice, and even catfish, around here now. And they say this catfish thing is big—now they're turning some of the farms into raising catfish. Belzoni's the catfish capital of the world now. You know, it's a sad thing to see. A great change has come. You know how cotton has always been such an important thing here in the Delta . . . well, now people don't want cotton any more because the ladies don't want anything they have to iron! And they are talking against the cotton all the time. Of course I don't say anything about this to them, but all the time I know what's happening to our cotton. And I think sometimes how

sad it makes things. These ladies and their husbands maybe have big plantations and yet they come in to buy pants or a dress and they don't want to buy cotton things. So I think, oh my goodness, shame, what is the world coming to? I think, oh, how sad. The men are trying to sell the cotton, and the ladies won't iron. So that's what's putting the cotton out of business. That's exactly what it is. That's the changing world we're in.

And business has changed in the Delta, too. It's really changed a lot. I can remember when the Delta country was going good—before tractors, before all this cotton-picking machinery and everything came out—why, the fall time here was something else. You know, when I was a little girl, if we wanted anything special, Mama and Daddy would say, "All right, if we have a good fall." I never did know what "a good fall" was. I could only visualize someone falling, you know. And I thought if you landed down easy, you'd get "a good fall." I never did know what they meant. But here in the Delta everything is related to the fall, to when the crops come in. You know they'd pick that cotton by the hundreds in the fall, bring it to town, and get so much money for it. And then on Saturdays they would come to town to buy what they needed. Everybody in the countryside came to town on Saturday. It was a big day. And I remember on Saturdays in our store, what a day it was at the first of the month when people would pay on their bills. They'd come in for their furnishings with plenty of money. Everybody worked all week, and on Saturdays they would come to town. And the streets would be so full that you couldn't walk down the street. You'd have to push your way in and out. But the atmosphere was so friendly then. It was just beautiful. The stores would be so full of people that you couldn't hardly wait on all the customers. And we couldn't close our store. People would stay in town late on Saturdays, and they'd still be in the stores, buying, you know. And of course the merchants were glad to sell. Business was good then. We'd open early and stay open long hours. During most of my husband's lifetime he'd open the store at about seven o'clock and close it at ten o'clock, except on Saturdays, and that would be eleven o'clock, or sometimes even midnight. But times have changed and it's not like that now. Saturday here is kind of slow now.

I think that's because people have cars, and they come in and trade all week long. When a lady needs a new dress, she'll just go and buy it, no matter what day it is, you know. One thing at a time they'll buy. They don't buy up a supply any more. The cars, and the good roads and highways make a difference. It's just progress, I guess. We live so fast now, and the world is really changing.

I met Hassan, my husband, during the summer vacation from school. They needed someone to help out at Mr. Slatter's bakery, so I begged Papa one day all afternoon long to let me work there. I just thought that would be the grandest thing in the world, to have a job like that. He finally said I could, but told me not to pay any attention to the boys that came in, and that I had to come straight home from work. He was very strict on me. But the first thing I knew, every day this one young man would come in and buy something for his lunch. And he had the most beautiful black eyes. He was from Lebanon, you know. I thought he was the most wonderful thing in the world, and the most beautiful thing I had ever laid my eyes on. And so he would buy bread or some little cakes, and he would stand there and kind of smile at me as he ate them. So one day I said to him, "I believe you really like those cakes."

He told me, "I like *you*. And you're going to be my wife."

I think that was the first thing he ever really said to me. I was just a silly little girl, and that just thrilled me to death. So the minute I got home I told Papa about it. Anyway, it wasn't long until Hassan began to come to the house to see me. I really didn't know him. I hadn't said many words to him; I'd just see him at the bakery. So we'd sit there and talk about the weather and things that strangers talk about, you know. And I was perfectly uneasy. So he finally got up and went in to talk to Papa. And they got well acquainted. So the next night when he came back, it was the same thing: he wanted to go in and talk to Papa. So all the time he was coming to see me, he really spent most of his time with Papa. Papa always said that was the way they probably courted in the old country. Papa liked Hassan very much. Anyway, in a year or so we were married. He already had the store going then.

I made a picture of me and my husband browsing around on the bluebird of happiness when we first married, looking for the pot

of gold at the end of the rainbow. And when we found our pot of gold, it was full of children, and not money! I think getting married and having children was the most wonderful thing that ever happened to me. Really and truly, having children and a large family is a miracle. Raising eight children is a wonderful experience. Each one is different; each one has their own special ways. I really don't know what it is about our family that makes it so close. It's amazing how my children love each other. It's a funny thing, too, when we all get together, we just hate to go to bed. We'll sit up until three or four o'clock in the morning talking and telling each other things that are going on.

You know, to be seventy is nothing to dread. It's really wonderful, because at seventy you can be the age of whoever you are talking to. Do you know that now I feel like I'm your age? I feel like I'm living in *your* world. And if I'm with my children, or even my grandchildren—the little ones—I understand them and feel like I'm their age. It's because I've been there and I know what it's like. So I can be any age I want to. That's just something extra that comes with old age, I think. My family just has fun together. I don't know why that is. There's no certain rule or reason. I don't hardly know how to express it or explain it . . . but it's there, that big love we all have for each other.

My pictures are mostly from little memories—more like a family album, you know. When you grow older and you've had a full life, your memories are so wonderful. Somehow you want to remember, to relive them. Somehow or the other you call back things that have passed a little bit that way. It's not that you dread the future, but you kind of want to hang on to the past, especially when you have children. You don't want to lose touch with the children. Just a lot of memories go along with raising children. And when you look back, even the sad things usually become happy, or funny. All my little memories are very dear to me now. So it's a great pleasure to me to make pictures out of my memories.

When I start one of my pictures, I just think about how things looked then, all the different details about the scene. This picture is called "Waiting for the Stork." It's the night before Carol, the last baby, came. See the seven little pictures in their frames above the

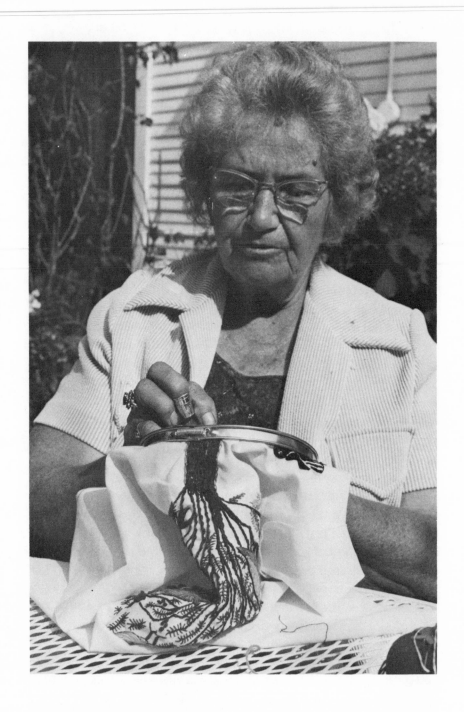

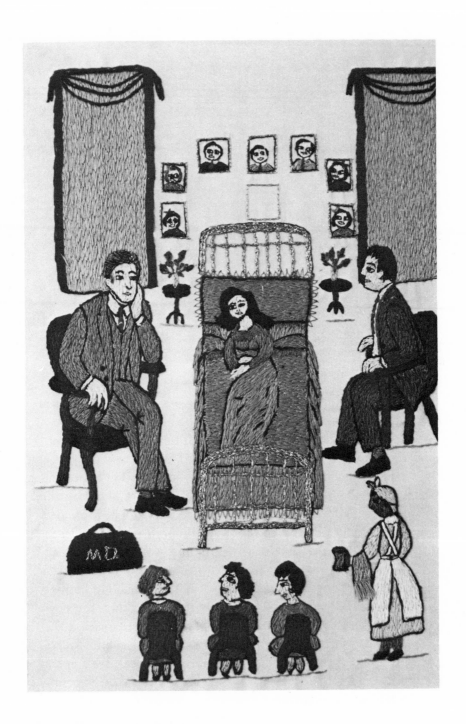

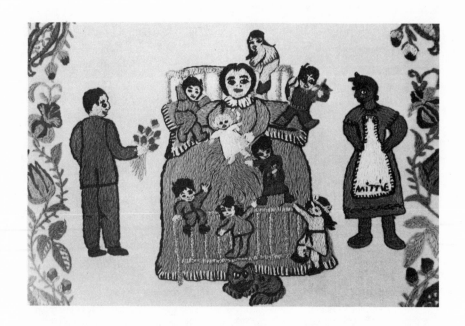

bed? There is a blank space where the baby's picture is going to be. And there's the doctor, and the midwife—we had all the babies at home then, not at the hospital—and all the neighbors that have come in to sit with me. And over here Mittie is telling the other children, "Before day, the stork is going to bring a new baby . . . it may be a boy, and it may be a girl." Everybody is all in hopes and so excited. The whole house was. And then down here in the nursery is Buddy, my baby boy. He wouldn't leave the baby bed. He hadn't been sleeping in that baby bed for over a month, ever since I had gotten it ready for the new baby. But he just wouldn't get out and go to his own bed. I wanted him to go to sleep, you know. But he was wide awake, and he wouldn't get out of that bed. He kept saying, "I want to be in the baby bed when the stork brings the new baby. He's going to put the baby in here, and I'll get to see it first—maybe before Mama does." But he went to sleep of course, and missed the stork. And that's the truth, you know. Well, it was real funny. I just thought that was the cutest thing. And of course I never forgot it. So that's where I got the idea for this picture.

Here's my picture of Carol, "The New Baby." We named her

Carol because she was born on Christmas. I'm holding her out on the bed, on exhibition. It's the day after she was born. All of them are glad to see her. And Dad is standing there just thrilled to death. He loved children. Carol had just had her bath, and she was in a little white dress, and everybody except Mittie thinks she is so pretty—the most beautiful baby in the world. Mittie is so disgusted that she won't even hardly look at the new baby. She had told me, "I don't want to see her. I'm not going to have a thing to do with that baby. I'm through with children. I've raised enough children as it is." Mittie had been with us for more than twenty years and she took care of all my children while I was at the store. But she died when Carol was six years old. So I could just see this picture in my mind, you know. And I tried to put it all down, every little detail I could remember about it.

And here's Mittie again. It was a rainy day, and it looked like we were going to have a real bad storm. So I hurried home from the store to be with the children. And when I got home, we were all just scared to death that we'd all be blown away any minute. The wind was really blowing, hail was coming down, and everything. So I looked around, and I suddenly realized that every child I had was on Mittie's lap, except for one that was on my lap. So I said, "Don't you children want to be on Mama's lap, now?" They all said no, and huddled closer to Mittie, even the dog! So I said to myself, "Oh, my goodness, how wrong I am to have a nurse to help me to raise my own children. What an eye-opener this is! Here we are going to be blown away by the storm, and all my children love Mittie better than they do me." But it didn't turn out that way, you know. I guess I was just a little jealous of her, like a young mother would be. But of course I didn't even think of letting her go, I needed her so.

This picture is called "Family Night at the Movies." That was the Crescent Theater in Belzoni. And on the front row there—me on one end and my husband on the other—are all the children lined up between us. It was during the Depression days, and the whole family could go for the price of two tickets. So that was a big night out for us, you know. That was an enchanted time.

My husband used to come home from the store, and after supper, just before bedtime, he'd tell the children the most beautiful

stories. Every night it was something different—"The Girl with the Iron Hand," stories like "The Magic Horse," and "The Man in the Net" from *The Arabian Nights*,[2] and many others that he just made up. He told one story, I call it "The Late Lunch." It's about a man in Lebanon who used to step out on his wife, you know. This one day he and his wife had been picking grapes. The weather was beautiful and cool, and they had been making good progress. So at lunchtime he told her to hurry home and boil some eggs for them to eat, and then come back and they'd finish picking the grapes. But she stayed, and stayed, and stayed away. When she finally came back he asked her, "Why did you take so long with those eggs? It shouldn't take that long just to boil eggs." So she said, "Well, I had to dye them like Easter eggs, and make them look pretty so they would taste good to you." And he said, "Woman, you're so silly. Don't you know that a plain egg tastes just the same as a fancy egg?" So she told him, "Well, why do you step out with the pretty women? Is it because I'm so plain?" He told her then, "Well, you are wise. You've got more sense than all those pretty women, so I'm not going to do it anymore." And all the children would crowd on him like that and listen to his stories. He was a good father, and they all loved him so.

My husband used to tell a story about the man who was dying, and told his oldest son to bring him eight sticks. This old man had eight children, like we did. So he said to his oldest son, "If a family sticks together, they can never break." So my husband would tell this to the children, and he'd take eight sticks, and show them how one stick would break easily, but nobody could break the eight sticks if they were together.

I'd feel kind of lost without my pictures. They're like having my children around me. I think of them like children, in a way. You know, I didn't really realize my children had all left me until Carol was already married and gone. She was the baby. My husband was alive then, and I actually looked at him one time and said, "Do you know, I feel almost ashamed. We've never been by ourselves before, and I'm afraid folks will talk about us!" Anyway, I felt real lost when Carol left home. I felt so alone and heartbroken, I didn't know what to do. So I said to myself, "I think I'll lock her bedroom

up, seal it off, never go in it again, and just forget them all." Of course I didn't do that, but I did have that horrible thought. That was perfectly silly, but at first I had the awfulest feeling. But you really don't want your children to stay at home with you for always. You want them all to be happily married, and out on their own.

But I do like them to come and visit. That's the reason I keep this house. There's plenty of room, and it's always ready, so they can come home and stay as long as they want to with their children, my grandchildren. I love to have the house full of children. I guess I'm the happiest when they're all with me. If the children are all around me, I know they are all safe and sound. I like the whole family to be here, especially on Christmas, Easter, and the other holidays.

Up in my attic I have the children's little scrapbooks, love letters, report cards, drawings they did when they were little, their games and toys, and all things like that. My grandchildren call all that stuff "Big Mama's Treasures." That's what my grandchildren call me, "Big Mama." They really love to go up there and look around. There are so many old things. It is a fun place, it really brings back memories. It's kind of dreamy. Looking at their toys and things, I remember so many things that happened when they were little. I think back through the years when they went to school. I don't know, I just enjoy being up there sometimes. I don't want to sound silly and like I'm half nutty or anything, but really the attic is a world of enchantment to me. Sometimes when I think of something, or maybe I just want to go up there, I remember what an enchanted place that attic is. I see their toys, and I can almost see the children at play again. So I stay there a little while, you know, and I enjoy that kind of like it was a special fairyland.

It's really just a figure of speech, you know, but sometimes I feel in a way like I live in three different worlds. I have my attic world, my store world, and my world of travel—you know, when I take trips and go to festivals and places. And I think that's good for you, to be able to move into another place and feel that you are in a different atmosphere altogether. And then I would say that I have my world at home, my embroidery world here downstairs. My house is a completely new world, and very different from the store

and the world of people. Here I forget about my problems, and just live a very quiet kind of life.

When I work on my pictures, I think I'm sort of another person. I think and I feel differently then. This is more of a private world all my own. Oh, it's not *really* private; it belongs to the children too. But it *is* another world. With my embroidery, it's peaceful and quiet, and that's another world in itself.

Listen, as I pull the needle through the material, it makes music. I think that's the reason I'm so enchanted with it, it's a very quiet, but beautiful sound. It sounds like birds singing, don't you think? Maybe that's the reason I like so much to embroider all my birds and animals and things.

If I didn't have a hobby like needlework, I just wouldn't know what to do with myself. Of course in the daytime the store keeps me busy, but when I get home at night, that's when I need something to do. That's when I do most of my pictures—alone here at home in the evenings. Usually I listen to the TV while I work, and I'll look up every now and then to see what's going on. And I laugh a lot. If I see something silly, or make a funny picture, I laugh. Sometimes I think if people could see me, they'd think I was crazy.

I don't like to go out very much at night. I'd rather stay at home. After I've been in the store all day, seeing people, I kind of need to be by myself at night, you know. I need some time to myself. So when I get home at night is when I do my embroidery. You know you can't think of yourself when you're embroidering, you have to think of what you're making. You just don't have time to be lonesome.

You know, they say that each of the people in my pictures have their own individual expressions. But I don't mean to do that; they just come out that way. As I'm making the pictures of the people, I feel very near that person. I have that particular family, that special person, in mind. I get right into the mood of the people in the picture so that I really feel like I'm there with them. And I feel nearer to them that way. So that's why it's just wonderful for me to be doing this. It's like painting, I think. It's sort of like you put your feeling on material, you know. You kind of make a picture of the way you feel, in a way, something like that. I guess I just hope that people will think of my pictures as showing love, friendship, and happy moments. I think this kind of handwork is a beautiful thing to do, and I wish everyone could do something like this.

When I was a little girl, maybe eight or ten years old, if I was being noisy Mama would say, "Now here's a needle and thread. Come sit down and be quiet and sew a little bit." So I'd maybe work on a quilt block, a pin-cushion, or something that Mama was working on. I learned to crochet and I learned the very simple little stitches, like the chain stitch, that way. Or she'd say, "Let's embroider a picture of our little calf," or "Come and make a picture of our little dog." And sometimes I'd stitch a picture of myself, or make some flowers on a pillowslip or something. Even as a little girl I loved the thought of pretty embroidery.

Then later on I thought I would try painting. I wanted to do something to express my feelings. So I bought myself some brushes and paints and things and I would try to paint my memories, you know. I used to paint until I got sleepy. I'd have all my paints and things laying out on a card table, and I didn't want to have to put everything away every night. And the children would come in and use my paints, and leave the tops off, and everything. So I said to

myself, "I have too many children. I just can't paint. That's all there is to it. I'll just have to paint with a needle and thread." So that's what I did. And it was better for me to embroider. I really enjoy it more. For some reason, there is a greater pleasure for me in stitching my little pictures.

My husband and I went to Lebanon in 1947 to visit his people. We went over on an Egyptian ship that went straight from New York to Beirut without stopping. And it was just great. When I got on that ship and saw they all had these Egyptian costumes on, I thought I had stepped right into *The Arabian Nights*. They were wearing little embroidered suits and hats, and just about all they said to me was, "Will you sit down, Madame?" I thought it was just marvelous. It was just perfectly wonderful.

We stayed over there six months. And I saw some of the needlework they do there in the old country. When I got ready to come home they gave me some patterns of birds and flowers and things. I think they use them for pillow covers or something. They gave me a lot of things to bring back. And I think maybe that did inspire me to do some of this type of work, because I hadn't really seen anything quite like that before, you know.

I did a picture I call "The Third Crusade." I picked up *National Geographic* magazine one day. It was an old one; it had been around quite a while. And there was a picture of this beautiful tapestry of the Norman Conquest. I thought that was the most beautiful thing I had ever laid my eyes on. So I got my encyclopedia down, and I looked up the Bayeux Tapestry,[3] and I found out that Queen Matilde was supposed to have embroidered it. So I said, "Well, if Matilde could do that, I believe I can too." But I decided to change mine a little. I decided to call mine "The Third Crusade."

When my husband was sick, I thought he would enjoy the little scenes from *The Arabian Nights* since he was from Lebanon. So I made some sheets and pillowcases for his bed. On the sheet, where you'd turn it back over the blanket, I made a real old design—little flowers and birds—from a pattern they gave me when I went to the old country. And every day I'd change the pillowcases, so he would have a different scene to look at. I don't know that Hassan ever did say what he thought about it. I do remember once I made a picture

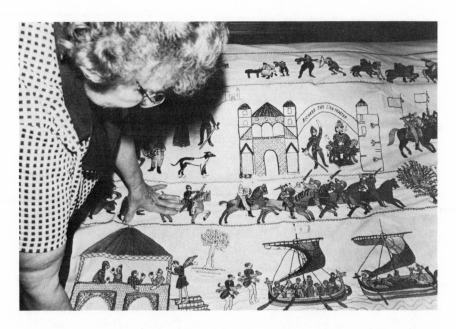

of an apricot tree with a thousand blackbirds—a bird for every apricot—and when I finished that he laughed about it. He liked that, I think.

I started to do embroidery by patterns. I think that's a good way to begin—to learn to hold the needle and handle the thread, you know. Then you can branch out on your own. But I really started making my needlework pictures after my husband passed away, that was in 1965. At night when I'd get home from the store I would embroider something just to pass the time, you know. I used to look at little pictures, and say, "Oh, that'd look pretty in thread. I believe I'll just draw that off right quick and do it." You know how you'll be flipping through a magazine, and see a little picture you think is cute. I think one of the first ones I did was of this Chinese painting that I had. I don't even know that artist that did it. But I thought that was pretty much fun, you know. Like my name, one night I just saw some beautiful colors around a name in the *TV Guide*. I had finished what I was doing, so I just made my name like that.

Or I used to grab a pillowslip off the shelf at the store, and bring it home and start stitching a picture on it. I wouldn't embroider any two alike. I'd make a different picture on each one. And I'd get so carried away that I would sit up half the night working on my pictures. I was thrilled to death. But, like I always said, how many pillowslips can you make? You kind of get tired of doing the same thing. So then I began to cut out squares of cloth and make little pictures, more like paintings, I guess. And I began to want to add things onto the picture I was copying. I wanted to add something of my own to it. That's the way I usually work now, I keep thinking of things and adding them as I work. When you do a picture that's your own, it takes a good while to draw it out and lay it out on the material. But if you don't have anything to do and you want to do something quick, just look at a picture, and you can whip it up right quick. So I think "The New Baby" was the first picture of my own that I made. And it was so much fun that I began then to go out on my own, drawing my own little pictures of things that had happened that were real interesting.

Most of my pictures take maybe a week or two for me to make,

according to how many little details I put into them. But now something like I made for the Smithsonian Institution,[4] it took me four months to make that. I work on one area at a time. I'll get that finished, then maybe I'll work on the other end, you know, to see how it's going to balance out. First I draw it out on paper and get my pattern down. You have to do that, because you have to erase a lot until it's really straight. I use a ruler for this. But that's really just a basic outline. Everything else I add with thread as I embroider. I think of things as I go along. I have fun planning the next step—adding on and seeing what the people in the picture will do next.

Usually I crowd my pictures too full. But I'm always sorry that I don't have room for something else. So you just have your line there that you've drawn, and you take your chain stitch and fill it in, you know. To cover a spot, it's the best filler in the world. I don't do too many different stitches. I use the French knot, the chain stitch, the blanket stitch, the running stitch—they're just the very simple and basic stitches. I don't use too many fancy stitches. Really, if you know how to do the chain stitch, you know it all. That's the whole secret. It's like crocheting; there is really just one stitch. The chain stitch, you can just turn it into so many things. See, to make the chain stitch, you just make a long loop over the needle, and pull it. You've got to be very careful and get all your threads level, but it's very, very simple.

I like to use a crewel needle because they have large eyes. I put a long thread in my needle, so then I don't have to thread it all the time. But that's not always a good idea for beginners, though. See, your thread makes a knot unless you know just how to handle it. And if I want a tree to look heavy, for example, and stand out, I'll use six strings [strands] of thread. But my little birds, I'll probably make them out of three strings so they won't look quite so heavy. Or like I'll use one strand of red for the mouth, or for a little blue around the eyes. I never worry about my colors. I just pick up any thread that's handy out of my big sack of thread. I really don't worry about it because they all look pretty together. You arrange it so that everything blends together. Like my birds—they're funny colors. You never see a bird that color, do you? But that one is that color. And it looks all right. For your backgrounds, it's kind of hard

to find just the material you want—like a certain kind of blue for your sky. For a background where I want it to look like something is growing, I usually try to get a small little print fabric.

Nearly always when I start one picture I'll think of something else. Usually there are a thousand things I want to do. So I'll get up and start another one. Sometimes I have five or six pictures started at one time. That way I don't forget my idea before I can get on to the next picture. I'm usually so excited when I think of a new little picture. I always want to get on to it as soon as I can and I hate to put it down. So that's why it doesn't take me long to get through with something. Each one is just a thrill all in itself, just a pleasure. And you know you're happy if something exciting happens. It's something you really like to do, you know, and you want to do it every minute of your life.

I think so much in my pictures is from imagination. I think that might be the reason my birds are different colors, not like they actually are, because my pictures are a sort of fairyland. It's a world of enchantment. You know, sometimes I just want to make a bird that's pink and blue. But you never ever see a bird that's pink and blue. And like that bluebird that I made on one of my pictures. His legs are too long, but I'm not going to take the stitches out and change him. He was just born with long legs!

Sometimes I like to put, well, different things in my pictures. My "Arts in Mississippi" picture had a deer up in a tree. I started not to put it up there, and then I said, "No, I think he'd look cute up there." So I went ahead and stuck that little deer up in that tree. And one night I made a little quilted tree that I thought turned out real pretty. But I wanted to put something under it. So I thought about a poem that I learned in school when I was a little girl:

> In the nighttime, at the right time, so I've understood,
> 'Tis the habit of Sir Rabbit to dance in the wood.[5]

And I remembered that poem and thought it was just great. So I put little dancing rabbits under that tree.

When I was little I used to wish I could go home with the rabbits, and maybe spend the night with them. I always wanted to see what it is that they do. And I remember we used to have a cedar

tree close to our house, and the chickens used to roost up in that tree. They would just talk and make funny noises, and I used to wish I could understand what they were saying. I bet they had a lot to say to each other, talking about what went on during the day. I wanted to crawl up in that tree with the chickens and be a chicken for one night. Their world fascinated me, you know. And I guess I like bugs as well as I do animals. I think they're all wonderful. I mean, I think God loves little bugs and little frogs and things just as well as He loves us.

You know one time I thought it would be a good idea to get a little pig, because we had so many scraps and things from the table. So we got a pig, and we named him Albert. We fed him all the food scraps, and he grew big and fat. And then the day came when a man came in to butcher our little pig. And Mittie cooked it. So, my little daughter Sunshine said, "Mama, do you think that Albert knows that we're having him for lunch?" I said that I didn't know. We were all sitting around the dining room table. And everybody put their fork down. Nobody tasted a bite of that pig. Nobody could eat him, we loved him so. And that was the only pig we ever had as a pet. They say that some of the animals in my pictures look almost human, like they have human faces. But I never notice that until I finish them, and I just don't ever go back and do them over.

There's something special about artists, I think. I feel more at ease around artists than around other people. I like people that do things with their hands, I guess. I think keeping your hands busy keeps you relaxed. And artists are doing what they love to do. I know they are happy. I know how they feel. They know how to express themselves. And I think they get more joy out of living than other people. I think art helps people understand each other— there's something special about artists, more that you understand about that person.

This is the picture I did for the Smithsonian Institution [1974 Festival of American Folklife][6] up at the festival in Washington, D.C. When I was up there I loved all the people from Mississippi—every one of them. My heart went out to everyone— the blind broom maker, Sam Chatmon,[7] Ray Lum,[8] the Leake County String Band,[9] the basketweaver, the spinners, the quilters,

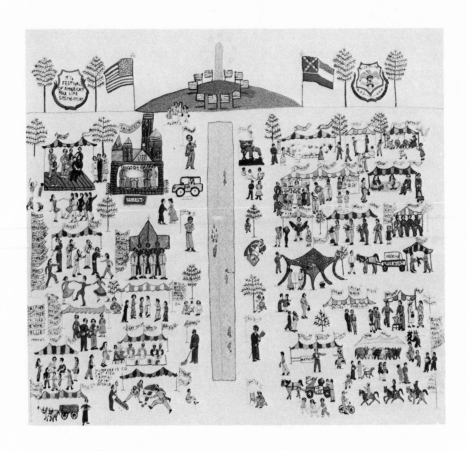

the dancers, and all the people. Everybody who took part is in my picture. All of that was Mississippi. It was every bit Mississippi. I think that was just wonderful what they did to bring everybody all together like that. And, you know, now there's a feeling among everyone that will always be there. That drew us closer together and made us proud of Mississippi, you know. Those people I was in the festival with just have a special place to me. I think it did a lot for us. We already knew what we were doing, but it made us feel like we were important, that we were a special group. And I'm really proud of that. It impressed me a lot. And I could have stayed forever with all those people, I just loved them.

You know, I think that there's a lot of wonderful things—really truly wonderful things—in Mississippi that are just handed down

from mother to daughter, and never studied in books or anything. A lot of women say, "I want to do like my mother did in this." Not better than my mother, but "I want to do like my mother did." Like making quilts, often a woman will say, "I want to do just like Mama did." And that's the real artist, isn't it, to bring that down from one generation to another?

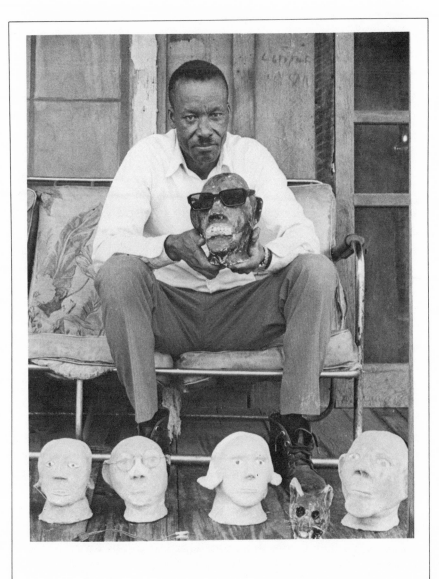

James "Son Ford" Thomas
Sculptor | Leland, Mississippi | Born 1926

Reprinted from: William Ferris, ed.,
Afro-American Folk Arts and Crafts.
Boston: G. K. Hall, Inc., 1982.

I WAS BORN in Yazoo County, Mississippi, in 1926. When I was small, I went to Memphis once, but I can't hardly remember nothing about it now. All I can remember is I saw a streetcar, and I remember a big old clock my auntie[1] had. That's all I can remember about Memphis. I was real small. After I got grown, I didn't go much further than Alabama, and right around here in Mississippi. Well, November 27, 1944, I went to Camp Sheridan, but I didn't pass for the Army. I don't know what was wrong with me, but they just wouldn't take me. Well, I went there twice. I went there again in 1951, I believe.

I had two brothers and a sister, but we wasn't raised up together. I lived with my grandmother and granddaddy. They raised me. My mother . . . I never did live with my mother. I wouldn't live with her because she seemed like she was mean. My grandmother raised me. My mother, she gave me to my grandmother and I stayed with her until I got grown. My mother lived in Leland, but we lived in the hills over at Eden, south of Yazoo City. You know, Eden is a tough place . . . toughest I've ever lived. When I was a boy, me and my granddaddy made his crop together. We didn't get but about six dollars a month apiece. That was to buy groceries; we didn't have rent to pay. He'd wind up with some change every month, and every month I'd come out a dollar or two behind. He'd ask me, say, "How much money you got?" I'd say, "I ain't got nothing, I owe the store two dollars." So he'd give me the couple of dollars he had left. And when work time started the bossman[2] come around in the morning about eight o'clock. We'd all be out there in the field hoeing, and when he'd leave and go into town we'd slip off and go fishing.

I could sort of have my way with my grandmother. With my grandmother, if I didn't want to go to school, she wouldn't make me. I could go fishing or hunting or do like I wanted to. I didn't like to go to school too well after I got a good start, and with her I could play sick. She'd put her hand up there on my head and say, "That boy got hot fever. I ain't going to let him go to that school and fall down." I'd be feeling good. But I'd get back in the bed and I'd grunt around there till school time was over with. Then grand-daddy'd get his fishing pole and get ready to go fishing. I'd jump up out of bed and say, "I feel a whole lot better now." We used to have a time.

Most of the time when I was young, I never did fool with no boys or nothing. I mostly played by myself. I never did play with too many children. Well, I had one friend or two that I played with—we'd go out and shoot BB guns, or go swimming or hunting or fishing over on the Yazoo River, things like that. But I never did fool with too many boys because I was always busy. Just anything would run across my mind, I'd do it. I was always around the house making fish nets, or molding clay, or something.

And I used to listen to the Grand Ole Opry a long time ago, before television come out. We tuned the radio in every Saturday night, me and my granddaddy would. We wouldn't go nowhere, we'd just sit there and listen at the Grand Ole Opry. I believe we tuned in to Cincinnati, too.

A long time ago all we had to play records on was those graphophones because we didn't have no electric [electricity] and there wasn't no big albums like you got now, you know. They was the biggest records you could get. Records was all the same then. I remember friends would come by to listen to our graphophone, and we'd stay up all night long listening to that thing. My granddaddy, he was kind of scared of it when it first come out, you know. He was scared to play it. He'd say, "You play that thing in the house, and it'll start telling the bossman what's going on." He'd holler to me, "Cut that damn thing out, or the bossman will come!"

Weekends I played guitar. Well, my granddaddy, Eddie Collins, was a musician too. He played guitar, and my grandmother, she could play piano. I remember my granddaddy used to play that song

135

"Little Red Shoes"[3] for white people at dances. He's dead now, but that's where he got that from. He died in 1957. He couldn't play like we do today. He played old records further back than we can go. He played them old-time blues. You know, he used to keep a gang around the house all the time. He'd play guitar and tell funny jokes, and it'd be just like we was selling whiskey, there'd be so many people there.

But my uncle learned me how to play guitar when I was eight or nine. He put marks on there and that started me off. After I learned how to make a couple of chords, why I could beat him. And then he started charging me fifty cents or a dollar to play his guitar. He wouldn't let me play his guitar lessen [unless] I paid him back. Sure did me that away. I wasn't able to buy one then because I never could make enough money. So when he'd go to work, his wife would let me play his guitar. I'd play until noon. Then when he'd come in I'd quit, and I'd start back playing again at one o'clock. He didn't know anything about it, but I learned to play real good that way. Then I got able enough to buy me one. And after I bought me an electric guitar my uncle didn't have one, and he had to borrow mine.

We was both playing in Yazoo City and the people always came down to where the loudest music was. So *his* cafe closed up. He just had a little old small guitar, see. So he came down to where I was playing, asking me if I needed any help. I said, "No, I got it made." Oh, I had so many peoples in there I had to get up on the counter and play.

The first guitar I owned was in 1942. I picked enough cotton to pay for that. I decided to go up to Cairo [Illinois] and spend a little while with my mother who was living up there, and I ordered me a guitar out of Sears and Roebuck . . . a Gene Autrey guitar . . . it was eight dollars and fifty cents. After I got my guitar I wouldn't pick no more cotton. That was it. I wouldn't work no more, so my mother she gave me my fare and she sent me back home [to his grandmother's] again. She hollered at me all night long, "If you don't want to pick cotton, you can work at the sawmill." So I said, "I'm going back home to my mama." She told me *she* was my mama. Then I told her she gave me away and kept the other children, and

136

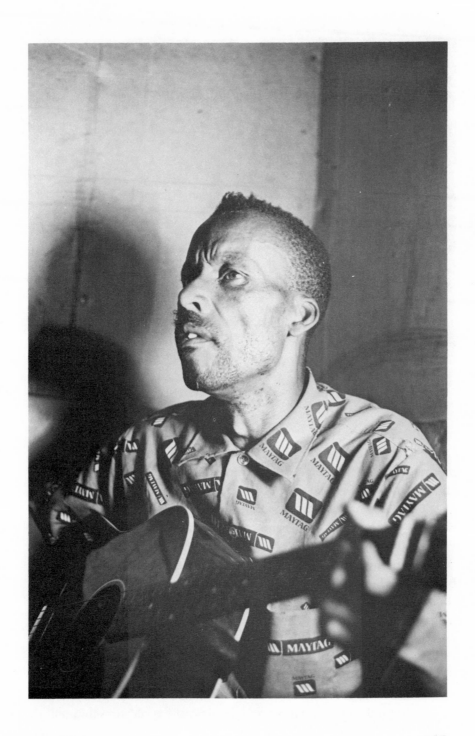

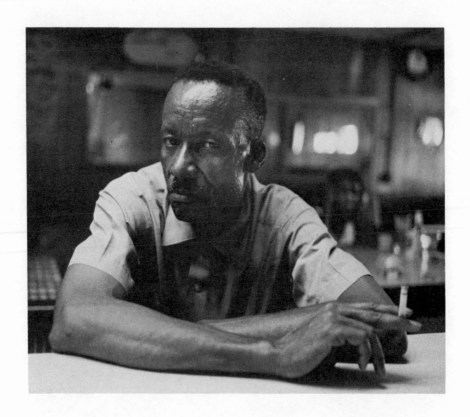

that made her mad. But I always wanted to stay at my grand-
mother's. That's how I learned to play the guitar. My uncle played,
and my granddaddy played too.

The blues has been out so long, you know, you can't hardly tell
where it started at all. My granddaddy, he was about seventy-five
years old when he died, and I used to hear him talk about the blues.
Well, there must have been blues before his time, because there was
blues when he was a boy. You can't never tell about that. I think
there always was the blues. They come from the country, I believe.
You take a long time ago, you see, you'd catch fellows out in the
field plowing a mule. You'd hear them way down in the field late in
the evening . . . you'd hear them singing the blues. That's why I
say blues come from the country.

When I heard some of them old songs, I was a young boy, see.
I'd slip around to those dances and I'd hear them old-time blues.

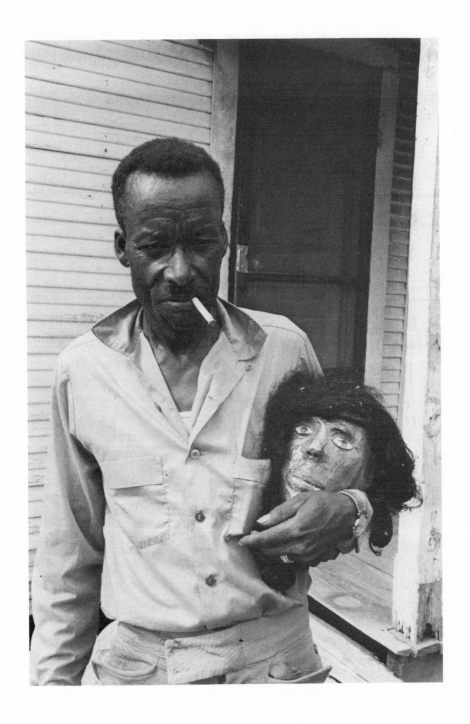

They'd [there would] be house parties back in the hills, out in the country. That's what you call juke[4] houses. Those are them old raggedy houses way back out in the country. We didn't have but one night to have a good time, see, so we'd stay up all Saturday night and try to get some rest on Sunday. All in the late hours of the night you could hear those guitars. You could hear them for three miles either way. And if you be quiet, you could hear them sing and everything.[5]

We danced the Slow Drag, you know, that's the old style. There's a lot of dances in Mississippi. But most of them they don't want to swing out—that's when the one you dancing with be way over yonder and you be way over here. And they used to do the Cakewalk, but now if you come down to a Saturday-night dance, they just want the Slow Drag.[6] And, you know, every time a man's back is turned to his girlfriend or wife, he's whistling at another woman. All right, I'm going to ask you this now. Just like you eat eggs and bacon in the morning for breakfast. Would you want that every morning and every night? Nothing else but eggs and bacon every morning, and dinner time come around, serve the same thing? Well, that's the way this love goes. You get tired of the same woman all the time. You want to change up. You'll be walking down the street and say, "She sure look good." There you go. Everybody can get that on their mind. You can marry and love your wife, but you're going to see somebody out there on that street, and go, "Ooowee . . ." That's the way it does down in Mississippi.

You know, the blues is nothing but the devil. You couldn't go to church and sing a blues song. You wouldn't do that. But a spiritual song, well, you wouldn't mind playing that in church. I go to church all the time. Well, I take that back. I go to church all the time but I don't belong to a church. I don't belong to no church because I haven't made up my mind to join a church. It's just like if you went to that store over there and they said, "You want a Coca-Cola?" You say, "No, I don't believe I want any." See, you ain't *ready* for that Coca-Cola. You ain't thirsty, you just ain't ready. But when you make up your mind to do something, then you go ahead and do it. But if you ain't got your mind made up, nobody can force you into it. I always say that when I decide to join a

140

church, I'll lay all them blues aside. I'd probably quit playing the guitar, period. I always say that if I ever join the church, I'm going to let all that go.

You can't carry both of it on. Saturday night you can't go over to Greenville and play the blues at a nightclub over there, then come Sunday morning call yourself a church member. I'd be afraid to do that because something bad can happen to you. Because if you play spirituals and you used to play the blues, the next thing you know the devil gets in you and you're going to start right back playing the blues. That's what you call going too far wrong. You can't serve the Lord and the devil too. You can only serve one at a time.

And you can't always go by what them preachers say, because right now some of them drink more whiskey than me. Some of them preachers ain't living for nothing but money and some chicken and a nice-looking woman. That's all they're living for. So you can't go by them. You have to go by what you believe. You have a feeling, you know, when you're right.

Women is what give me the blues. Woman tell you, say, "I love you," and all that and you go and find out she in love with somebody else. Well you can't have nothing but the blues.

I get a feeling out of the blues. That may be because I been worried a lot. See, my first wife quit me and I had the blues ever since then. Any time you get lonesome, you want to hear some blues. That's the way I feel. Like that record come out, "Baby, Please Don't Go."[7] That's just like you got a wife and she packed up and is getting ready to go. That's how blues started. It ain't very many blues that ain't made up about a woman. There's a few, but most of them is "My baby this" or "My baby that." Something like "Little Honey Bee."[8] You ever heard that record?

> Sail on, sail on my little honey bee, sail on.
> You going to keep on sailing till you lose your happy home.

That's one of Muddy Waters' recordings. In other words, he wasn't actually talking about a bee. He was talking about a woman, but he called her "my little honey bee." Mighty near every record where they sing the blues is made up about a woman. That's what your

mind is on . . . your woman. She's giving you the blues. You get worried over something, what you call a deep study . . . that's the blues. Like you'll be thinking way back about how some woman intrigued you, or something like that. You want her and she don't want you. That's what the blues is made up about.

Some of my songs, you know, are just made-up[9] tunes. I couldn't necessarily go back over them again because they're make-ups. Well, I maybe could sing some of them again, but they would be a little different. They're right-now songs. That's like when you make up a story or something. Just like if somebody mistreats you, you can make up a recording [song] about them. You sing, like:

> You mistreat me now,
> But you can't when I go home . . .

That's the starting of a song and from there on you can put in anything else you want. But first you give them the title of the song. Like if you wanted to make up a song about me. Well, you just think up a verse and go from there. From then on you can just skip around and do what you want to do. You get you some more verses and put them together and mix them all up. I can make you one up right now . . .

> Beefsteak when I'm hungry, whiskey when I'm dry,
> Beefsteak when I'm hungry, whiskey when I'm dry,
> Good-looking woman while I'm living, heaven when I die . . .[10]

See, that has never been recorded. I just made that up myself out of my head. But being there's so many records out, I don't care what verse you pick out, it will be something out of somebody's record. They've just about done run out of verses. So you get all your verses together. You just sit down and they'll come to you. Sometimes I try to make new songs up, because you got to try to get some of these new verses going or else you can't get to play at these clubs. Just like you hear a record on the radio, well, you try to learn some of the verses in that. See, you got to let them know what you're trying to do even if you don't get it direct [exact]. Nobody's going to get it direct—*just* like another man plays it. But you can play close

enough for them to know who you're playing after. You get some of their style mixed up with some of yours.

Back where I lived in Yazoo County they wouldn't hardly know who you was talking about if you'd go over there and ask for James Henry Thomas. But if you say "Son Ford"[11] they would know because they give me that name when I was going to school. I used to make little Ford tractors out of clay. I'd put me some sticks through there [as axles] and make me some wheels and let it dry and then I'd have something to roll across the floor. That was back in 1937 when they first started calling me "Thirty-seven Ford," and then they started calling me just regular "Ford" from then on. So I said if I ever record records, I'd have it put in, "Sonny Ford." That's so all my friends would know who I was.

This [his sculpture] is all done by head, not by no book or no picture. I have never went to school to do this. No teacher has ever taught me nothing about it. My Uncle Joe was the first person that showed me. He started me off molding. But he never did make nothing but little mules and stuff like that. If my uncle had kept on he probably could do as good as me. But now I doubt whether he could make anything. He didn't know what there was to it. After he quit, then I taken that trade up. I tried the same thing that he tried and I done pretty good on it, so I took it over. It wasn't too hard to me to catch on. I just kept on trying until I got perfect on it. A lot of days I would be by myself and I'd walk two or three miles to get me some clay and I'd come back home and sit up by the fireplace at night and make things until I got sleepy. I got where I could make mules, and rabbits, and squirrels, and things like that, and from that I went to making birds. See, this is a quail I made here. In Mississippi the white people didn't want the colored people to eat no quail. See, they had more meat than other birds . . . better meat. So I don't care if you had a license for hunting, you couldn't kill no quail and let it be known. You could kill blackbirds, but if you killed a quail, it was just like you done shot somebody. Well, I got better and better all the time on molding. The more you make, the more it'll come to you what to do with anything.

That was when I was a little-bitty boy going to school—I'd say about six years old. That's how I got my school money. My grand-

mother and granddaddy would work a whole week for two dollars, so they wasn't able to buy none of that stuff for me. So I made this sculpturing to buy me crayons, pencils, paper, and all like that. I'd sell the things that looked good enough around the neighborhood where we lived at. And so after I got grown I liked to be doing it, and I just kept going.

The highest I ever sold when I was small, one day I sold some horses and I got three dollars for them. A fellow from Vicksburg was over at Eden and I had them horses in a box.

He said, "Where'd you get them little horses?"

I told him I made them.

He said, "I'll give you three dollars for them."

Well, that sounded big then, and I just handed him the whole box. So I would wind up making more than my grandmother and granddaddy and I was just sitting at the house sculpturing.

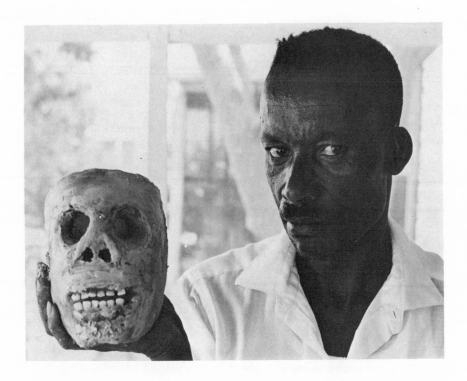

The first time I made a skull I was living with my grandpapa in
Yazoo County. I made a great big skeleton head and I had corn in
his mouth for teeth. I brought it in the house and set it up on the
shelf. We didn't have no electric lights then. My granddaddy was
scared of dead folks, and one night he had stayed up late. He came
in and lit him a match to light the lamp and, first thing, he looked in
the skeleton's face. Instead of pulling the globe off the lamp, he
jumped and dropped the globe and run into my room and told me,
said, "Boy, you get this thing out of my house and don't bring an-
other in here. I already can't rest at night for spooks now."

You don't never hardly hear nobody talking about being scared
of spirits now. They ain't got time to think of it. But a long time ago
there was a whole lot of people would talk of spooks. White people
would use the word ghosts. They say ghosts, and not spooks. I don't
know why there's the separation in that. But right now the average
person in Leland, if you go and talk with them they'll say, "Oh,

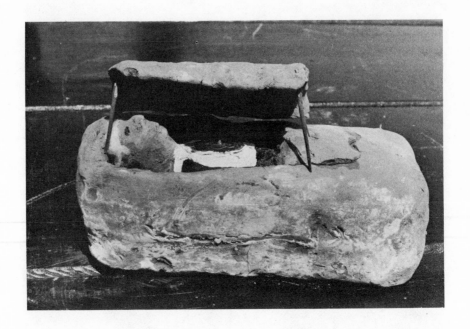

there ain't no such thing as a ghost." Some don't believe in them. But I believe in ghosts. Of course I work for a funeral home, but I don't never let night catch me out. I always get through before night, or either wait and finish the next day.

And a lot of colored people believe in what they call the hoodoo.[12] Most of the white people, they don't believe in hoodoo. But it *is* something. It's got to be. You can get sick—you don't have to be real sick—but your blood can get wrong and you can get that way where you'll lay down and see things. People that's low sick [deathly sick], they'll see things sometimes. When my stepdaddy died, he used to say, "Look at them dogs. Get them dogs out of here." Well, that's low sick. And I got that way once. I was small and my grandmother, she'd make me sleep on this cot that we'd got from some white people. I just couldn't rest on that cot. I'd see all kinds of men and little boys and everything coming up around that cot and hitting at me. And I heard my grandmother and them whispering and saying they believed I was going to die the way I was carrying on. So they finally got rid of that cot. And I didn't feel that way no more. I don't know what it was.

146

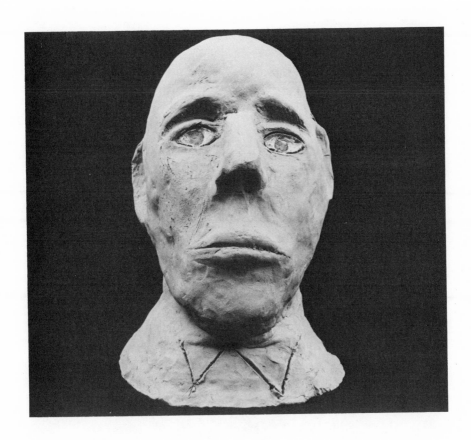

I moved to Leland from Eden in 1961. I've been here ever since. Before that I was a tractor driver for three or four years, well, longer than that, off and on. And I was always farming. After that I started working at the funeral home—working in the yard, mowing grass, and digging graves. I been opening and closing graves ever since 1961, and I always say that I got a cemetery of my own, I done dug so many graves. I used to help my stepdaddy dig graves and I got to where I liked to do it. My stepdaddy didn't have but one arm. And he used a three-foot shovel. I used to come out and help him. He'd tell me, "Son, I believe I can beat you digging." Even though I had two hands, it didn't make no difference. He always beat me. So he learned me how to do it, and after he died, I taken over the job. I never did do no easy work . . . and I thought digging graves was all right for me.

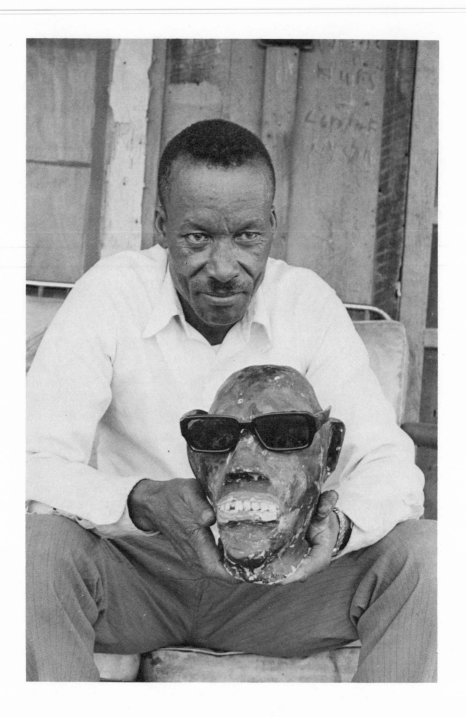

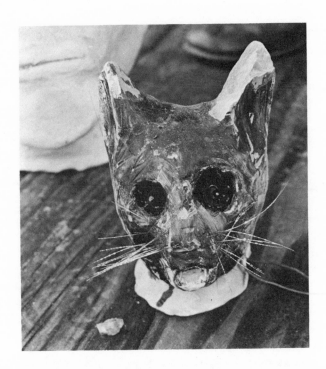

I make deers, rabbits, quails, fishes, skeleton heads, and solid heads. I make them out of gumbo clay. Some of it comes from the hills around the other side of Greenwood. It holds together just like the regular molding clay. I get some clay south of Leland, down at Black Bottom, too. The name of it really is black gumbo, but some people call it buckshot because it's so sticky it takes a buck to run through it. It *is* sticky. I've known places where people raised chickens, and come a rain those little baby chickens they'd get stuck in that clay. It'd be all balled up under their feet.

When it rains, I let the clay soak up the water. Sometimes I mix a little wax with it to help hold it together. It cracks open real bad if you work with it like it is. Then I put hair grease on there to smooth it down and get the wrinkles out of it. Like if I make something and I don't want to work on it any more until tomorrow, I put me some towels across there and wet the towels to keep it soft. But it don't dry out too fast. Then after I get it worked out, I put putty on it.

149

That's for if it happens to crack, that putty would still be holding and you couldn't see the crack, unlessen it got real bad.

Well, I started painting them a long time ago. If I was making it for myself, I'd just paint it the first color I'd get to. It wouldn't make me no difference. I'd use whatever I'd think would show up on there the best. You can paint them anytime. I wait until they're dry and then paint them. Like this mallard, you paint the bill yellow, and then you would put green on the head to make it show up. Or you could paint the head and the body white. That shows up good, too. I get different colors of paint at the ten-cent store. I have gold I spray on sometimes, and beige, and white, and black. Things that show up, you know. But when I first started, I couldn't get no paint. I would just let them dry. That hill clay, you could put it in the fireplace and bake it. In the wintertime, I'd make me a dog or something out of clay and I'd throw it in the fire and let it cook and turn red. Sometimes my granddaddy would go to put a stick of wood in there and I'd jerk it out real quick! He'd tell me, "Keep that mess out of that fireplace. I can't keep no wood in it." Well, that sculpture of mine would get just like a brick and it would rattle too, you know.

When I do my sculpturing work things just roll across my mind. Like I see a picture in a magazine or on television, and that's what I'll go by. Sometimes I may not get it direct [exact], but I make it as far as I can remember on it. I look at the picture to get the future of it better. The future . . . that means if I was going to make a man that looked just like you, that would recollect you. The futures come in dreams. The dreams just come to me. I lay down and dream about the sculpture, about how to fix one of the heads, things like that. I'm liable to dream anything. That gives you in your head what to do. Then you get up and try. If you can't hold it in your head, you can't do it in your hand.

I make a face first, then make me a skull. First I shape it up like a regular man's head. *Then* I cut it down to a skeleton head. That's the onliest way you can get a shape. The cause of me taking the top out of the head, that's for an ashtray. That's about the best ashtray you can have, because you can put a whole lot of stuff in there if you make it big enough. I take both thumbs at the same

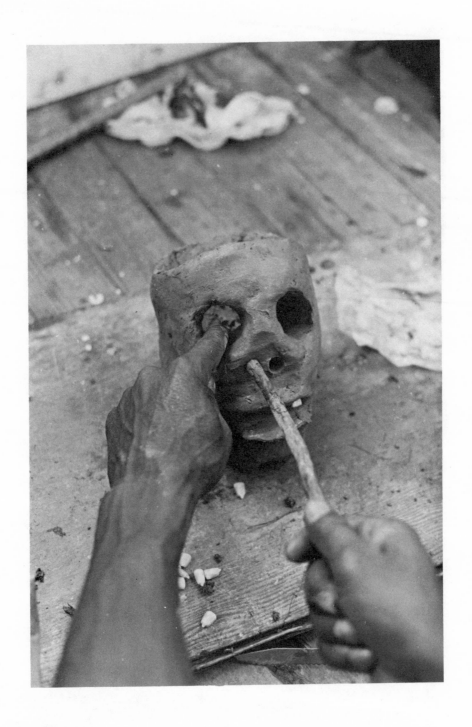

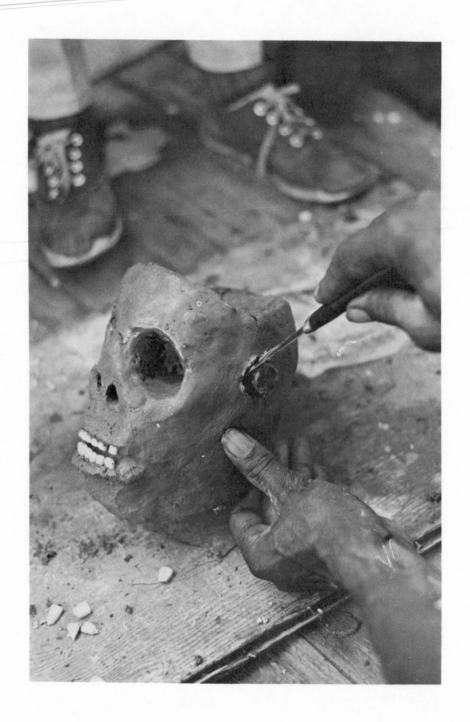

time and squeeze it in to make the eyes. I put marbles in there for eyes,[13] or like that duck, I put match heads in there for the eyes. That's in case you want to paint his eyes, so when it dries you can spot them. That way you'll know the direct place where you want them at. You can just take the matches out and paint the eyes in there. The eyes should be clear and plain, just like a picture you take with a camera. There is one thing I'd like to improve on and that's the eyes. You have to draw your eyes in there before you can get them lined up. Your eyes are on a level with your ears. They can't be a bit higher than your ears and they can't be no lower. They got to be the same level your ears is and that's why you don't have no trouble making glasses. If some people's eyes was down below their nose, they couldn't get no glasses to fit them. If I ever get the eyes just like I want to, I can make any kind of future.

So I go back to where I done mashed up there with the eyes, and that's automatic the nose. Then I build up on that. I cut the nose off then, to get the holes in the direct place. I use corn for teeth because I couldn't think of nothing else. You know the reason I started cutting that corn off? Because the first one I made, I noticed the teethes came out. They would move, you know. I checked on it then, that skull I had up there at Shelby's [Shelby "Papa Jazz" Brown],[14] and that corn was sprouting in there! That's where I decided the next one I made, I would cut that corn off to where it wouldn't sprout. Then I got another idea. If it keeps on sprouting, I decided I'd try painting them teeth in there. I'd paint them white and get me some clear varnish so they'd shine. That thought come to me not too long ago. I hadn't never given it a try yet. But I believe I could take something and cut some teeth in there. It might do a better job. I don't know.

A skull has got to be ugly because it's nothing but bones and teeth. People are more likely to be interested in something like that than they would be in a bird. They'd rather see a skull. Then too, a lot of people have never seen a real skull and they're probably wondering how it will be when they die. They say, "Will I be in the same shape that skull there is in?"[15]

When I get it worked out, I stand back and look at it, see, to see if I have it in shape. In working close, you can't hardly tell

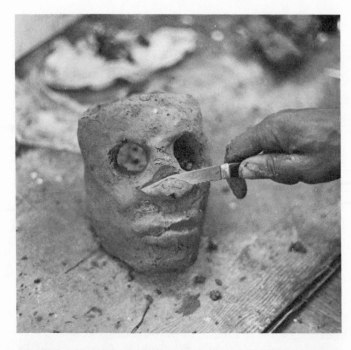

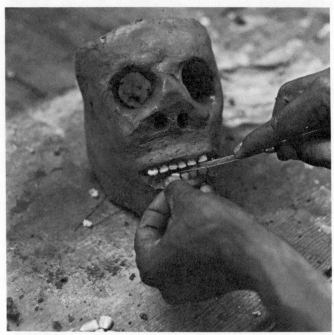

about how it looks. You have to get off from it and look and see
what shape you got it in. You have to see if you got it too large on
one side, or not large enough. Then you level it up. You stand off
from it to tell what you've done. It's got to be even on each
side, see.

I don't like to do my sculpturing all the time. It just hits me by
spells. A spell will hit me and sometimes I can make them for half a
day. Then I'll get tired of that and be wanting to go somewhere or
do something else. In the wintertime I'll be sitting up and not doing
nothing, so I'll just sculpture a while and then quit. I don't know
what I'd make if I'd just go steady at it all the time. But to do
this you got to have patience. You got to *feel* like doing it. You can
do a whole lot better when you don't try to make too many. You
just have to take your time.

If I could get to a mountain where they have this clay like I
use, I believe I could do me a whole man. I believe I could put a
whole statue of a man standing up in that mountain. If the clay
worked right, I could start at the head and come right down to the
feets. I believe I could work a statue as big as a man. I believe I
could make him just as tall as me or you if I could get the right
height dirt where I was going to work at. That's six foot high. Give
me plenty of room to pull it all together and just make it in the
bank and then put me some kind of paint on there and finish it up.
I haven't ever did it, but I believe I could do it.

Othar Turner

Cane Fife Maker | Senatobia, Mississippi |

Born 1908

Reprinted from: William Ferris, ed., *Afro-American Folk Arts and Crafts*. Boston: G. K. Hall, Inc., 1982. Portions of this interview were recorded by David Evans.

I WAS BORN the second day of June in 1908, east of Jackson in Canton, Mississippi. That's where I was born at. I was brought here in my mother's arms, a little-bitty suckling baby. And I've grown up here ever since I was big enough to walk. Free Springs is where I was raised at. As a running kid on the ground, that's where I was, right there. And I been around here for all my days, right in this community. I been right around from Free Springs Church, Water Valley, Oxford, Holly Springs, Chulahoma, Looxahoma, Senatobia, Thyatira, Como, and Sardis.

I was up to Muncie [Indiana], too, oh, for about nine months. That's this side of Chicago. Indianapolis, Memphis, Blytheville, Grenada, Batesville, and Jackson—I been in all them places. But otherwise I've been mostly around here. I worked on the railroad up there—laying steel, taking out cross ties, and spiking ties. They had tie spacers, to place the ties in the holes. They didn't have no songs, but they had, "Whoa, boy!," up and down. "Whoa, boy!," up and down. They used to say that. See, that's when you push out one tie and push another one in. When you push up, that's shoveling it out. When you push down, that's pulling a cross tie in. And I used to snake logs with just a pair of mules. On a log wagon, you had a mule in the back, and one in the front, that was the lead mule. That song, "Levee Camp Blues,"[1] I used to sing that all throughout the woods.

I ain't got too much schooling. But I learned another way. I been out on the farm a good while and raised six kids, and I don't know how many other people. I get on by it. I can dance, I can sing, ride horses, chop cotton and plow, whoop and holler, cut somersets, do all that stuff. I been on a farm all of my days. Right in this vicin-

ity here, it's all a colored settlement. That man up there at the store, he's just got a little place he bought right on the corner. But all the rest of it belongs to the colored. Now I got two acres and two-tenths of land. I bought it. Scurrying hard, my labor paid for it. That's right. I paid one thousand for the land, and a hundred-and-fifty dollars for the house. Paid three-hundred dollars to move the house. And I rent twelve acres and a half of cotton land.

I always did farming. Worked by the day. Plowing a mule, chopping cotton, driving two mules with the lines. I raise my own hogs, cows, chickens, corn, peas, sweet potatoes, tomatoes, okra, beans, turnip salad, and watermelons. And I kill my own meat. Sugar, flour, coffee, snuff, tobacco, and salt, that's what I have to buy from the store.

I have four head of stock—an iron-gray mare and a colt, a bay horse with white feet and a blaze on the face, and a red sow. And I have three head of cattle—one black-and-white-faced motley cow, a solid black cow, and a bull calf with a white tip in his tail and a star on his face. And I got one goat, two head of geese, about fifteen hens, and one rooster. I've got eight dogs and one cat, too. That cat

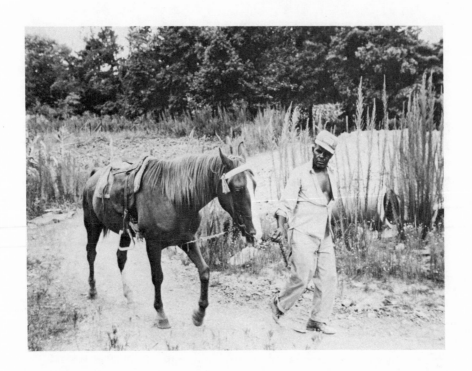

don't allow a mouse to walk across the floor. And when I'm out hunting, you know, I just blow my horn[2] for the dogs. I hit that horn a note and they hear me and come on back to me. There's no special call or tune, I just blow for them.

I shoe all my own horses. I wrap their feet and shoe them, myself. Practically all the work on the farm, I do it myself. That's right. It's just my making; it's my birthmark. I reckon it's just bred into me. My father could do it, and my granddaddy could do it, and now I do it. There's certain things you can do. You can't just pick anything up and do it, you know. That's the way it goes.

You know, when dinnertime comes, Ada will blow the horn to notify, to call me. Because, I don't know, I'll be down there plowing and maybe singing and when they get that horn and blow it, I'll stop, and come back in again. I say, "Whoa, time done come now, I'm going to feed my face!" Well, when I get back home, the first thing I do is to take my mules out and water them. Turn them loose there, see. Then go on and put the feed out. Come on into the

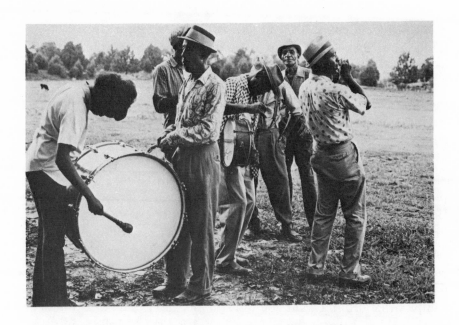

house. Wash my face and hands, sit down and eat my supper. Sit there and relax and talk a while and then go to bed.

In my band now, there's four pieces: two kettles, a bass, and the fife.[3] That's what there is. There's three drums—two kettles and a bass. And the cane, which makes four pieces. That's the music there. With the two kettles, now, you've got a lead kettle and you've got a bass kettle.[4] Now the bass kettle, it plays a little heavier, grosser. But the lead kettle is real light, it's smaller. It's got a different head in it. It don't play as loudly. So you've got a lead kettle, and the bass drum right behind it. The fife is in the front. That's the four. You play them standing up. You got a strap and you snap them drums on. You buckle in the drum in that ring and put it over your head. And you hold it to your side, or in front of you. Now tap or snare drums, you'd sit down and play them. But drums like we got, you play them standing up and you play them in a march. And you plays them in the rain.

You know, when the dew atmosphere falls, them drums get slack. But you've got to keep a good tight drum to put out the right sound so you can hear the music. So you make you a little blast of

fire to tighten them heads, just like when the sun shines, see. But when the atmosphere is damp, a drum will swing. So you build your fire and hold your drum to the fire,[5] turn it around, rub them heads good, and tap them. You can hear that drum popping, tightening all the time. When it gets tight, see, it changes the tune of the drum. And you can play on it all day and you'll never bust it, but if you got a slack head, you're not going to hear it too good and you're going to bust it. That's right.

That song, "Granny, Will Your Dog Bite?,"[6] that's one of them pieces that we play real fast, using that double lick like my daughter Bernice plays: "Boom, diddie, boom. Diddie, booga, booga, booga, boom." The kettle plays that. See, in that tune, you roll it and the bass is back there catching it. He can't play it as fast, rolling it, but you keep on with that double lick. That's the way it goes. My daughter Bernice, when she was little, she said, "Daddy, I believe I can play that drum. I want you to learn me." So I told her I couldn't learn her. I said that if she had that in her and she had the vim, then she could learn better than me trying to learn her. I can't learn you. What I can play, you can't always play. You've got to take something from your own . . . your own gift, and then you can play. So Bernice started, she picked it up herself. That's the way she learned to play the drum.

I can play anything I want on a drum. But the whole group's got to know it, too. That makes a difference. You can start trying to play something, and if they all don't fall in line and play the same beat, it ain't nothing. You can't call it nothing because it ain't. I can play all of it—cane blowing, kettle playing, bass, all of it. My real boys, who we generally play with, well they can play all the parts too—from the kettle to the bass and back from the bass to the kettle. But some of these youngsters, they can't even blow a cane. Well, to tell you the truth about it, a whole lot of youngsters don't even know how to play the guitar. Don't know nothing about them. That's right.

I play the guitar too, but I haven't had a box in my hands in about . . . oh, it's been close to three years. Well now, if I had me someone to sit around here with and try to learn pieces and change on them, I could play pretty good. But when you've been off that

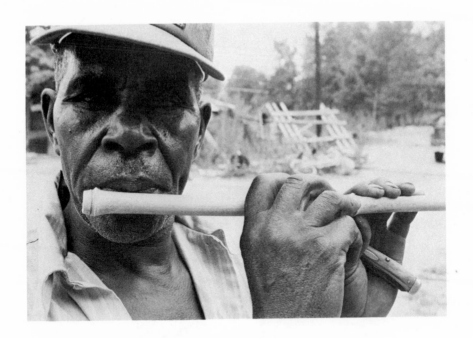

way, you just can't play it right. You supposed to be straight and
correct when you play a piece, not stumble and bump on it. See, my
hands are sore now, so I can't clamp those strings like I want. But if
I could get me some kind of old box just to frail along on, I could
pick up all this stuff again. Then I could pick me up them sixes
[six-string guitar] and make me a good sound.

 When I used to have an old piece of a guitar, I'd sit up until ten
and eleven o'clock at night. And that bottleneck [guitar style], I
tried my best to learn that. I wanted to learn it bad, but it looked
like to me, I couldn't break my fingers down fast enough. It was
hard to me. I couldn't ever catch the hand of that. But the first
piece I learned how to play on the guitar was "Bullyin' Well."[7]
That's for clearpicking. You can't frail and play that. You've got to
do that with your fingers. But my fingers are so sore now that I just
can't choke those strings. I hear the notes, but I can't do it right.
That song's really an old piece. There was one boy, Sammy Smith,
that used to sing it, but he's long dead and in his grave. I used to
hear him playing it. I'd go over there sometimes and stand in the
corner and look at him. I'd watch how he'd work his fingers, and

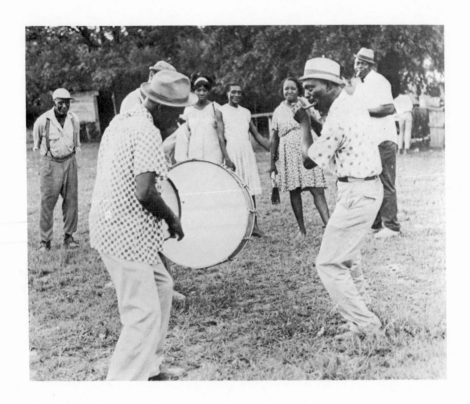

say, "I can do that." So I'd get that old box of mine and I'd frail[8] on
it, I'd tune it, I'd break more strings, and buy me some more. I just
kept choking it and messing around, until I got the tune of it right. I
kept on until I got it. And after I learned it, I could play that guitar
pretty good. But, wheew, it's been so long. Then I used to sit
around on the porch at night by myself. I'd start playing that box
and they'd leave home, walking. They'd come up here and sit on the
porch steps around here looking at me, listening to me play. I
played, yes sir, I played. Man, I'm telling you the truth, the house
would almost break through at night with all the dancing.

When we have a picnic, see, we put it out from three to four
weeks ahead. That's the broadcasting: "I'm giving a picnic—Othar
Turner's place. Everybody come. It'll be an enjoyment. Everybody's
welcome." Then I go ahead and get my stand ready. I kill my hog,

scald him, clean that, cook my meat, take it up and barbecue it, and take it to my stand. We sells it by the sandwich. And we'll have that pork meat, fish, and drinks.

Then I start the drums to playing and the cane fifes to blowing. We play "Shimmy She Wobble,"[9] "My Baby Don't Stand No Cheating On Her,"[10] "Granny, Will Your Dog Bite?," "Rolling and Tumbling,"[11] "Glory Hallelujah,"[12] "When The Saints Go Marching In."[13] We play all stuff like that you know. We got a whole lot of different pieces we play. You know, you *can* sing to the drums, we've sung to them many times and played. It just depends on what you want to do. But now ordinary playing in a picnic, that's just for drawing a crowd. We go out there and go to playing the drums, sometimes go to hollering and playing and making monkeyshine with the drums, just cutting up, you know. That's what will draw your crowd. That's what that's for. That's the drawment [attraction], and all the people start to come from that. That's what draws the people from further and nearer. The people come from everywhere.

There's always plenty of fun. People are laughing and talking, associating with one another. Just fun. Little kids go out there and dance behind the drums. We have all of that. It's really what you call a good time. That's what it is. Just for enjoyment, to keep from being at home and lonesome.

We all meet there—white people come there just like the colored, and sit down and laugh and talk. White peoples, they appreciate the drumming, too. They look at us and take up money for us to play. They stand around and look and ask us to play and pay us to play. They don't ever try to learn. They'd just rather hear us play. They get more enjoyment out of just standing and looking. Everybody has a swell time. They be dancing, laughing, talking, enjoying, smoking cigarettes, looking, listening to the music.

And we has the law [the sheriff].[14] All the picnics we give we have the law to come there. That's for to keep down the stabbings, to keep people from getting killed. Keep people from wrecking cars. Keep people from shooting one another. That's for peace, you have that for peace. No clowning, no cursing and hooting and hollering. No guns. No cutting and shooting. That's what that's for. That's what we have. No trouble, we don't have any trouble. Every-

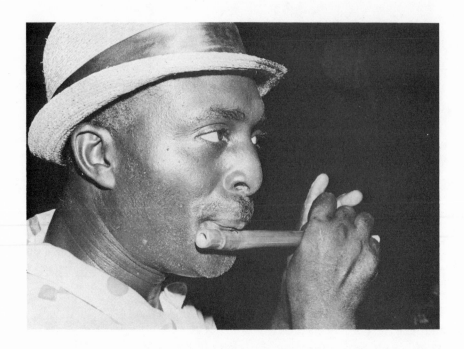

body be loving and peaceful, we all are one then. Just an enjoyment. That's the way we have it.

So that's the picnic. Everybody's welcome that wants to come. Everybody that comes down there treats me nice; I don't have no trouble. We have a good time, sells out, and that's what the picnic is. You start on a Friday—you barbecue Friday night. The picnic starts at one o'clock on Saturday and goes until twelve that night. That's the end, because when twelve rolls up, then Sunday takes over. That'll be the end of that. That's the close-out, see. We don't have drum playing on Sunday.

I learnt myself to make a cane fife. I was thirteen years old and there were these old drum players around here, Bill and Will. I would stand there and look at them—and they had a player man that blew a cane, too—and say that I wished I could do that. See, I'd already taken up learning how to beat the drum. So I asked him to let me see his fife. I figured I could do it too. So, he revealed something to me, he said, "Now look, what you see somebody else doing, there's no way to make a failure but to try. If you think that

you can do it and you believe that you can do it, try." So I just kept
a tuning and tuning and blowing and tuning. The more you do a
thing, the more perfect it comes to you. The more I tried, the bet-
ter it come to me. And so I tried and tried and I learned it. That's
my make. Ain't nobody trained me or nothing. I take that
for myself.

And so I made several canes for other people. I don't know
how many I done made for them. I made the first cane Napoleon
Strickland[15] ever blowed in his life. I made it and gave it to him.
That's right. He'd just walk up and down the road, night and day,
toting his cane. He just kept on, until it come naturally to him, too.
As soon as he learned to blow one piece, he learned him another.
Just like playing a guitar. You can start playing a guitar and when
you learn one piece, you just keep on until another comes and you
learn that. So I learned Napoleon his cane, and he tried to blow like
me. He just took it up hisself after he heard me blow a piece. And
now old Napoleon can really blow a cane.

To play the blues takes time, you know, and there are other
worries about it. You got to have faith in it. If you've got faith in it
and believe you can do it, believe you want to do it, then you can
do it. You can't do nothing unless you make a failure. There's no
way to make a failure but to try. Just keep on trying, and you will
make it. But if you believe you can't make it, and don't try to make
it, you never will make it. That's the way that is. I can't learn you to
play music. You can stand there all day and look at me working my
fingers, but you never will learn if you don't try to do it yourself.
The minute you pick it up and it enters into your mind that you
want to do it, and try to do it, you can learn it. By keeping on try-
ing. Isn't anybody can learn you how to do nothing, you've got to
learn yourself.

I make my own fifes. The cane grows right down there in the
ditch banks down in the bottom. First you go out there and cut you
a piece of cane. You judge the length you want your cane—you
going to make your fife a foot, or a foot and so many inches long. A
two-foot cane is really too long to blow. It's best a foot or so, I
reckon. And your cane should be a medium size around. Too large
a cane and you can't tune it. That cane grows from the earth so high,

167

see, and it's jointed. You pick you out so many joints and cut it off. Then you take your knife and dress it down.

You get you a rod of iron and put it in the fire and get it red hot, and bore you a hole in your cane. See, sometime if you don't get your hole large enough, that fife won't blow good, so you got to twist it around and blow that hole out. You got to hold that rod in there so it starts smoking and steaming. You hold it and then, whoop, slide it on through there. You put all them holes in there that way.

You space your fingers on the cane, see, to see what distance apart to make the holes. I measure mine with my fingers. I know just exactly what distance to go. That's the way I do it. Then I take me a pencil and I mark right there where my finger's at. Then when I go to burn the holes in the cane, I get right at the center of that place where that black mark is. Now you got to line your holes up—straight up and down that piece of cane. I put five holes in my canes. I never use but five holes in a cane to blow it. Of course the hole what you blow through with your mouth makes it six. But it's quite natural that some people that blows a cane needs more holes to blow than I do. See, what I blows, they can't blow. Some takes more, and some takes less. Like Napoleon [Strickland], he uses that last hole. But I don't use it, except as a rest for my finger, see. I take five holes. That's the way it goes.

You can blow on a cane and it'll blow all day and that's *all* it's going to do. You got to *note* it with your fingers. It depends on how hard you blow, too. It's different in blowing a church song, than in blowing a blues or a reel on a cane. That's right. And if you make it right, you can tune it any way that you want. But if you don't make it right, you just going to be going "wooo, wooo," and that's all. You got to tune it with your finger. That's your tuner. That makes your fife. Then you blow it. I blow a cane from the left. Some people blows from the right. But you can blow it either from the right or the left.

I reckon singing is just a gift, like anything else. I used to be a real blues singer before I was married. I'd sing throughout the night, out riding my horse. Folks would get up and light a lamp and

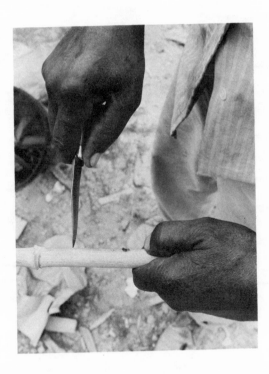

come out into the yard to look at me singing the blues. I could sing.
Yeah. I used to ride my horse at night, just hollering the blues, just
riding along singing.

Now I can be out there working in the fields and something
will come to me. I can sing the blues so well then that it'll do you
good to stop and listen. It's true. Now when my mind ain't on it, it
don't come to me and I just can't do it. That's right. It's just a gift.
That's the way it is.

The blues is a kind of thing that if you're driving along, plow-
ing in the field, and something comes to you, you just start to sing.
You make that up yourself. You can put anything in a blues.

> Sitting here wondering,
> With my matchbox open and closed.
> I ain't got so many matches,
> But I got so far to go . . . [16]

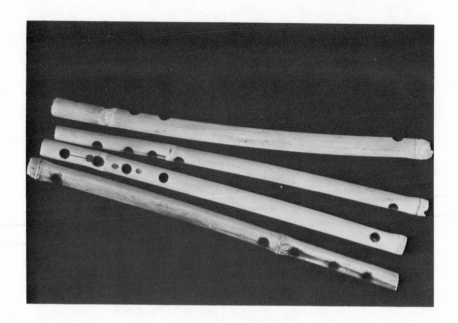

Now that just naturally comes to you. That's what it is. You make up your own blues singing. I make up my own songs myself. That's the way I play. I can't play someone else's songs and their tune. I have to play mine, or I can't play at all. The words come from me. They're just thoughts that come to me as I'm playing the box. And them songs can just come to you that way when you're out working. It just do me good to be out there plowing a mule and hollering on high. I like that. Singing, that's my pedigree.

I come up the hard way, but I never been in no trouble. Never have. I never had a law to come and say, "Well, I got you for killing a man, I got you for stealing this, I got you for such and such." Never been arrested and carried and locked up in jail in my life. You can search from Free Springs, Holly Springs, Thyatira, Looxahoma, Senatobia, Coldwater, Sledge, Crenshaw, Batesville, Grenada, Canton, Jackson, around on back to Como. Nothing about Othar. "Othar," they'll say, "Oh, I never knowed Othar to do nothing to nobody, he's a good man. If he's done anything, he's just getting a little fun. I don't believe nothing like that about Othar. He don't do nothing but to treat you right." That's what I mean by

that's my motto. My mother taught me from a baby, until I got big enough to know, to get out on my own: treat everybody right. Treat people like you wish to be treated. I want friends and good behind me when I'm dead and gone. I want people to speak well of me. I work for that. I love to meet anybody with a smiling face. That's the way I live, and that's the way I hope I'll go.

Pecolia Warner

Quilt Maker | Yazoo City, Mississippi | Born 1901

Reprinted from: William Ferris, ed.,
Afro-American Arts and Crafts.
Boston: G. K. Hall, Inc., 1982.

I LEARNED everything from my mother. She brought us up in the church. And she would have prayer meetings at home with us every Wednesday night. I never grew up knowing too much about the world because I wasn't raised up to that. I always said, "Lord, when I get grown I want to be just like my mama by the church." I do love my church work, too. I am the mother of the church— every Sunday I wear my white uniform, my white hat, and my gloves. Yes, I moves at God's command. Whatever the spirit leads me to do I'll do it. I can't do nothing without God. I need Him in everything I got to do. He teaches me. He's a comfort for me. He's a leader. He's everything to me. I get to talking sometimes, and I just can't hold my peace, because I do know that I am a child of God. That's right. And I've been a child of God ever since 1917. I've been on that hill a long time now—I was fifteen years old when I found Jesus. I was brought up in the church, and I've stayed in the church.

I've had the spirit to call me in my dreams. The spirit would shake me, wake me up, and tell me to pray for the sick and needy. I'd wake up and be crying and praying for them, not even knowing who they was. My pillow would be wringing wet. When I was sick and the doctors couldn't seem to reach my complaint, I commenced to praying for the Lord. I said, "Lord, I know You are above all doctors, and if it's Your will, Jesus, heal me. I know you're sufficient to do it." I went to sleep, and Jesus was showed to me in a dream. He told me what to do, how to move my misery by His help. So the next morning I went on up there where he told me to go—up to that doctor in Drew [Mississippi]—and that man healed me through the Lord.

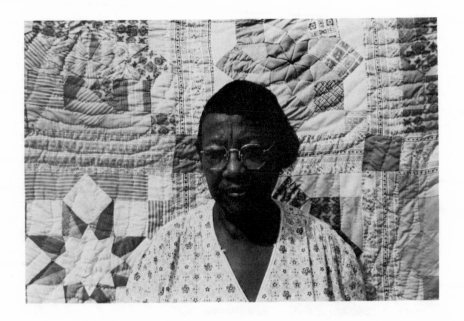

Plenty of times I've dreamed about making quilts, too. I dreamed one time about making a Pigpen quilt, and I ain't never seen one made on a paper [quilt pattern]. I just remembered how we used to make pigpens for our hogs and I made it up. First you put a floor down. That'll be a solid piece, a square. And then you lay the rails all the way around the pen. See, you take a strip, that'll be your first rail, and you go all around that square. Then you get another strip of a different color, and keep going all the way around until you get the pen built. You don't strip it nowhere, you just keep coming all the way around. See, that's the frame of the pen. Then it'll be like a pen to put your hogs in. And that's just the way I made that Pigpen quilt. It's two colors. It's not stripped or blocked, I just pieced it up all over the bed, around and around. I dreamed, too, of making a quilt with diamonds. I still want to quilt out a ring and diamonds. That'd be a pretty quilt.

When I work on my quilts, I'll always be thinking about religion—first one thing, then another. I think about the church, about when the next meeting is, about the suppers and rallies, and different things like that out at the church. I say to myself, "Thank

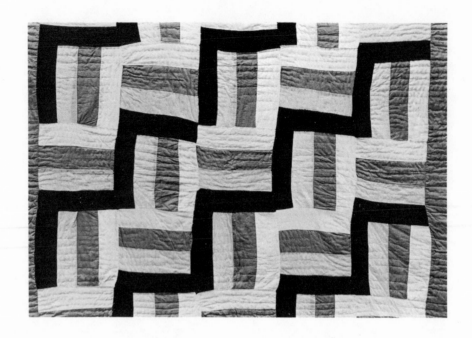

you, God. You abled me to do this. I couldn't of did it if You wasn't
with me." He's with me in everything I attempt to do. I'm going to
put Him in the front. That's where He always is. Without Jesus I
can't do anything. With Him making quilts is easy. It's a gift from
God to be able to do this. If it weren't for Him, I wouldn't be able
to do it.

I want to do something—I'm just sitting down holding my
hands, doing nothing—so I go in there and get my pieces and com-
mence to sewing. For me, piecing up quilts keeps my limbs from
getting so stiff. If you're always doing something, then you stay sup-
ple. And it keeps your mind occupied. Keeps your mind together.
This is my company. You get lonesome, you know, and one mind
tells you, "Get out in the streets." That's the devil telling you that.
See, when women is doing something like making a quilt, they're
not out in the streets. They're not out in the jukes and taverns.
They got something at home to occupy them without going in
those places.

When I'm working I think on Jesus, and I read my prayers.

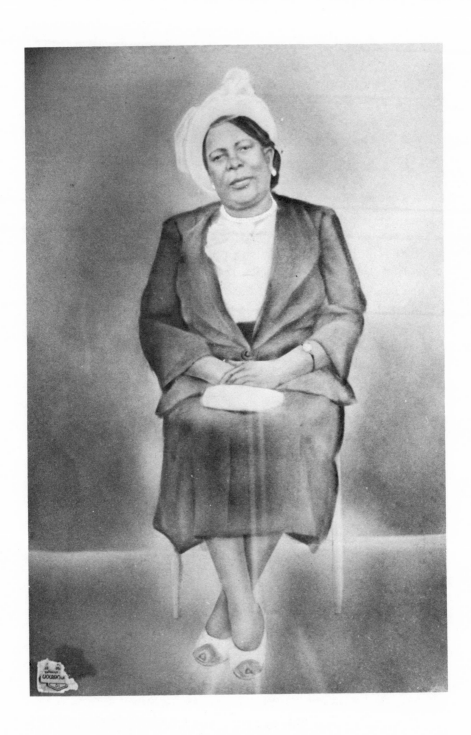

When I do that, it looks like I work easier, my work won't be so hard to me. I'll be thinking on Jesus. Then it's fun to me to sit down and piece a quilt. But you've got to make up your mind to do it. You can't do nothing if you don't make up your mind to do it. But if you set your mind on such and such a thing—say "I'm *going* to do it"—you're going to do it by the help of the Lord. When I'm working I'm giving thanks to the Lord. And I hum or I sing.

If I get to quilting and singing in there, my husband, Sam, he'll say, "Pecolia, that hymn is naturally sounding good."

So I'll tell him, "Yes, and I'm feeling good, too!"

I was born on March 9, in 1901, down there on the Lee Place in Rose Hill, by Bentonia, Mississippi. I was Pecolia Jackson before I married. I was raised and schooled in Yazoo City, Mississippi. When I was a kid coming up, I had to take care of my two little brothers. I was the onliest one in the house after my sisters had married and left home. Then when I got big enough, I had to go to the field—I was raised up in the field. I'd hoe and I'd pick cotton. Then I'd come home and cook and clean house, milk five head of cows, feed the chickens, churn, and all like that. Yeah, I come up the hard way. But I always said, "Thank God that Mama learned me how to work." I do appreciate it.

I was born in a log house—it was made out of logs with mud between them and rough boards nailed on to hold the mud in there. And I've pieced up a Log Cabin quilt. It's a string quilt,[1] and it's easy to piece. See, it has one, two, three pieces. First you put the two long ones, then you come across there and go around with the other ones. It's an easy-made quilt. I remember when I was a child, how me and my friends would get to playing, and how I'd steal chickens from my mama and cook them up under that log house. The house was tall up off the ground, you know, and we had us a place fixed up under there. We had made us a stove with some bricks and things. I kept my salt, meal, lard, and everything under there. A skillet, too. Me and Bud and Bessie and Toot and Dalton and Rebecca, we'd sit up under the house and eat dinner. And when Mama come around where we were, she'd say, "What you all been doing?" And we'd tell her we was just playing. She'd ask us, "You all ain't cooked nothing have you?" And I'd tell her that *Bessie*

hadn't cooked anything. Bessie was my sister, see. Then I'd say, "But we ain't hungry, though." And Bud, that was my brother, he'd say, "No, Mama, Pecolia ain't hungry . . . because she stole a chicken and cooked it!" And you ain't going to believe me—we being nothing but little childrens—but we used to hunt grasshoppers. We'd catch them grasshoppers, pull them hind legs off, put meal and salt and pepper on them, and fry them in hot grease. Man, you can't imagine them chewing up in your teeth!

My mother was a schoolteacher. My daddy died when I was nine years old, and my mama raised us without a father. Seven of us she raised up without a father. She taught us all how to do some of everything. How to cook, how to clean up the house, how to wash and iron, how to sew, and how to make quilts. My mother made beautiful quilts. But after her eyes commenced to failing she had to quit.

I remember when I was growing up they used to have quilting bees. My mother used to give them, that's why I know. We was in the country then, and no houses was very far apart. So Mama would have them at our house, or she would go to my auntie's[2] or my cousin's, and she would help them to quilt. I was a little girl, but I'd be following her, because I wanted to learn how to do that. I used to say, "If I ever get grown, I'm going to quilt, myself." It would be at night—or during the day, when the women wasn't in the field. Seven or eight women would gather around a quilt, sitting there talking and working. They'd take out two quilts a night. And they wouldn't be over three hours quilting out one quilt. They would have a break—coffee to drink, and crackers or cookies, something to go with the coffee—then they'd get right back to the quilts. They'd go on to twelve o'clock at night. When I was a little girl I used to love to get up under the quilt and watch them. I watched how they put their hands up under there and pushed the needle up—I liked to watch how they kept their needles working. I'd be under that quilting frame just watching how they used their hands! I never will forget it, me just a little old girl laying down on the floor under there.

They didn't buy no batts, they'd save cotton and work it out themselves. When they'd go to the gin, they would save out a sack

of cotton. And they'd pull some out and put it on the floor. And with a switch, they'd just whip that cotton—they'd beat it out thin. Then they would use that to pad the quilt with. They'd use a blanket or something on the bottom for a lining, then put the quilt top over that and tack it down. Then they'd stretch it out in a frame and just roll it right up to where they'd want to start quilting on it. They'd hang that frame up in the house by four ropes. Then they had a swinging quilt to work on.

While they'd be sitting there, they'd get to gossiping, and talking about religion, and the Bible, and what happened at church, and all like that. And they'd get happy and commence to crying sometimes. I'd be laying up under there watching them, and I'd say, "Now if they get happy and shout, I don't want them to stomp me!" Because I was lying down there on the floor, see.

So I took all of that in. I was ten years old when I pieced up my first quilt. See, at that time my mother was taking in sewing. And she would tell me there were some scraps that I could have. So I took them, and she taught me how to piece a quilt out of those little-bitty strings of leftover material. I pieced them all up myself, from the head to the foot—in a straight line just as long as the bed. Twelve or sixteen strips like that I made. Them was the legs, so Mama named it: a Spider Leg quilt she called it. Then she showed me how to strip it. Put a plain strip in between each of those strips that I'd pieced up, you know. Then after it was put together, she quilted it out for me.

So just from watching, I learned. You know, when I was a child coming up, it'd be raining and bad out, and so we couldn't get outside to play. My mother would be piecing quilts—sitting by the fireplace—and I'd be sitting there watching her, wanting to do the same thing she was doing. So she bought me a needle and a little thimble to use, and she showed me how to sew. By me just watching her, I learned how to do everything, see. I appreciate that Mama learned me how to make my quilts, because I've sold many a one. So I'd say, "Look, Mama, how's this look?" after I'd made something. If it wasn't right—if I made a stitch that was too long—she didn't do no laughing and talking! If it wasn't right, she'd take it and look at it, and then commence to pulling it right out!

She'd say to me, "That ain't right. Fix it right or else I'll put a strap on you!"

If I didn't do it right, she'd always make me do it again. She used to say, "If you're going to do anything, you do it right." So that's the way I always followed. From then on, if I be sewing or piecing and it's wrong, I sit right down and take it loose. See, that growed up in me. I haven't forgot that fireplace training.

My mother's father was an Indian, but her mother wasn't. That made her a half–red Indian. I can remember my granddaddy. He wore his hair plaited and it hung way down his back. Nobody messed with him, either, because he didn't believe in nothing but a bow and arrow. And he'd kill as much that way as you would with a shotgun. The way he farmed, he farmed with oxes, he didn't use mules. And if he worked on halves with a white person, he'd go and wore his hair plaited and it hung way down his back. Nobody messed with him, either, because he didn't believe in nothing but a bow and arrow. And he'd kill as much that way as you would with a going to work yours." And when he gathered his own cotton, he left

the white man's there in the field. He believed that white man should gather his own crop. And so they told him, "You ain't going to sell that cotton."

But he told them, he said, "Me? I *am* going to sell my cotton. And after I sell it, I'm going to move out of here."

So he loaded his cotton up on a wagon, and came from out of the hills, on over here to Yazoo City. Then he sold his cotton, wagon, oxes, and all, and went on over to Greenville and went to living there.

My mother told me about how she used to work in the fields when she was a little girl. Well, one time she was plowing and turned a snake over on her foot. And that snake bit her on top of her foot. She went home and told her papa—that's my Indian granddaddy—that a snake had just bit her. Her foot was all swoll up by that time. So he just went out there in the yard and caught him a black chicken. He didn't kill it, he just cut it in half, and put that black chicken on her foot. It drawed all that poison out of there.[3] Then he just throwed the chicken away. She never was crippled or nothing. That took the swelling and all right out of her foot.

At that time—when children were coming up in them way back times—there wasn't no operations, nothing of the kind like that. My mother didn't believe in no doctor; she never did go to a doctor. Whenever any of us got sick—if we'd have a fever or a headache— she'd go out in the woods and get some kind of herb, or bark, or weed, and make tea for us to drink. Like she'd go out and collect that old bitter weed[4]—the one we called cow weed.[5] She'd bring it back home and wash it, put it on to boil, and strain it up. And boy, she'd make us drink that without any show! That'd always cut our fever down. And she'd go out in the woods and cut the bark off the north side of a red oak tree,[6] and bring it on back and boil it up. She'd bathe us in it. I don't care how high your fever was, that would sure bathe it down. And she'd grease us down—especially our chests and our feets—with quinine and tallow or fresh lard,[7] stuff like that. Or she'd take a brick and put it in the fireplace until that brick got hot. Then she'd take it out and pour some water on it to make steam. Then she'd put some turpentine on that brick, wrap it up in a newspaper and a towel, and place it on your chest. My

brother-in-law had pneumonia, and Mama treated him that way. He didn't get no doctor. My mother cured him, just cut that sickness loose. That's all my mother believed in when we was sick, going out there, and digging up some kind of roots, or bark, or weed. That's the way she raised us. We didn't know what a doctor was, until we gotten grown and gotten married. When they first carried me to the doctor, I cried and hollered, I wouldn't stand for it. I wanted to know what that doctor was going to do to me. I didn't know nothing about no doctor! And I was twenty-one years old then.

Anyways, I didn't marry until I was twenty years old. Then I was Pecolia Harris. My first husband and I farmed. And the hardest work I ever did was after I married. We were cleaning up new ground. See, we had a settlement with the white man about that place. That was his land. He'd give us our part of the crop and he'd take his part. My first husband, he didn't get no man to help, *I* helped him. I used to roll logs like a man—saw them logs, roll them, and burn them. We'd put them in a heap and set them afire, you know. And I got on out there and hitched up a mule to plow, and hauled with a wagon just like a man. I run a cultivator for them to plant cotton, and I run the stalk cutter, too. I'd take an ax and go through the field, cutting the stalks on cotton. And I drove a tractor from down at the mill for them to pull corn. Yes, I did all of that. And I worked too hard. All five of my children died. I miscarried with all of them along about that time. But I say thank God I ain't got to do that now. Me and Sam Warner was married in 1972. The Lord have blessed me and I've got a good husband now.

Then after I quit farming I went out working. Cooking is mostly what I did. I could get a job anywhere I went, cooking for white peoples. I worked in lots of places. I was in Chicago for seven years. I worked around white peoples cooking, cleaning up, washing and ironing, and nursing. Anyway, they was paying good, so I didn't mind that work. I always lived on the premises, and I didn't have to rush to try and get through things, because I knew I had five days to do the work. Saturdays and Sundays I didn't work for nobody. On Sundays I'd always go to church, see. And I worked as a practical nurse at the hospital, too. So I been working all my days—ever since I been big enough to work. Then I left Chicago in

1971—I left my first husband up there—and came back to Mississippi. I been back here in Yazoo City ever since.

When I lived out of Mississippi, I always thought about coming back here. I lived in New Orleans, I lived in Chicago, and I lived in Washington, D.C. I was working the whole while I was in those cities. Out of all those places I like Mississippi best. It's not as terrible as these other states. I used to miss Mississippi a whole lot because in Chicago you are afraid to go out. You'd better not sit out on your porch after sundown. If you sit out up there, you're liable to get a brick or a rock up the side of your head. While you're sitting on the front porch, somebody's trying to break in the back. They're going to take all that you've got. So in Chicago when night comes you'd better be sure you're in your house and fastened up. But here in Mississippi, you can sit out on your porch at night and cool off. And you can walk the streets. Nobody ain't going to bother you. Those cities is tough to live in. I don't want to live nowhere like that. Out of everywhere I ever lived, you can give me Mississippi. Because I was born and raised up here. I was converted here. I do love Mississippi best out of all the states I done lived in.

When someone gets burned out, you know, I'll donate them some quilts. I don't necessarily altogether piece them up for myself. I like to help people with them. You know, people is just crazy about my quilts. I could of gave away and sold every quilt I got if I had listened to all of them. But I wouldn't do it. I want to keep some of these old-time quilts for myself. I ain't going to sell them. I likes my old quilts. I get to looking at them and think about where I was living when I pieced them up and quilted them out. Now the quilts that I don't sell, what I keep for my own person to use, I put them away after the winter's over. I washes them, and put them up there in my cedar chest, and I stack some of them under the bed tick. Sometimes, though, I just wish I could sit down and piece up quilts and give them all away. But I say, "No, I'm going to keep a quilt for myself because I don't like blankets at all." For sleeping I don't want no blankets. A quilt will keep you more warmer, and it's more healthy than a blanket. My husband, Sam, he says they're too heavy. You ask him how many quilts I've got on the bed, and he'll

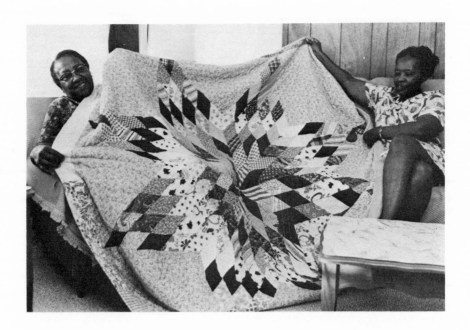

tell you, "You call them quilts, but I say I'm sleeping under three mattresses!" Well, they *are* heavy, but they sure keep you warm.[8]

I used to quilt alone by myself at night. I'd sew on until I couldn't hardly see, then stop and start again the next morning. Now I ain't going to quilt nary a stitch at night anymore. I always do it in the daytime now. I got to the place where I'll be sewing so hard at night that I'll lose my needle and I can't find it. I have to ask Sam to come and find my needle. So I don't do no sewing at night anymore. I usually work in my living room or dining room, anywhere it's cool. Sometimes I works at my quilting with Theresa. That's Sam's daughter, my stepdaughter. Like if I want to piece up a quilt I'll call her and ask her to cut the pieces out for me. That makes me get through with my quilt real quick. See, she can cut four or five pieces at one time, and I can just cut one. That way I don't have to do anything but just piece—just sew it together. It's tedious all right because you got to watch your pieces and see how you cut them. It's all in how you cut your pieces.

If I just get down to it, you know, it don't take me no time to

187

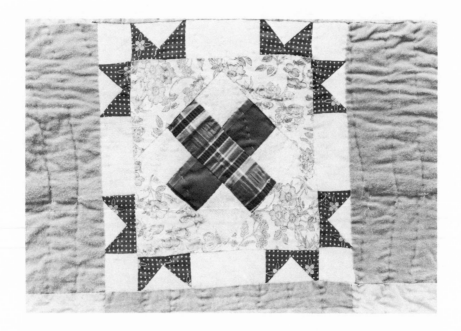

piece up a quilt. If I take a notion to finish something I can soon get through with it. Some of them I can put up in just a day—like that Rocky-Road-To-California. Or the Bear's Foot. But that Little Star, now it took me a good bit to piece that one up, because it's in such little-bitty pieces. Now it's tedious and it takes patience, piecing up them little pieces like that. Took me a good while to piece it. But that's a fancy quilt, see.

But you can sit down and make them string quilts real quick. For a string quilt, I just commence to piecing up blocks out of strings—they're scraps, you know, I have from sewing, and some that other people save for me. Like that Six Strips quilt I made, that ain't nothing but a lot of strings sewn together. That way you won't throw away any pieces. See, when you get a box full of strings, you got about five or six quilts. With string quilts you ain't got nothing to throw away. You ain't got nothing to waste. Just like when my husband Sam was in the hospital, I pieced up four string quilts. Just going back-and-forth down there to see him I did that.

A lot of these patterns—some of the different designs of these fancy quilts—that I've done pieced up, I got them out of a quilt

book. See, I borrowed this book of patterns from my sister-in-law for the summer, one time. And my mother was a schoolteacher and sometimes she'd get the newspapers after they was done with them. She'd cut the quilt patterns out of them then. The name of the quilts would be already on the pattern. That's why I knew how to name them. And now, some patterns I get is from the newspaper, too—I cut them out and fix them right on pasteboard. Anything I see on a piece of paper, I can sit down and look at it and piece it right up. I could always see a lady with a dress on and just imagine the pattern of it. I'd go home and get me a piece of paper and sit down and cut me out a pattern for a dress just like she had on. I wouldn't need no pattern to go by, no book or nothing. I'd just see somebody with something on and I'd go and make it up for myself.

But lots of them are made-up quilts. See, there's no pattern for those. I just sit down and start to sewing them up. I call them make-ups. See, that's your own mind. You make it up by looking at something and imitating it. You draw it off in your mind, see. Then, when you get it cut out you put it together and see if it's in the right shape. Practically all my quilts are make-ups. Of course some are out of that book, but after I'd pieced them up once out of the book, I just kept them patterns in my mind. I didn't need the book to look at no more. My Pineapple quilt, that's pieced up like a star, see, but it's really a Pineapple. I saw one in the grocery store—it wasn't peeled—and I just looked at it to see how it was made. I didn't have no pattern for it. I just looked at the shape of that pineapple in the store there, and tried to make me a quilt like that. See, it's easy, if you count your blocks—it's four. You get you one solid piece straight and then cut the three corner pieces.

And like that wheel [tape recorder reel] going around there—I can look at that wheel and imagine me a quilt from it. I can take me some paper and cut out a pattern and piece me up a quilt just like that. Just by looking at it I could do that. I guess I'd call it a Tape Recorder quilt. That would be my name of it, since that's it's name, ain't it? Many of my quilts I've pieced up just by looking at things that way. Now I did one of the initial of my name, Pecolia. I was just sitting around one time and didn't have nothing else to do. So I said, "I just believe I'll make me a piece that will be the start of my

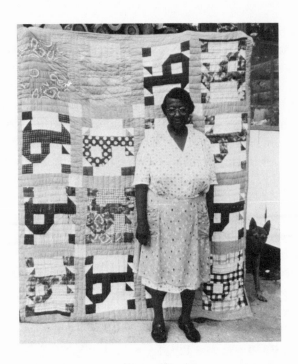

name." I call it a P quilt. I just took me a piece of paper and drew
that P with a pencil. You make it like if it was printed somewhere.
Then you take your scissors and cut that P out. You got you a pat-
tern then, see. Then you get your material and cut it on out by the
pattern. You piece your straight piece that away, and you put them
two ends on it then. That gives you a P. I want to make more let-
ters, just like I made that P. I bet I could even do the whole
alphabet.

One time I said to my stepdaughter, "Theresa, I'm going to
piece me up a pattern of the Star." I love the Star. It's my favorite
pattern because it's so beautiful. Just about the prettiest quilt you
can piece is a Star. It just seems like it always shows up more better.
And I think the biggest quilt I got is that Star. I can travel so fast
with it—I can sew it up fast, I mean. See, it's an eight-point star.
You get the middle of that first. When you get that right, see, then
you can go on. Getting that middle first, that's the main thing. If
you get that one straight, then you can get the rest right. But no

piece is going to fit, unless it fits directly in those points there. You've got to have all your pieces cut just alike so it'll fit. If you ain't got it cut right, it ain't going to fit. You can't *make* it fit to save your life. If you don't get them cut correct, you just have a messed-up quilt. You have to just bag it up and do it again better. Then when you get them eight pieces just alike you sew those together. Then you fit them solid blocks into each one of them corners. See, with the Star, you can make it as large as you want, and you can make it as small as you want. You can make the pieces larger, just so you have them to fit right.

I been wanting to piece quilts ever since I saw my mother doing it. I wanted that to grow up in me—how to make quilts. I thought it was fun, you know, seeing her do it. I didn't know it was as hard work as it is. But that's hard work: piecing, putting them pieces together, and quilting them. It's hard work, but I love it. That's my talent; making quilts is my calling. Of course I been doing it since I was a child, so it don't go hard with me now, anyway. I do love to do it. Two things I love to do: to cook and to piece quilts. And since I learned when I was a kid, I haven't forgotten it. I still makes them; I guess I ain't going to never stop quilting. I always say, "Well, I think I'll stop piecing for awhile." But I guess as long as I can see, I'll still be trying to thread a needle. I wouldn't want nothing to happen to my quilts after I pass on. I want people to keep them to remember me. They'll say, "Well, I knew one old lady, that's all she did was to piece quilts." I'd like them to remember me quilting.

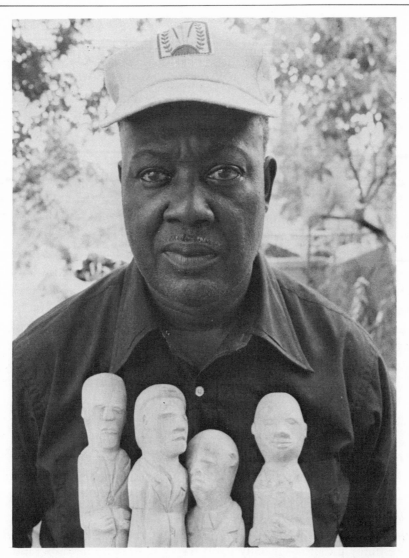

Luster Willis

Painter and Cane Maker | Terry, Mississippi |
Born 1913

I WAS BORN in 1913 in Hinds County near Terry [Mississippi], but later on my parents moved to Copiah County right at this present place where I now live. I grew up here in Mississippi in the Crystal Springs and Egypt Hill community. I attended Egypt Hill Public School and joined the Egypt Hill Baptist Church. I've lived around here all my life. Mostly I used to chop wood, practice barbering, and work on the farm. In 1943 I went into the service and spent about three years. I was in Europe during World War II—in France, and up in Austria. Then I came back home and went back to the farm. That's about all of that part of it. I'm kind of retired now. I carpenter a little bit off and on. My health is not too good and my working is kind of limited.

When I was going to grammar school, I always liked to draw and make little sketches. I'd just see somebody or something that impressed me and I would try to draw it. At school they didn't teach that subject and I got chastised quite a few times for drawing in school but that didn't discourage me. I just continued sketching and trying to draw. I could draw almost anything. Mostly I would draw animals and flowers, and sketch faces of the children in school. That's the way I got started. Trying to draw somebody. Lots of them were funny pictures—usually I was trying to draw something kind of on the fun side to get a laugh out of. They got lots of laughs.

I've never taken a drawing course. I just took that up on my own. I had several offers way back, you know, in my younger days to take it up, but at the time I didn't have the money to pursue that course. I just went on through my own imagination. Some of the people in my pictures are just made-up characters, they're no particular individuals. They come to me through imagination. Some-

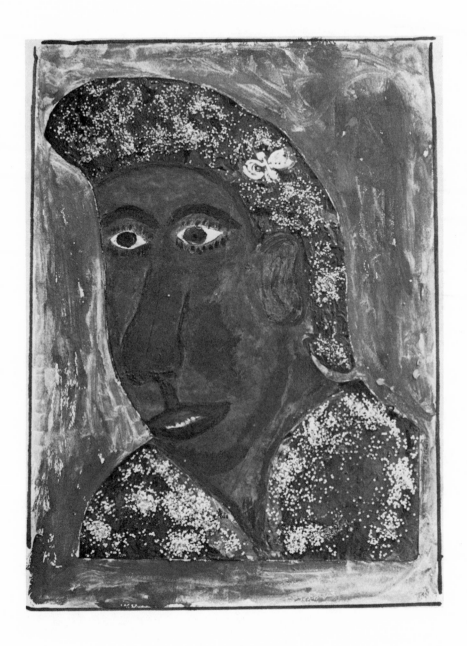

196

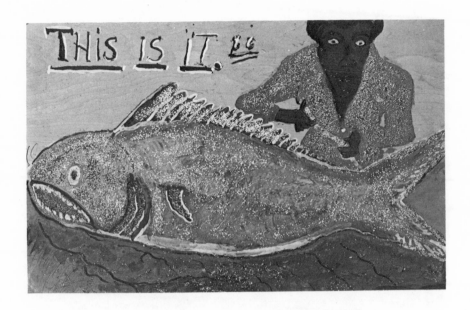

times I don't have any particular person or object in mind. I just draw something that I have on my mind and then after I get it painted out, then whatever it favors most, why then that's the name I apply to it. And then other times I'll sketch something particular that runs across my mind, and I see if I can paint it.

Lots of times I can be just sitting, and look out on the wall or somewhere, and I can see a picture—an image that resembles a flower or an animal or a face or something. I just fish it out of my mind and try to draw it, kind of through imagination. I sketch it and then try to place a person in with it, something like that. I did a picture about twenty years ago of a little boy that was killed here in Mississippi. They called him Emmett Till.[1] I think he was mobbed or something. They killed him and threw him in the river. There was a lot of talk and publicity about it. It's just one of those imaginary paintings, just something that rolled across my mind. Maybe I saw a newspaper clipping or something, and I imagined what it was about. I drew him in his casket in the funeral home, with people passing to view the body. I used to like to draw a lot of caskets and put imaginary figures in them. I think death is interesting because it's something that, sooner or later, we all will have to meet. In

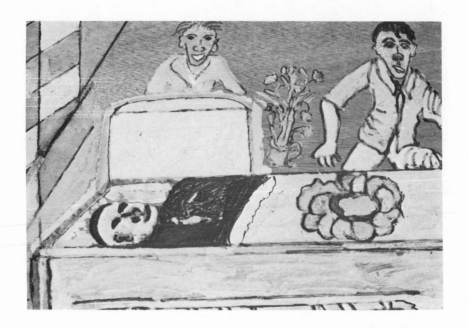

drawing a casket you get different reactions from different people.
Some folks will come by and look at it, and wag their heads and
walk away and say, "I wouldn't draw such as that." But I just love to
try my hand at drawing a casket or something like that. I catch a
kick out of it. That's just one of those imaginary things that I
like to do.

I just get to thinking what I can make, what I can draw or
paint, and I compare it to life as I know it. I made a picture about
being back on the farm in Mississippi—and it comes from my own
experiences all through life. It shows everybody wanting to do
something. The little boy is attempting to ride, the mule wants to
run, and that mischievous one there with the slingshot, he wants to
torment them and have some fun. He gives the mule a shot and al-
most throws his brother. The father, he wants to catch the mule and
do some plowing, but he's been stampeded by the children. He
can't get his job done. The mother, she's in the house there resting
and just looking on. All through my life I've plowed, and I've used
slingshots, and I've tried to ride. I just tried to see if I could use my
imagination to express some of the things that I've been through. I

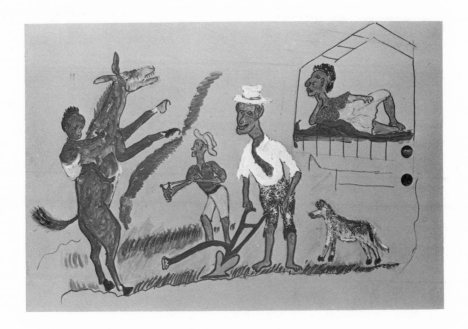

can look at one of my pictures and it brings back to mind many
things that have happened over the years. I draw from life to em-
phasize it, to speak through a picture what can't actually be brought
into words. A picture tells more than a thousand words could
express.

　　I was sitting up one night, and I just pictured in my mind a
story from the Bible. The one I had in mind was about Lazarus and
the rich man.[2] You know that Bible story was in my imagination
when the panic was on back in '32. Lots of people were handi-
capped by not having enough food, not enough nothing. So later I
made a painting to demonstrate what that Bible story really meant. I
call it "The Rich and the Poor." I did it a long time ago. It might
have been in the fifties or somewhere along there. It shows a fellow
that's been chained down. He wants something to eat and all he can
get is a bone. There's also a rich man, one of them big money men,
a man that has everything. Instead of having a bone in his mouth
he's smoking a cigar. He's burning up his wealth and the poor man
has nothing but a bone. The rich man has the power to give or to re-
lease but he's not interested in the poor fellow down on his knees

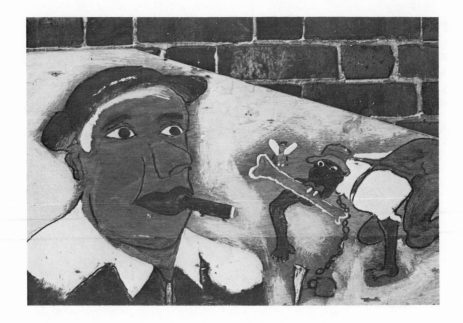

with nothing. I think what I had in mind was trying to make a comparison of the rich and the underprivileged. So many people have everything and there's a bunch that don't have anything. The poor man is in that group that's handicapped. He's handicapped, chained down, not able to smoke—all he can do is hold a bone in his mouth. He doesn't even have any meat, just a bone. The bone is rotten, it's not fit to be eaten, except by a fly . . . yet that's his way of life. He's like an animal because of lack of opportunity. He desires a better way of life, he desires something, but the rich man isn't much interested in giving anything up. He doesn't even have a smile on his face—all he's interested in is his big cigar.

I think I can see things and feel them with my imagination, then sketch them on a piece of paper. I think it helps me to understand people. I can understand why the poor man is like he is because he has been deprived, and the rich man is like he is because he has had it good all of his life. Maybe I'm somewhere in between there—I'm not the worst poor and I'm not the greatest rich, but in my heart I'm satisfied to be just in between.

We had a church anniversary once and the preacher wanted a

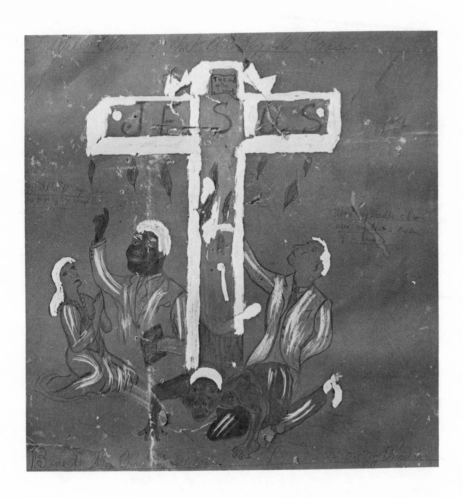

picture to represent our church. I drew the old ship of Zion[3] with
all the apostles on it, and backed it up with the words, "Faith Hope
and Charity." On the bottom I put the motto, "Except Ye Abide
On This Ship Ye Shall Not Be Saved." That went over high. The
preacher took my theme for his text that Sunday and that was the
first donation I think I ever got for drawing a picture. That was back
in the thirties. Sometimes in church I'd sit up there and sketch the
preacher and different people in the congregation. Being in the
country, I know pretty much how people act in the church, and I
tried to see if I could picture it. I did a painting that's a symbol of
the old country revivals we used to have years ago that lots of

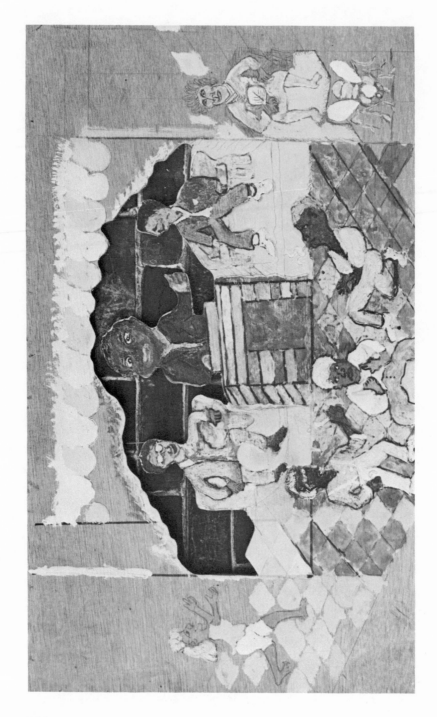

202

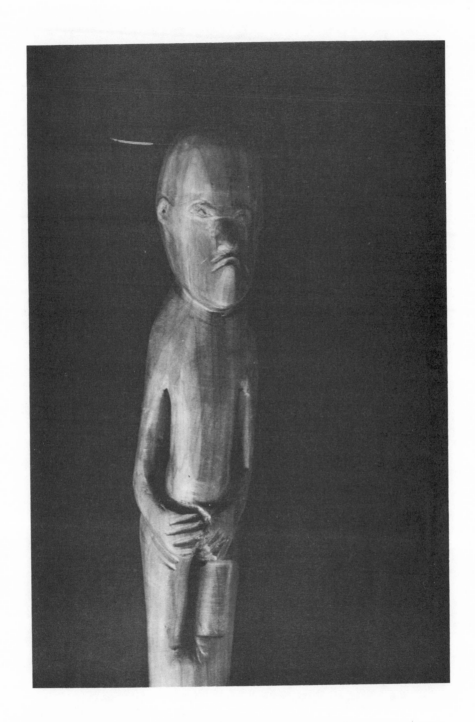

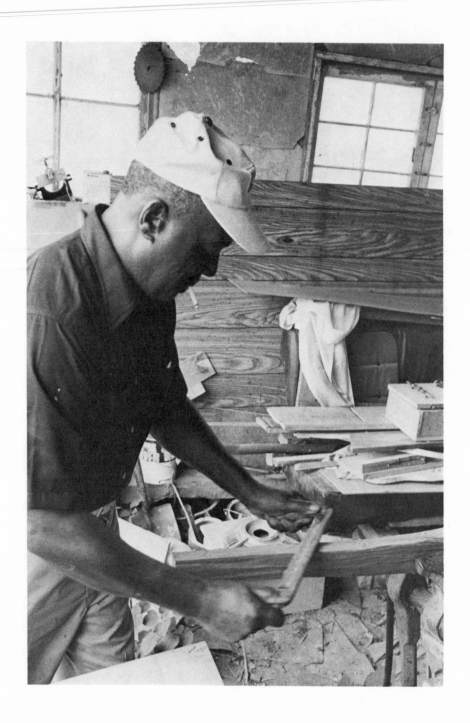

204

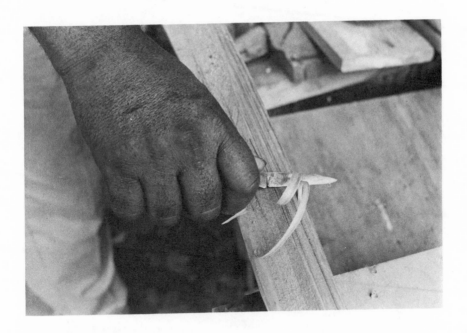

people used to go to for different reasons. Some would go to eat; some to have other enjoyments. In the painting there is a minister attempting to preach. He's one of the old-type country preachers that believes in the old way. There are two of his comrades beside him, and they're listening to his sermon, but the individuals down at the bottom, they seem to be more or less interested in themselves. One wants to eat, the other one wants to smoke, the other one is engaged in talking to himself. The little girl over to the left, she's trying to get inside to hear what's going on, and the lady over on the right is unconcerned, she's just trying to keep cool, because the revival is usually held in the summer, when the weather is pretty hot. A visitor from the insect kingdom is also attending the revival—a hornet who wants something sweet, like some of that watermelon the fellow in the middle is eating. It's kind of a hard-to-reach congregation.

I first started making walking canes back in the early thirties when the Depression was on and jobs were scarce. Without having a job, I just thought of what I could do on my own. I saw a fellow with a carved walking stick one day, and I wondered if I could make

me one. Whenever I saw somebody else doing something a different way, I'd try to do it too. So I just went out in the woods and picked me a tree out, and split it up, and tried it. Course I messed up quite a few, but by not giving up I was able to perfect a pretty good walking stick. During the Depression the panic was on, and almost everybody in the community was on welfare and the bucket brigade, but I kept the wolf away from my door with walking sticks, and that's the truth. I tried to place a stick in the hand of everybody around this community, which I did. Course I sold them very cheap—as low as maybe seventy-five cents, and maybe as high as five and six dollars for some. Some I put the names on, or wrote little phrases, and Bible verses, and different things. I've made lots of them over the years in different forms and fashions. I made them for a good long while, and then I found a job, so I sort of slowed off that and went into something else.

I first started out making crooked sticks out of hickory, but then I began making them out of cedar because it's softer and easier to trim. I used straight heart of cedar. It's a good wood to work with.

First I try to select a good piece of timber that's suitable for carving—it should be good and straight with very few knots, if any. It has to be smooth, soft, and easy to cut. Then with an ax I split it out in the desired shape and form, and smooth it with a drawknife. Then with my pocketknife I begin to carve the figure that I have in mind to try to imitate. I first shape off the body and the head. I go from there and get the arms carved out. Then I use sandpaper to smooth it off. It takes a lot of patience.

I just pick faces out of the hat to carve on my walking sticks. They're just familiar faces. If you can carve one that resembles somebody, then they're very easily identified. I did one of Mr. Ed Sullivan, and one of President Ford, and one of Lorne Greene. I also did one of Redd Foxx. He plays on "Sanford and Son" on the television. I just had an image of him in my mind, so I decided to imitate him on a walking cane. In carving I could get his image fixed in my mind, and he wasn't too much trouble to carve out.

After I came back home from the service I made likenesses of people that I knew around the community. I kind of remember

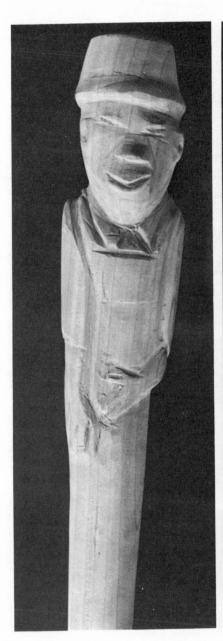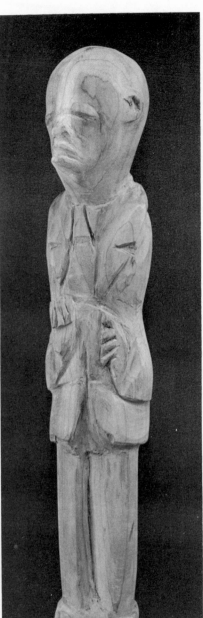

207

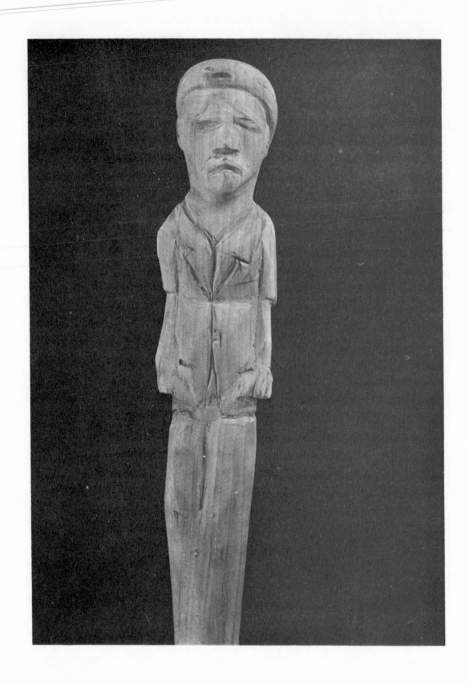

208

faces and I tried to draw them as best I could. Usually I could just look at someone or a snapshot of them and get my mind on it. I could just picture it and pretty near draw anything that came to mind. I just sit down and sketch them out. Mostly I just paint people now. I like to paint individuals. I can look at a fellow and study a few of his features, and almost copy him. I like to sketch almost anybody.

I put my pictures on whatever I have handy that has a smooth surface. Some things are drawn on paper, some on pasteboard, some on plywood. I tried some experiments with cardboard to see if I could make an impression on the cardboard that would leave the face parts sort of lifted up. I don't have any particular color that I favor for my paintings. I use colors that I have handy, mostly water colors. I never did have too much experience with oil painting. I use water colors and regular finger paint, and I've used regular old shoe polish. For my backgrounds I mostly follow the color of the picture and use what colors I have handy. That's a little less expensive than buying coloring. I use several types of paper and assemble them and that will give me a background better. To make a set-in I cut out around the edges of the picture which is one color and paste it onto a different color paper and it gives it a darker background so it shows up better. You know, that has been one of my greatest set-backs in drawing. Any sketch I can usually do, but when it comes to coloring, sometimes I get myself mixed up; maybe I don't use the best background. I always have trouble with background and color. I work on the eyes a lot too, touching them up to try to make them look more human-like. Maybe sometimes I overdo it.[4]

I get my feeling for drawing when I get a little lonesome or something like that. You have to have that feeling to do something. I draw at night—usually in the wintertime and early spring when it's cold and you can't get out to do anything. I have nothing else mostly to do then and I just sit up and draw something to pass away the time. I can draw my best pictures when I'm alone, private. Usually when I'm attempting to draw something I don't want anyone looking over my shoulder. I want to finish it and then show it. Usually during the day I'm maybe busy with something or somebody is around to interrupt me. I might have a mind to draw something and

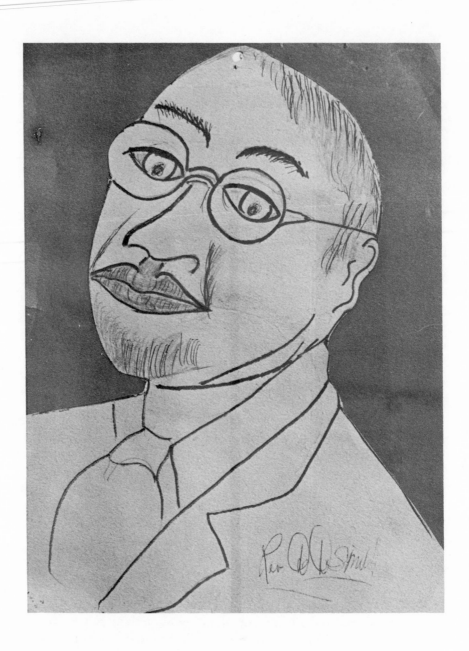

I get about half way through and somebody comes in and disturbs me. Then I lose that thought or that interest and it might be weeks or months before I get that feeling again. I have the most peace and quiet at night. At night I can sit up as late as I want to without too much disturbance. Usually they all go to bed and leave me up. I'll be sitting up mostly by myself and painting.

GLOSSARY

to barnstorm: to appear at county fairs and carnivals in exhibitions of stunt flying and parachute jumping

batts, batting: middle layer of padding, or interlining, of a quilt; in the rural South often made of unginned cotton saved from the crop, or store-bought rolls of cotton fibers that have been mechanically wadded together

bed tick: a light mattress without inner springs

bends, the upper bends: three loops in the main channel of the Mississippi River above Greenville, Mississippi; when the river's channel changed, these loops formed oxbow lakes

blanket stitch: sewing technique forming long vertical stitches with interlocked loops at their base; used by Mrs. Mohamed as an outline and edging stitch

to block: to sew together the "blocks," or major sections of a quilt; to sew large blocks of solid fabric together for areas left blank in the patchwork, often alternating plain blocks with pieced blocks

to bolt timber: to split or cut a chunk of wood off a large piece or log

bottleneck: style of Delta guitar-playing, utilizing a broken bottle top or a piece of metal on the index finger, to slide up and down the strings and produce a unique "wailing" sound

bottom: low-lying land often adjacent to a river or a stream

bottom-up-ards: upside down; short for "bottom upwards"

box: a stringed instrument, usually a guitar

break-down blues: rhythmic blues tunes used for faster dances

breaking its back: bending wood out of its normal shape

Brown Mule tobacco: brand name for plug chewing tobacco

buckshot clay: see *gumbo clay*

Cakewalk: a strutting or shuffling ring dance, based on parody of promenades of slavery days, in which those performing the most unusual steps won cakes as prizes

cane fife: five- or six-hole transverse flute, handmade from a joint of bamboo cane found in bottom lands in the South

chain stitch: embroidery technique forming a chain of successive loops; used extensively by Mrs. Mohamed as an outline and filler stitch

close-out: to wind up or end; the conclusion of an event

coming up: growing up as a child

concrete mat: interlocking mattress of concrete reinforced with steel wire which is laid in the water by a specially-designed barge; to stabilize river banks by protecting them from erosion

corn whiskey: bootleg whiskey distilled from corn

the Delta: A flat plain of alluvial soil lying on each side of the lower Mississippi River. East of the river, it extends from Memphis, Tennessee, south to Vicksburg, Mississippi, and is defined by loess bluffs on its eastern edge.

devil's leg: a heavy central strip of wood which runs from one edge of the basket's rim, through the bottom, and up to the opposite edge of the rim

dogtrot house: housetype common throughout the South, in which a floored and roofed hall or breezeway separates two adjacent rooms on each side

flat (noun): low-lying ground

frame: a quilting frame; a large rectangular wooden frame on which quilt layers are stretched and held taut for stitching; sometimes suspended from the ceiling by ropes

French knot: embroidery technique forming a tightly-clustered knot; used by Mrs. Mohamed for flower buds and stamen, leaves, berries, cotton bolls, and eyes

future: the mental image of imagined work, often drawn from dreams or visions

gin: cotton gin; machine that separates the seeds and seed hulls from the cotton fibers

graphophone: an old-fashioned record player, whose trademark was originally "gramophone"

ground-hog sawmill: small, mobile sawmill which is quickly assembled on the site where timber is to be cut

grubbing hoe: a heavy hoe for grubbing up roots

gumbo clay: very clayey, dark-colored soil common in the Mississippi Delta, containing very sticky, plastic clay that shrinks and swells upon wetting and drying; also called "buckshot clay"

hollering: singing the blues

home-brew: homemade beer

hoodoo: conjuration; magical practices; the casting of spells

hoops: frames used to hold needlework taut

hoopwork: embroidery or other needlework

house parties: parties held privately in homes as opposed to public juke joints; especially popular among blacks in the Mississippi Delta

jaw-jerking: talking a lot

juke: to play the blues; to have a good time

juke joint: tavern or house where liquor is sold and music is played

to knock down baskets: to tap down with a metal tool the horizontal strips ("splits") of a basket so that they wedge tightly against adjacent vertical strips and strengthen the basket

to lace baskets: to weave splits to form a basket

to lay baskets: to lay and interlace wooden strips ("splits") on a flat surface; these laced splits form the bottom of the basket and their extended edges are built up as sides

levee: a small dike or large wall of earth designed to contain a river during high water

Louisiana cane: a grass (*Sorghum vulgare*) which is cultivated as grain, forage, and as a source of syrup; also called "sorghum"

make-ups: blues songs composed on the spot from spontaneously created, or borrowed, verses; also called "right-now songs"

mojo: a charm or amulet carried to bring good luck and ward off evil spirits in the practice of hoodoo; also called a "trick," "hand," "toby," or "jack."

mother of the church: the female leader within a congregation; often an older woman with extensive knowledge of the church's history

old country ball: a dance held at a juke joint, often a special social gathering

old hard blues: traditional blues with a slower beat; also called "gut bucket," "snuff dipping," and "low-down" blues

old harp work: see *Sacred Harp singing*

old tap-dance pieces: faster tunes, often derived from white dance music

on halves: tenant farming or sharecropping; a half share of the crop yield is given to the landlord in lieu of rent

peckerwood: a ground-hog sawmill; a woodpecker; derogatory slang for poor whites or "rednecks"

216

to piece: to sew cut shapes of fabric together into a geometrically patterned block, patchwork style

prayer meeting: a religious gathering on a weekday at which hymns and prayers are shared; the preacher is often not present at these meetings

to pull timber: to rive white-oak splits with a knife to the exact size required for weaving a basket

to quilt: to stitch layers (top, batting, lining) of a quilt together, usually in an outline, crisscross, shell, or other decorative design appearing on the topside

quilt top: uppermost, or top layer of a quilt, made up of the strips, blocks, or individual pieces that have been sewn together into a decorative pattern

reel: a secular tune played by Othar Turner on the cane fife; probably derived from old minstrel show pieces or instrumental dance tunes

rib: one of a series or pair of long, thick, curved white-oak splits extending upward and outward to form the framework of a basket and establish its shape

root doctor: practitioner of traditional medicine who uses herbs, barks, roots, weeds, and berries to prepare medicines and charms; also called "hoodoo doctor" or "conjure doctor"

to run baskets: to lace or weave splits to form a basket

running stitch: common sewing technique forming a small, even row of stitches; used by Mrs. Mohamed to outline and accent

Sacred Harp singing: simplified shape-note system of reading music popularized in the nineteenth century by itinerant singing-school masters and preachers; named from the 1844 hymnal entitled *Original Sacred Harp*; also called "Fasola singing," after the names of the notes

seed house: a small building used to store cotton and corn seed until needed for planting crops

set-in: a silhouetted picture that is glued onto a second surface

shotgun house: possibly African-derived housetype common throughout the South: one-story, one room wide, and two or more rooms deep, with frontward-facing gable and entrance; supposedly so named because a shotgun blast into the front door would go through the entire house and come out the back door

the sixes: a guitar

slave-time houses: cabins or small houses where slaves lived

slip: mule-drawn dirt scraper used to build and maintain levees along the Mississippi River; the slip moved dirt from the bottom to the top of the embankment; also called a "mule scraper"

Slow Drag: black dance characterized by shuffling steps and African-style hip movements to a slow, low-down blues; a favorite of couples in rural juke joints

smoothing iron: an old-fashioned externally heated flatiron used to press clothes

snag boat: a tugboat that patrols the Mississippi River, dragging obstacles out of the way of river traffic; invented in 1824 by Captain Henry Shreve and relatively unchanged to the present time

Snake Hip: African-influenced black dance featuring elaborate knee movements and rotating hips

to snake logs: to drag logs through the woods with a rope or chain

sorghum mill: a press used to crush sorghum cane for syrup; a pole, or sweep, attached to rollers which squeeze the juice out of the cane, is turned by mules or horses

somerset: rolling head over heels; also called a "somersault"

split: a thin strip of white oak woven around the ribs to form the base and sides of a basket; also called a "splint"

striker: apprentice to the engineer on a Mississippi River steamboat

string quilt: a quilt made of long, thin strips of leftover cloth pieced together; also called a "strip quilt"

strings: long, narrow strips of cloth, often leftover from sewing, used for quilting; also called "strips"

to strip: to organize a quilt in long rectangular strips of cloth, rather than in blocks; to alternate strips with pieced blocks, or use them as a border

talking the bottle: blowing in a bottle partially filled with water to produce a "whooping" sound

thousand legs: a crosscut saw, hand-held by two men to cut across the grain of a log

town ball: game in which the ball is thrown in front of runners to count them out; similar to dodge ball

turnip salad: leaves of the cultivated root plant, *Brassica rapa*; also called "turnip greens"

Two-Step: a dance in 2/4 time characterized by long, sliding steps

to weave baskets: to lace splits through ribs and each other to form the body of the basket

whip-cracker: a children's game in which a human whip, formed by holding hands, is sharply swung and popped; also called "whip-lash" or "pop-the-cracker"

to whoop: to utter a hooting cry; to call with a loud shout

to whop: to whip; to thrash

willow mat: large mattress of closely woven willow branches placed on river banks to prevent erosion; now replaced by mats of reinforced concrete

yard goods: cloth sold by the yard; sometimes called "piece goods"

NOTES

Victor "Hickory Stick Vic" Bobb

1. Brierfield Plantation was the home of Confederate President Jefferson Davis, and was located on Davis Island, near Vicksburg, Mississippi. It became a model Freedman's Bureau colony after the Civil War, and burned in the 1930s.

2. Ray Lum (1891–1976) was a mule trader and auctioneer from Vicksburg, Mississippi who worked throughout the U.S.

3. The best white oak for baskets is said to be found growing on the north side of slopes, where the relative lack of light causes the tree to grow straight up, without twisting or putting out branches on the lower trunk. Red oak bark used in conjuration is taken from the north (strongest) side of the tree. [*See also* Pecolia Warner, p. 12.]

Leon "Peck" Clark

1. St. John's weed may be the yellow-flowered St. John's Wort (*Hypericum*) also used in European healing and witchcraft. It is probably unrelated to the commercial substance called "St. John the Conquerer" used in hoodoo and conjuring, which is actually a mixture of several types of roots.

2. "Indian herbs" might refer to one of several plants used by folk healers: Indian Physic (Bowman's Root), Indian Mustard, Indian Potato, or Indian Turnip, but "Peck" Clark is probably using the term collectively, in an association of herbal remedies with American Indian practices.

3. It has been suggested that folk medicines are often bitter tasting and strong smelling in the belief that this helps enable them to drive away sickness, disease, and evil spirits. [*See* Georgia Writers' Project, *Drums and Shadows*, p. 216.]

4. The sage grass "Peck" Clark remembers in broom-making is probably broomsedge or broom sage (*Andropogon virginicus L.*), not the more familiar broomcorn (*Sorghum vulgare technicum*).

5. The verb "to tote" (to pick up, haul, or carry) may be derived from the West African word *tot* which has the same meaning. [*See* Turner, *Africanisms in the Gullah Dialect,* p. 203.]

6. In Afro-American culture such nicknames, often taken from personal characteristics or episodes from the individual's past, are prevalent, and may be related to West African name-giving traditions. [*See* Herskovits, *The Myth of the Negro Past*, pp. 190–194; *see also* James "Son Ford" Thomas, pp. 12 and 20.]

Louis Dotson

1. Perhaps the customary usage of the familiar term "auntie" is related to the significant roles played by elderly females in Afro-American life. [*See* Herskovits, *The Myth of the Negro Past*, pp. 176,179, 180; *see also* James "Son Ford" Thomas, and Pecolia Warner.

2. Chinaberry trees (*Melia azedarach*) are widely grown throughout the Mississippi Delta as flowering shade trees. Their leaves, roots, and berries are used in Afro-American folk medicine. [*See* Genovese, *Roll, Jordan, Roll*, p. 528, and Puckett, *The Magic and Folk Beliefs of the Southern Negro*, pp. 317, 346, 384.]

3. The belief that all fish bite best during the dark (waning) moon is very old and widespread. [*See* Randolph, *Ozark Magic and Folklore*, p. 252.]

4. The term "shotgun," as it refers to a house type, might derive from the Yoruba *to-gun*, meaning "place of assembly." [*See* Vlach, *The Afro-American Tradition in Decorative Arts*, p. 131; *see also* glossary definition.]

5. The origin of the Afro-American term "juke" is from the term *yuka* (*juka*) of the ViLi dialect in the Congo, which can mean "to make a noise, to hit or beat" or "infamous, disorderly, or wicked." [*See* Dillard, *Black English: Its History and Usage in the U.S.* p. 118, and Turner, *Africanisms in the Gullah Dialect* p. 195; *see also* glossary definition. James "Son Ford" Thomas and Pecolia Warner also use this term.]

6. A one-string guitar is also called a "jitterbug" or "diddley bow" and has been very influential on the Delta "bottleneck" style of guitar playing. Dotson's instrument consists of a piece of broom wire stretched vertically on the outside wall of his house, which serves as a resonator for the instrument. The "one string" is played by striking the string with the right index finger, while sliding a bottle held in the left hand along the string's surface. One-string instruments are found both in West Africa and the Caribbean, as well as in the Mississippi Delta. One-string guitar players can

be heard on the following recordings: *Afro-American Folk Music from Tate and Panola Counties, Mississippi, Detroit Blues,* and *One String Blues.* [*See* Evans, "Afro-American One-Stringed Instruments," Ferris, *Blues From the Delta*, and Vlach, *The Afro-American Tradition in Decorative Arts*, 24.]

7. Stearns in *Jazz Dance* and Jones and Hawes in *Step It Down* discuss these and other traditional Afro-American dances. [*See* glossary definitions; *see also* James "Son Ford" Thomas.]

8. First recorded in 1930 with violin accompaniment, "Sitting on Top of the World" was the Mississippi Sheiks' biggest hit.

9. "Bottle Up and Go" was the most popular song recorded by Tommy McClennan (Bluebird, 1939). It was also recorded by Blind Boy Fuller, and others.

10. This widespread song, usually titled "Vicksburg Blues," is based on the "44 Blues" theme. [*See* note 11, below.] It was first recorded by Eurreal "Little Brother" Montgomery in 1930.

11. In 1929 Roosevelt Sykes was the first to record this very influential song. The "44" of the lyrics can refer to a revolver, a train, or the keys of a piano. [*See* Oster, *Living Country Blues*, pp. 393–395.]

12. A similar version to that sung by Louis Dotson was recorded by "Little Hat" Jones in 1929, under the title "Two String Blues." The song refers to the city and the talisman most often associated with hoodoo [*See* glossary definition]. It is frequently titled "Going Back to New Orleans." The term "mojo" may derive from the Kikongo word *mooyo*, meaning "soul." [*See* Oster, *Living Country Blues,* p. 274 and Turner, *Africanisms in the Gullah Dialect*, p. 198.]

13. Several blues songs ("Stormy Monday Blues" and "Blue Monday," for example), and numerous verses, deal with returning to work on Monday, after weekend partying.

14. This traditional spiritual, usually identified with New Orleans, was originally a Sanctified shout celebrating those Holiness church members who were "saved, sanctified and filled with the Holy Ghost." [*See* Heilbut, *The Gospel Sound*, pp. xvii, 176; *see also* Othar Turner.]

Theora Hamblett

1. Miss Hamblett's painting shows a fenced enclosure that holds the cow while it is being milked.

2. Lye was used, in combination with water and animal fat, to make soap, and was obtained by leaching wood ashes.

3. The very popular and much-recorded old country hymn, "Will the Circle Be Unbroken," is part of both black and white gospel traditions. It was popularized by a Carter Family recording in the 1930s. [*See* Heilbut, *The Gospel Sound*, p. 279.]

4. *Dreams and Visions* is a book published in 1975 by Miss Hamblett, discussing her inspirations for her paintings.

5. The painting that Miss Hamblett calls "The Golden Gate" was included in an exhibition at the Museum of Modern Art with the title, "The Vision." [*See* Bihalji-Merin, *Modern Primitives, Masters of Naive Paintings*, p. 210.]

Ethel Wright Mohamed

1. Merchants, as an occupational folk group, probably circulate similar beliefs, but I have been unable to locate any such references. Mrs. Mohamed's "superstitions" about the first customer of the day are related to those about the first visitor on New Year's Day. [*See* White, Newman Ivey (ed.), *The Frank C. Brown Collection of North Carolina Folklore*, Vol. VII, pp. 525 and following.]

2. Mr. Mohamed often told his children bedtime stories from *The Arabian Nights*, a great literary collection of folktales which includes the familiar "Open Sesame," "Aladdin and His Lamp," and "The Forty Thieves." The stories are believed to be of Arabian, Indian, Egyptian, and Jewish origin.

3. The so-called Bayeux Tapestry is actually an embroidery attributed to Queen Matilda, wife of William the Conqueror, which depicts the Norman Conquest.

4. One of Mrs. Mohamed's stitchery pictures was used as the cover illustration for the Program Book of the Smithsonian Institution's 1976 Festival of American Folklife. It shows the various participants from Mississippi, the featured state in 1974.

5. I have been unable to identify the poem quoted by Mrs. Mohamed.

6. *See* note 4, above.

7. Sam Chatmon, the blues guitarist from the prominent Mississippi Delta musical family who played together as the Mississippi Sheiks in the 1930s, was one of the featured musicians from that state at the 1974 Smithsonian Institution Festival of American Folklife. [*See* Oliver, *The Story of the Blues*, p. 49; *see also* Louis Dotson, note 8.]

8. *See* Victor "Hickory Stick Vic" Bobb, note 2.

9. The original Leake County String Band recorded for Columbia in the late 1920s. Members of the band, which was also featured at the 1974 Festival of American Folklife, now include: Roy C. Alford, Sam Alford, Barney Ellis, Morgan Gilmer, and Howard B. Smith.

James "Son Ford" Thomas

1. *See* Louis Dotson, note 1.

2. Thomas is referring to the owner or foreman of the tenant farm on which he and his grandfather lived and "worked shares."

3. James Thomas plays this song in the key of "C natural" and with a 3/4 beat—traditional for white guitarists, and what Thomas calls "cowboy songs." I have been unable to identify the song he mentions.

4. *See* Louis Dotson, note 5.

5. James "Son Ford" Thomas can be heard on the following recordings: *The Blues Are Alive and Well, Blues From The Delta,* and *Mississippi Folk Voices.*

6. *See* Louis Dotson, note 7.

7. There are numerous folk variants of this traditional piece, many of which may have been derived from the 1935 recording by Big Joe Williams. A common stanza follows:

You got me way down here (repeat)
Behind a rolling fork,
You treat me like a dog,
Baby, please don't go.

8. "Honey Bee" is an old traditional song that was recorded by Muddy Waters in 1948. The bumblebee is a frequent metaphor in blues songs.

9. James "Son Ford" Thomas, like other blues singers, utilizes in his songs combinations of: 1. traditional verses and phrases, learned through direct oral transmission; 2. variants derived from phonograph recordings and radio; 3. new lines ("make-ups") created by his own imagination, often spontaneously. This creative process in blues, as in quilt-making [*see* Pecolia Warner, note 8], typifies an Afro-American folk aesthetic that values imagination, improvisation, innovation, experimentation, and variation. [*See* Ferris, "Vision in Afro-American Folk Art: The Sculpture of James Thomas" and Vlach, *The Afro-American Tradition in Decorative Arts*, pp. 3–4: *see also* glossary definition.]

10. Thomas quotes here from a "make-up" song he frequently improvises, drawing on a traditional stock of blues verses.

11. *See* Leon "Peck" Clark, note 6.

12. The term hoodoo (also, voodoo) is derived from the Fon *vodu*, meaning "spirit, deity, or power." [*See* Turner, *Africanisms in the Gullah Dialect*, p. 204, and Dillard, *Black English: Its History and Usage in the U.S.*, p. 118; *see also* glossary definition.]

13. Eyes are also very significant to Afro-American hoodoo doctors and faith healers, who believe that supernatural powers are reflected in their eyes. [*See* Ferris, "Vision in Afro-American Folk Art: The Sculpture of James Thomas," Guillaume and Munro, *Primitive Negro Sculpture*, p. 29, and Georgia Writers' Project, *Drums and Shadows*, p. 210; *see also* Lester Willis, p. 10.]

14. Shelby "Papa Jazz" Brown was a friend of James Thomas from Leland, Mississippi, who ran a juke joint there for many years. He died in 1974.

15. Ugliness is a frequent theme in Afro-American folk culture, and is, in some cases, an aesthetic preference. [*See* Ferris, "Vision in Afro-American Folk Art: The Sculpture of James Thomas" and Brearly, in Dundes (ed.), *Mother Wit From The Laughing Barrel*, pp. 578–581.]

Othar Turner

1. Recorded first by Clifford Gibson for Victor, "Levee Camp Blues" illustrates many elements of field hollers and work-songs that are still found today in the blues. [See Oster, *Living Country Blues*, p. 12.]

2. A cow horn is used by the Turner family for hunting and signaling.

3. A strong tradition of fife and drum music exists today in the hill country of northwest Mississippi. David Evans has studied black folk fife and drum music, and has found that it has its origins in part from the European-style marching band music of local militia units. It dates back to the colonial period, and, up until the Civil War, often featured black musicians. In addition, this music has been strongly influenced by African and Afro-American dance-oriented folk music. Vlach states that the cane fife came to the United States from Africa through Georgia. Today in Mississippi fife and drum music is played primarily for dancing at outdoor community picnics held in the summertime, from the Fourth of July through Labor Day. [See Evans, "Black Fife and Drum Music in Mississippi," Vlach, *The Afro-American Tradition in Decorative Arts*, p. 23, and Oliver, *Savannah Syncopactors: African Retentions in the Blues*, pp. 25, 78–79, 109–110.]

4. The two snare drums are tuned an octave apart and are called the "lead kettle" and the "bass kettle." Examples of fife and drum music can be heard on the following recordings: *Traveling Through the Jungle: Negro Fife and Drum Band Music, Mississippi Folk Voices, The Roots of the Blues, Mississippi Delta Blues, Volume I,* and *Afro-American Folk Music from Tate and Panola Counties, Mississippi.*

5. The African manner of drum-tuning over an open fire has been found among Caribbean as well as Afro-American musicians.

6. David Evans has recorded Turner's band playing this old minstrel song on *Traveling Through the Jungle: Negro Fife and Drum Band Music.*

7. "Bullyin' Well" has been issued on *The Blues Roll On,* (Atlantic SD-1352), recorded in 1959 by Alan Lomax, and sung by Rosalie Hill of Senatobia, Mississippi.

8. Othar Turner may be distinguishing between the traditional thumb-picked strum of the banjo style (frailing) and fingerpicking on the guitar (clearpicking).

9. "Shimmy She Wobble" refers to a group of freely-improvised songs after the popular dance of the 1920s of the same name. It was recorded in 1928 on Victor by McKinney's Cotton Pickers with the title, "Shim-Me-Sha-Wabble." It can be heard by Turner's band on *Traveling Through the Jungle: Negro Fife and Drum Band Music.*

10. This popular blues song, known as "My Babe," can also be heard on *Traveling Through the Jungle: Negro Fife and Drum Band Music.*

11. This old traditional blues is related to "Vicksburg Blues" and "44 Blues," and was recorded as "Roll and Tumble Blues" by "Hambone" Willie Newbern in 1929. It was later recorded by Muddy Waters and Elmore James, among others.

12. This very popular Sanctified gospel song has been widely recorded, with the alternate titles, "When I Lay My Burden Down," and "Since I Laid My Burden Down." Othar Turner's version is recorded on *Mississippi Folk Voices.*

13. *See* Louis Dotson, note 14.

14. At the picnics a fight may break out between a husband and wife, or between two men over a woman.

15. Napoleon Strickland is a friend and neighbor of Othar Turner who has in recent years worked with his band as a fife player. He can be heard on *Mississippi Delta Blues, Volume I.*

16. Othar Turner misquotes the usual opening stanza of "Matchbox Blues." Blind Lemon Jefferson, the influential Texas-born singer and guitarist, first recorded this song in 1927. The first stanza follows:

I was sitting here wondering, will a matchbox hold my clothes,
 (repeat)
Lord, I ain't got so many [matches], but I got so far to go.

Pecolia Warner

1. Vlach states that string quilts are the single most prevalent item of domestic Afro-American material culture. They are certainly the most popular type of Afro-American pieced quilt. He relates them to West African textiles, where long narrow strips are also the basic structural and design units. [*See* note 8, below; *see also* glossary definition.]

2. *See* Louis Dotson, note 1.

3. Cures for snakebite are common in Afro-American medical lore. Puckett, in *The Magic and Folk Beliefs of the Southern Negro* (pp. 378, 425), documents similar uses of a black chicken to treat snakebite by "drawing the poison out." [*See also* Hudson, *Specimens of Mississippi Folk-Lore*, p. 141.]

4. *See* Leon "Peck" Clark, note 3.

5. Pecolia Warner is probably referring to one of many common pasture and roadside weeds (*Erigeron* or *Helenium*) which make cow's milk bitter when they eat it in the spring. [*See also* Leon "Peck" Clark, note 3.]

6. The bark from several different kinds of red oak is commonly used in folk medicine and in conjuration and is usually brewed as a tea, to bathe in or to drink. It is thought to cure backache, rheumatism, diarrhea, toothache, and chills and fever. [*See* Puckett, *The Magic and Folk Beliefs of the Southern Negro*, pp. 212, 366–367, 373; *see also* Victor "Hickory Stick Vic" Bobb, note 3.]

7. Salves made of grease and turpentine for colds, coughs, and chest congestion are a well-known folk remedy throughout the rural South.

8. Vlach has found that slaves brought to America their considerable expertise with textiles, and while quilt-making techniques are essentially of Euro-American origin, the structure and design of many Afro-American quilt tops have West African analogs. He describes the Afro-American quilt aesthetic, similar to that found in West African textile tradition, where improvisation, creativity, innovation, asymmetry, and variation rule. [*See* Vlach, *The Afro-American Tradition in Decorative Arts*, pp. 44 and following. Holstein, *The Pieced Quilt: An American Design Tradition,* and Orlofsky, *Quilts in America; see also* note 2, above, and James "Son Ford" Thomas, note 10.]

Luster Willis

1. Black teenager Emmett Till was murdered in September 1955 in Leflore County, Mississippi. The murder, which was racially motivated, received wide publicity.

2. This well-known parable of the Rich Man and the Poor Man is found in *Luke* 16: 19–31. Lazarus is the beggar who fought dogs for the crumbs from the rich man's table.

3. Willis's painting was probably inspired by the image depicted in the popular black version of the camp-meeting hymn "Old Ship of Zion":

> This old ship is a reeling and a rocking (repeat)
> Making for the promised land.

[*See* Odum and Johnson, *The Negro and His Songs*, pp. 117–118.]

4. *See* James "Son Ford" Thomas, note 15.

SELECTED BIBLIOGRAPHY

Books and Articles

Bastide, Roger. *African Civilization in the New World.* Peter Green, transl. New York: Harper & Row, 1971.

Bihalji-Merin, Oto. *Modern Primitives, Masters of Naive Paintings.* Norbert Guterman, transl. New York: H. N. Abrams, Inc., 1961.

Bishop, Robert Charles. *American Folk Sculpture.* New York: E. P. Dutton and Company, Inc., 1974.

Blasdel, Gregg N. "The Grass-Roots Artist," *Art in America,* 56:5 (Sept.–Oct. 1968), 24–41.

Bragg, Marion. *Historic Names And Places on the Lower Mississippi River.* Vicksburg, Miss.: Mississippi River Commission (for the Corps of Engineers, U.S. Army), 1977.

Browne, Ray B. *Popular Beliefs and Practices from Alabama.* Berkeley and Los Angeles: University of California Press, 1958.

Carrahar, Ronald G. *Artists in Spite of Art.* New York: Van Nostrand Reinhold Company, 1970.

Chase, Judith Wragg. *Afro-American Art and Craft.* New York: Van Nostrand Reinhold Company, 1971.

Cohn, David. *Where I Was Born and Raised.* South Bend: University of Notre Dame Press, 1967.

Cooper, Patricia and Norma Bradley Buferd. *The Quilters: Women and the Domestic Art.* Garden City, New York: Doubleday and Company, Inc., 1977.

Cotton, Gordon A. (ed.). *Vicksburg Under Glass: A Collection of Early Photographs from The Glass Negatives of J. Mack Moore.* Raymond, Miss.: The Keith Press (for the Vicksburg and Warren County Historical Society), 1975.

Dalby, David. "The African Element in American English," in Thomas Kochman, ed., *Rappin' and Stylin' Out.* Chicago: University of Illinois Press, 1972, 170–186.

Daniel, Pete. *Deep'n as It Come: The 1927 Mississippi River Flood.* New York: Oxford University Press, 1977.

Dillard, John L. *Black English: Its History and Usage in the U.S.* New York: Random House, 1972.

Dollard, John. *Caste and Class in a Southern Town.* New Haven: Yale University Press, 1937.

Driskell, David C. *Two Centuries of Black American Art.* New York: Alfred A. Knopf (for the Los Angeles County Museum of Art), 1976.

Dundes, Alan (ed.). *Mother Wit From The Laughing Barrel: Readings in the Interpretation of Afro-American Folklore.* Englewood Cliffs, N.J.: Prentice-Hall, 1973.

Eaton, Allen H. *Handicrafts of the Southern Highlands.* New York: Dover Publications, Inc., 1973.

Evans, David. "Afro-American Folk Sculpture from Parchman Penitentiary," *Mississippi Folklore Register*, 6:4 (Winter 1972), 141–152.

———. "Afro-American One-Stringed Instruments," *Western Folklore*, 29:4 (1971), 229–245.

———. *Big Road Blues: Tradition and Creativity in the Folk Blues.* Berkeley: University of California Press, 1982.

———. "Black Fife and Drum Music in Mississippi," *Mississippi Folklore Register*, 6:3 (Fall 1972), 94–107.

Ferris, William. *Afro-American Folk Arts and Crafts.* Boston: G. K. Hall, in press.

———. *Blues from the Delta.* New York: Doubleday, 1979.

———. "Don't Throw It Away," *Yale Alumni Magazine*, 37:6 (March 1974), 20–22.

———. "If You Ain't Got It in Your Head, You Can't Do It with Your Hands: James Thomas, Mississippi Delta Folk Sculptor," *Studies in the Literary Imagination*, 3:1 (April 1970), 89–107.

———. *Mississippi Black Folklore: A Research Bibliography and Discography.* Hattiesburg, Miss.: University and College Press of Mississippi, 1971.

———. "Vision in Afro-American Folk Art: The Sculpture of James Thomas," *Journal of American Folklore*, 88:348 (April–June 1975), 115–132.

Finley, Ruth E. *Old Patchwork Quilts and the Women Who Made Them.* Philadelphia: J. B. Lippincott Company, 1929.

Freeman, Roland L. *Folkroots: Images of Mississippi Black Folklife* (1974–1976). Jackson Miss.: Mississippi Department of Archives and History, Mississippi State Historical Museum, 1977.

Freeman, Roland and Worth Long. "Mississippi Black Folklife," *Southern Exposure*, 3:1 (Spring–Summer 1975), 84–87.

Garrett, Romeo B. "African Survivals in American Culture," in Arthur L. Smith, ed., *Language, Communication and Rhetoric in Black America.* New York: Harper & Row, 1972.

Genovese, Eugene D. *Roll, Jordan, Roll.* New York: Vintage Books (Random House), 1976.

Georgia Writers' Project. *Drums and Shadows.* Athens, Ga.: University of Georgia Press, 1940.

Glassie, Henry. "Folk Art," in *Folklore and Folklife: An Introduction.* ed. Richard M. Dorson. Chicago: University of Chicago Press, 1972, pp. 253–280.

———. *Pattern in the Material Folk Culture of the Eastern United States.* Philadelphia: University of Pennsylvania Press, 1968.

Guillaume, Paul and Thomas Munro. *Primitive Negro Sculpture.* New York: Hacker Art Books, 1954.

Hall, Carrie and Rose G. Kretsinger. *The Romance of the Patchwork Quilt in America.* New York: Bonanza Books, 1935.

Hamblett, Theora in collaboration with Edwin E. Meek. *Dreams and Visions.* Oxford, Miss.: Theora Hamblett, 1975.

Hamblett, Theora in collaboration with Ed Meek and William S. Haynie. *Theora Hamblett Paintings.* Jackson, Miss.: University Press of Mississippi, 1975.

Hand, Wayland D. (ed.). *American Folk Medicine: A Symposium.* Berkeley and Los Angeles: University of California Press, 1976.

Harris, B. K. (ed.). *Southern Home Remedies.* Murfreesboro, N.C.: Johnson Publishing Company, 1968.

Hemphill, Herbert W., Jr. (ed.). *Folk Sculpture U.S.A.* New York: The Brooklyn Museum, 1976.

Hemphill, Herbert W., Jr. and Julia Weissman. *Twentieth Century American Folk Art and Artists.* New York: E. P. Dutton and Company, Inc., 1974.

Herskovits, Melville J. *The Myth of the Negro Past.* New York: Harper & Row, 1941.

Holstein, Jonathan. *The Pieced Quilt: An American Design Tradition.* Greenwich, Ct.: New York Graphic Society, Ltd., 1973.

Horwitz, Elinor Landor. *Contemporary American Folk Artists.* New York: J. B. Lippincott Company, 1975.

Hyatt, Harry Middleton. *Hoodoo, Conjuration, Witchcraft, Rootwork.* 4 vols. Cambridge, Md.: Western Publishing Company, 1971–1974.

Jones, Bessie and Bess Lomax Hawes. *Step It Down: Games, Plays, Songs, and Stories from the Afro-American Heritage.* New York: Harper and Row, 1972.

Jones, Michael Owen. *The Hand-Made Object and Its Maker.* Berkeley and Los Angeles: University of California Press, 1975.

———. "The Study of Traditional Furniture: Review and Preview," *Keystone Folklore Quarterly,* 7:4 (Winter 1967), 233–246.

Klamkin, Marian and Charles. *Wood Carvings: North American Folk Sculptures.* New York: Hawthorne Books, Inc., 1974.

Lipman, Jean. *American Folk Art in Wood, Metal and Stone.* New York: Dover Publications, Inc., 1972.

Lipman, Jean and Alice Winchester. *The Flowering of American Folk Art 1776–1876.* New York: The Viking Press (for the Whitney Museum of American Art), 1974.

Livingston, Jane and John Beardsley. *Black Folk Art in America,* 1930–1980. Jackson: Published for the Corcoran Gallery of Art by the University Press of Mississippi and the Center for the Study of Southern Culture, 1982.

MacLeod, Bruce A. "The Musical Instruments of North American Slaves," *Mississippi Folklore Register,* 11:1 (Spring 1977), 34–49.

Marshall, Howard Wight. "Mr. Westfall's Baskets: Traditional Craftsmanship in Northcentral Missouri." *Mid-South Folklore,* 2:2 (Summer 1974), 43–60.

McCulloch, Walter F. *Woods Words: A Comprehensive Dictionary of Loggers' Terms.* Portland, Ore.: The Oregon Historical Society and The Champoeg Press, 1958.

Miller, Jennifer. "Quilting Women," *Southern Exposure,* 4:4 (Winter 1977), 25–28.

Mitchell, George. *Blow My Blues Away.* Baton Rouge: Louisiana State University Press, 1971.

Mohamed, Ethel and Charlotte Capers and Olivia P. Collins (eds.). *My Life in Pictures.* Jackson, Miss.: Mississippi Department of Archives and History, 1976.

Morland, J. Kenneth (ed.). *The Not So Solid South: Anthropological Studies in a Regional Subculture.* Athens, Ga.: Southern Anthropological Society, *Proceedings* No. 4 (University of Georgia Press), 1971.

Morton, Robert. *Southern Antiques and Folk Art.* Birmingham, Ala.: Oxmoor House, Inc., 1976.

Naives and Visionaries. exhibition catalogue. Walker Art Center, Minneapolis, Minn. New York: E. P. Dutton and Company, Inc., 1974.

Orlofsky, Patsy and Myron. *Quilts in America.* New York: McGraw-Hill, 1974.

Palmer, Robert. *Deep Blues.* New York: Viking Press, 1981.

Parrish, Lydia. *Slave Songs of the Georgia Sea Islands.* Hatboro, Pa.: Folklore Associates, 1965.

Pederson, Lee, Raven I. McDavid, Jr., Charles W. Foster, and Charles E. Billiard (eds.). *A Manual for Dialect Research in the Southern States.* University, Ala.: University of Alabama Press, 1974.

Phillips, Karen (ed.). *A Catalogue of the South.* Birmingham, Ala.: Oxmoor House, Inc., 1974.

Powdermaker, Hortense. *After Freedom: A Cultural Study in the Deep South.* New York: Russell and Russell, 1939.

Puckett, Newbell Niles. *The Magic and Folk Beliefs of the Southern Negro.* Chapel Hill: University of North Carolina Press, 1926.

Randolph, Vance. *Ozark Magic and Folklore.* New York: Dover Publications, Inc., 1964.

Roberts, Warren E. "Folk Crafts," in *Folklore and Folklife: An Introduction.* ed. Richard M. Dorson. Chicago: University of Chicago Press, 1972, pp. 233–252.

Safford, Carleton L. and Robert Bishop. *America's Quilts and Coverlets.* New York: E. P. Dutton and Company, Inc., 1972.

Seibels, Eugenia and Jo Anne McCormick. *Southern Folk Arts.* exhibition catalogue. The University Museums, McKissick Library, University of South Carolina. Columbia: University of South Carolina, 1977.

Shapiro, Linn (ed.). *Black People and Their Culture: Selected Writings from the African Diaspora.* Washington, D.C.: Smithsonian Institution, 1976.

Smithsonian Institution/U.S. National Park Service. 1974 Festival of American Folklife. *Festival Program Book.* ed. Susanne Roschwalb. Washington, D.C.: Graphics Four, Inc., 1974.

———. 1976 Festival of American Folklife. *Festival Program Book.* ed. Bess Lomax Hawes and Susanne Roschwalb. Washington, D.C.: French Bray Printing Company, 1976.

Speight, Carolyn. "The Creative Hand," *South Carolina Wildlife,* 24:4 (July–August 1977), 24–41.

Stearns, Marshall and Jean. *Jazz Dance: The Story of American Vernacular Dance.* New York: The Macmillan Company, 1968.

Stein, Kurt. *Canes and Walking Sticks.* York, Pa.: Liberty Cap Books, 1974.

Szwed, John and Roger Abrahams. *Afro-American Folk Culture: An Annotated Bibliography of Materials from North, Central and South America and the West Indies.* 2 vols. Philadelphia: Institute for the Study of Human Issues, 1978. (Publications of the American Folklore Society. Bibliographical and Special Series, 31). Volume 1 covers North America.

Teleki, Gloria Roth. *The Baskets of Rural America.* New York: E. P. Dutton and Co., Inc., 1975.

Thompson, Robert Farris. "African Influence on the Art of the United States," in *Black Studies in the University: A Symposium.* ed. Armstead L. Robinson, Craig C. Foster, and Donald H. Ogilvie. New Haven: Yale University Press, 1969, pp. 122–170.

———— and Joseph Cornet. *The Four Moments of the Sun: Kongo Art in Two Worlds.* Washington, D.C.: National Gallery of Art, 1981.

Tullos, Allen (ed.). Long Journey Home: *Folklife in the South.* Special double issue. *Southern Exposure,* 5:2–3 (Summer–Fall 1977).

Turner, Lorenzo D. *Africanisms in the Gullah Dialect.* Chicago: University of Chicago, 1949.

Vlach, John Michael. *The Afro-American Tradition in Decorative Arts.* exhibition catalogue. Cleveland: Cleveland Museum of Art, 1978.

————. "Graveyards and Afro-American Art," *Southern Exposure,* 5:2–3 (Summer–Fall 1977), 161–165.

Wadsworth, Anna (ed.). *Missing Pieces: Georgia Folk Arts 1770–1976.* exhibition catalogue. Atlanta: Georgia Council for the Arts and Humanities, 1976.

Wahlman, Maude S. "The Art of Afro-American Quiltmaking: Origins, Development, and Significance." Unpub. Ph.D. diss., Yale University, 1979.

Wentworth, Harold and Stuart Berg Flexner. *Dictionary of American Slang.* New York: Thomas Y. Crowell Company, 1967.

Whitten, Norman E., Jr. and John F. Szwed. *Afro-American Anthropology.* New York: The Free Press, 1970.

Wigginton, Eliot. *The Foxfire Book.* 4 vols. New York: Doubleday (Anchor Books), 1972–1977

Multimedia Materials

The Art of Theora Hamblett. 16mm film—22 minutes—color—1966—Department of Film Production, University of Mississippi.

Basket Builder. 16mm film—12 minutes—color—1974—LucyAnn Kerry, Blue Ridge Films.

Basketmaking. 16mm film—15 minutes—color—date not available—Division of Media Studies, Western Kentucky University.

Basketmaking in Colonial Virginia. 16mm film—28 minutes—color—1968—Colonial Williamsburg.

Bottle Up and Go. 16mm film—18 min.—color—1981—Center for Southern Folklore. [Louis Dotson].

Buck Dancer. 16mm film—6 minutes—b&w—Edmund Carpenter, Bess Lomax Hawes, and Alan Lomax—Film Images.

Colors, Shapes, and Memories: three Folk Artists. slide-tape program—9 minutes—color and b&w—1978—Center for Southern Folklore [Theora Hamblett, Ethel Mohamed, James "Son Ford" Thomas].

Delta Blues Singer: James "Sonny Ford" Thomas. 16mm film—45 minutes—b&w—1970—Center for Southern Folklore.

Eli Johnson: Appalachian Split-Oak Basketmaker. slide-tape program—21 minutes—color—1977—Appalachian Museum, Berea College.

Four Women Artists. 16mm film—25 minutes—color—1977—Center for Southern Folklore [Fudora Welty, Theora Hamblett, Ethel Mohamed, Pecolia Warner].

Give My Poor Heart Ease: Mississippi Delta Bluesmen. 16mm—22 minutes—color—1975—Center for Southern Folklore [James "Son Ford" Thomas].

Gravel Springs Fife and Drum. 16mm film—10 minutes—color—1971—Center for Southern Folklore [Othar Turner].

Leon "Peck" Clark, Basketmaker. 16mm film—15 minutes—color—1981—Center for Southern Folklore.

Made in Mississippi: Black Folk Art And Crafts. 16mm film—20 minutes—color—1975—Center for Southern Folklore [Leon "Peck" Clark, James "Son Ford" Thomas, Othar Turner, Luster Willis].

Missing Pieces: Contemporary Georgia Folk Art. 16mm film—28 minutes—color—1977—Steve Heiser—Georgia Council for the Arts and Humanities.

Quilting in the Southern Appalachians. slide-tape program—20 minutes—color—1977—Appalachian Museum, Berea College.

Quilting Women. 16mm film—28 minutes—color—1976—Elizabeth Barret—Appalshop Films.

Traditional Quilting. 16mm film—30 minutes—color—Division of Media Studies, Western Kentucky University.

200 Plus One: Othar Turner's Gravel Springs Fife and Drum Corps. 1/2" videotape—29 minutes—b&w—Televista Projects, Inc.—1977.

Complete information about these and other films on folk art and crafts is available in *American Folklore Films & Videotapes: An Index,* (1976) Center for Southern Folklore, Memphis, Tennessee.

American Folklore Films & Videotapes: A catalog, Volume II, (1982), R. R. Bowker, New York, N.Y.

Recordings

Evans, David. *Afro-American Folk Music from Tate and Panola Counties, Mississippi.* Library of Congress AFSL-67.

———. *Traveling Through the Jungle: Negro Fife and Drum Band Music.* Testament Records T-2223.

Ferris, William. *The Blues Are Alive and Well.* Transatlantic XTRA-1105.

———. *Blues from the Delta.* Matchbox SDM-226.

———. *Mississippi Folk Voices.* Center for Southern Folklore, Southern Folklore Records 101.

Lomax, Alan. *The Roots of the Blues.* Atlantic SP-1348.

INDEX

236

PHOTO CREDITS

All photos listed below are from the Center for Southern Folklore Archives, Memphis, Tennessee.

Unless otherwise noted, all photographs are by William Ferris. Other contributing photographers with accompanying page numbers: *Victor Bobb Collection:* 6, 24 bottom; *Hester Magnuson:* 53, 55, 57, 65; *Carroll Frank Fourmy III:* 45, 47, 71, 73, 74, 76, 77, 80, 88, 93, 97, 100, 117, 118, 125 bottom, 179, 183; *Judy Peiser:* 80, 101, 107, 110, 122, 175; *Jane Moseley:* 81, 85, 87, 147, 172, 195, 196 (2), 197, 198, 200, 201, 202, 203, 207 (2), 208, 210, 211, 212; *Parents of Theora Hamblett/Theora Hamblett Collection:* 92; *Theora Hamblett Collection:* 78, 89, 98.

ABOUT THE AUTHOR

Dr. William R. Ferris, Jr., a leading scholar on Mississippi folk life, is director of the Center for the Study of Southern Culture at the University of Mississippi. He is Co-founder of the Center for Southern Folklore.

The Center for Southern Folklore, Memphis, Tennessee, is a non-profit multimedia corporation dedicated to preserving indigenous and ethnic cultures of the South through films, books, records, exhibits, and community presentations. Subjects include folk art and crafts, music, religion, and storytelling. The Center's work has received national and international recognition. Its films have been presented at the American Film Institute, Museum of Modern Art, the American Museum of Natural History and PBS. The Center's films, records, exhibits and publications are available for rental and purchase by contacting the Center for Southern Folklore, P.O. Box 40101, Memphis, Tennessee 38104. 901-726-4205.